# DECODING THE BAYEUX TAPESTRY

# DECODING THE
# BAYEUX TAPESTRY

## THE SECRETS OF HISTORY'S MOST FAMOUS EMBROIDERY HIDDEN IN PLAIN SIGHT

ARTHUR WRIGHT

FRONTLINE
BOOKS

# DECODING THE BAYEUX TAPESTRY
## The Secrets of History's Most Famous Embroidery Hidden in Plain Sight

First published in Great Britain in 2019 by

Frontline Books
An imprint of
Pen & Sword Books Ltd
Yorkshire - Philadelphia

ISBN 978 1 52674 110 3

A CIP catalogue record for this book is
available from the British Library

Typeset in 10.5/13 pt Palatino
by Aura Technology and Software Services, India

Printed and bound in India by Replika Press Pvt. Ltd.

Pen & Sword Books Ltd incorporates the Imprints of Aviation, Atlas,
Family History, Fiction, Maritime, Military, Discovery, Politics, History,
Archaeology, Select, Wharncliffe Local History, Wharncliffe True Crime,
Military Classics, Wharncliffe Transport, Leo Cooper, The Praetorian Press,
Remember When, Seaforth Publishing and Frontline Publishing.

For a complete list of Pen & Sword titles please contact

PEN & SWORD BOOKS LTD
47 Church Street, Barnsley, South Yorkshire, S70 2AS, England
E-mail: enquiries@pen-and-sword.co.uk
Website: www.pen-and-sword.co.uk

Or

PEN AND SWORD BOOKS
1950 Lawrence Rd, Havertown, PA 19083, USA
E-mail: Uspen-and-sword@casematepublishers.com
Website: www.penandswordbooks.com

# Contents

Chapter 1

# The Mystery at the Margins

Although it is difficult to obtain an exact economic value to the town of Bayeux today, 400,000 visitors each year pass through the Musée de la Tapisserie de Bayeux, established in 1949. Something like 400 books and articles have been written about this embroidery 224 feet long composed of eight bands of linen sewn into one continuous strip. It shows something like 632 human figures, 560 animals and a further 202 horses with forty-one ships and thirty-seven buildings and it is 950 years old. It is an incredible object and an amazing survivor and, until 1476, no one even knew it existed. Only in the early nineteenth century was it really recognised and from then onwards it has fascinated scholars and visitors, writers and readers, teachers and children by the millions in England and in France and right around the world. It is a 'national treasure', but whose national treasure is it really and, in spite of so many volumes (which do not always agree), who can be certain what it actually tells us? Who, indeed, has actually 'read' what all the words and all the pictures say?

The accounts we have of the events of 1066 were written by the victors (it is always so) and so the analyses presented by them and by their followers often display personal and political motivations. Accounts written not long after the event, for political reasons, though commonly employed as history, I call 'the panegyrists', 'toadies', authors seeking to flatter William and to justify the Norman occupation of England. They were the beneficiaries of the Conquest and, looking for further rewards, what else could they write but stories that conformed to the desires of the conquerors?

These histories of the Conquest do not always agree with one another, but they do all agree that the Conquest was a 'good thing'. Well, was it?

We all recognise that it is dangerous to listen to and then espouse one side in a dispute and not the other. Despite this, I am going to refer to the Bayeux Tapestry throughout as the Tapestry, even though it isn't a tapestry at all but an embroidery. Come to that, it was only *found* at Bayeux, it wasn't made there and might not even belong there. What is more, the Battle of Hastings wasn't fought at Hastings either. It seems that our histories aren't very logical.

To me the past is not just a kaleidoscope, neither should it be a false image, a door banged shut. Our embroidery, the Tapestry, is a veil to be lifted.

Others have pieced together the dynastic and chronological aspects of the main story shown on this embroidery, the main tableau. These scholars tell us both the broad and the detailed picture of events into which this visual record has to be set in order to comprehend its significance. What concerns me is the imperfect picture we have of the Norman invasion and Conquest on the English side, for though the Normans have left us a vast amount of material, or so it seems, it is difficult to construct the opposite side of the picture, the English story. I hope that I can correct this evidence, redress the balance and discover a fuller picture of the invasion. In fact, when we have *all* the evidence at our finger-tips we will be better able to evaluate what has been said before – because what has been said before has always omitted a key part of the evidence. We might declare that everything said so far has only ever been based on two-thirds of the embroidery. Now we will read it all.

To some people medieval history is a fantasy world, like the Game of Thrones. Well, our Tapestry has margins that fit this view very well. They are peopled with bright, imaginatively coloured birds and animals who call to one another, converse, play, cover their faces with their wings, bite their own tails, fall over backwards in excitement. Gryphons, fire-breathing dragons, half-dragons, ravens, vultures, eagles, lots of big cats of all colours, goats, bears, lions, camels, centaurs and other things besides are there, filling the space top and bottom until we come to the battle. Here there is all the violence and butchery you can desire.

We all accept that the people who designed our cars knew about engines, suspension and steering, otherwise who would race off at 60 miles an hour in one? But academics tell their students the pleasure of history is that opinions are always changing, new theories floated. Unlike science there are no inconvenient 'facts'.

My interest in the Tapestry lies principally in what we can lump together at the margins, the top and bottom borders that follow the main story, schema or presentation. I hope they may contain some clues otherwise overlooked. Pictures also communicate, sometimes much better than words. Indeed, it is often quoted as an educational axiom that 'one picture is worth a thousand words'. So, my aim is to explain these, heretofore, generally ignored and uncomprehended, subordinate (pictorial) details.

I do not subscribe to the argument that these margins are largely mere decorative elements. Neither do I accept them as being esoteric and intellectual exercises in the methodology of interpreting religious texts according to the accepted rules (called biblical hermeneutics) done for the amusement of a few (and of course, even then exceptional) superior monkish scholars. The Tapestry's audience was secular rather than religious and it certainly was not academic. I hope to demonstrate that these margins play an important part in both the schema and the story it presents at an everyday level and that they

2

consequently add to the picture we are able to reconstruct from this important period in our history. They help us solidify the knowledge gained from the schema. That they also open up a new window on the ability of our ancestors, who were very different to us in their thoughts and culture, to communicate, is a further bonus.

It is obvious to anyone that among these border-images are fables, little scenes with animals and birds, and in these we do have a point of human contact with our aboriginal ancestors, for the same fables have been handed down to us. That is why and how we recognise them. These fables have, from time-to-time, generated scholarly discussions. Such discussions have circulated around some religious or monkish connection, I suppose because scholars want to identify themselves with the creators of such a treasure and there were, in 1070 or thereabouts, no universities with which to identify. How could ordinary people be so educated to be able to 'read' such fables that today we struggle to understand? That is a question in need of an answer.

Then we have to ask ourselves whether the mass of original spectators, or even the generality of monkish viewers, would have enjoyed an education on the elevated plane required to enjoy all these fables (especially the supposedly esoteric ones)? Was the Tapestry designed not as a picture-book but as a formal and an intellectual exercise for an educated, tiny elite? Were the soldiers and participants in the battle, for example, to be treated to a series of lectures by eminent fabulists? For fable images have been identified as signs indicating the sources of remembered texts that would evoke particular details. That might be the case for the select few, but the generality of monastic viewers were far from educated and their secular elite would have needed greater knowledge than most in order to comprehend such an exclusive artefact. No, the fables shown were commonly known ones. What seems esoteric is, instead, a language.

My contention is that almost everyone could understand the margins and their graphic language to some degree so that the majority of viewers could indeed be said to have had more (not less) specialised knowledge than the monastic viewers, even though seculars did not understand Latin and could not read the superscript. We will explore this paradox as we proceed.

While it is always presumed that monasteries were the only seats of learning, the only schools able to provide Latin and Greek literacy through reading books, we should not forget that the rules of such establishments were strict, punishments could be savage and copying work was tedious and did not demand a high degree of scholarship. The strict hierarchy depended on many humble (in every sense) workers, a small elite of choir-monks and an aristocracy of fast-track younger sons (with an occasional scholar) destined for higher and more comfortable office. Few at any level had comprehensive knowledge of the outside world. Many were donated as infants and the practical orders such as Cistercians had not yet been created. Monastic, conventual houses were prayer-factories not universities and Faith counted for more than realty. I agree entirely with Dodwell

that this embroidery was a secular artefact rather than something produced solely for Bayeux Cathedral, in spite of the coincidence that it can be made to fit the present nave[2].

It has been found necessary to argue that giving a beast a lion's tail but no mane indicated or allowed allusion to a wolf But why such recurring creatures cannot be the less exotic pard (big cat), well-known at the time, is beyond my comprehension. Likewise, the invention of stories of rape and incest to explain the naked man and woman in Harold's embassy, and the similar invention of a juvenile daughter of William's with an English name, seem to verge on the ridiculous. Their only virtue, if it can be called such, is sensationalism, which is always attractive to the uncritical or superficial reader. It attracts readers, but it does not assist scholarship. I have elected to read all the symbols and fables as being consistently applied in realistic situations while the fables themselves I have related to Aesop, supposing that even by c.1070 many of these will have joined the everyday, rather than esoteric and scholastic, traditions. Aesop is therefore the most likely source for commonly understood fable stories and metaphors at this date. So where does all this take us? It eventually takes us well beyond the Tapestry itself.

Once we have established the full story hidden within the Tapestry, I have made so bold as to examine a number of related aspects more critically, to put them properly into context. Some have been examined before yet, because the full picture was not available, appreciation was limited to what writers knew and often to what people had been told. Some aspects have never been examined before, such as linking a reading of the *Domesday Book* entries in Sussex to the Tapestry's pictures. I have taken the liberty not only of intruding what I have discovered concerning the politics of the age, but also to put the sketchy topographic records of the Tapestry into context with the fuller economic and agrarian details the *Domesday Book* provides, now (for the first time) jointly creating a landscape by which to assess the impact of the invasion on the immediate locality of the battle. I believe a more accurate and a more balanced view of the Conquest is the result.

To go further we need to remember that we are entering a world that was far different from the one we inhabit today. We have to think in ethnographic terms, for example of cultures that had highly developed languages and pictures but no written script (e.g. Inuit, Vai, Bamun, Navaho), certainly cultures that knew nothing of our recent written sophistication. We have to think at their level, if we can, in order to enter their minds. How otherwise can we really comprehend their picture-language? It seems to me possible because we can combine the popular voice of the people, found among the illustrations of our Tapestry, with the statistical view of that world provided by the *Domesday Book*. The Tapestry will be the thoughts, the Book the reality seen, the vision of practical people who witnessed what they saw around them. Of course, both sources give us a view through their eyes but the nuances possible in our marginal, pictorial language

are not so fixed, not so devoid of imagination as the mathematical certainty provided by the Domesday statistics.

We are presented, therefore, not only with a full landscape picture but an amazing, undreamt of insight into education at the informal level. They could not read and write Latin, but had their graphic communication all right and, although they could not express the arithmetic in Roman numerals, they could nevertheless measure, add and subtract. As the London Science Museum tries to explain, people are mathematicians without knowing it, even when they disavow any such knowledge. Later on, Cotswold shepherds could voice numbers in their own language and count sheep even though they could not write the numbers down. England was a highly educated nation in 1066, but we need to remember that other peoples do not invade for an education. They invade for wealth. So I explore the economics involved in the attraction of England, what it was that made Norwegians, Normans, Frenchmen, Flemings, Vikings and Danes so determined to seize power for themselves. I believe that no one has examined this aspect of the invasion before. Why did they come?

So many questions remain unanswered and the answers lie not in the margins alone, but in the full picture, which reading the margins can provide. For a start, why did Harold go to France in 1064 and where was he going? This was not a day-trip. How accurate are the ship details is another question no less interesting to sailors. Why was Harold detained? When did all this happen? Why the naked figures and the priest and the lady? All these questions have clues helping to explain them revealed in the margins. What really happened in Brittany and just how realistic are the castles shown? Historians and scholars have speculated a great deal, in the past, about all these things but (remember) they only had two-thirds of the evidence before them. We have the lot. It also seems to me that historians may, at times, have been too ready to assist popular mythologies, especially those concerning a lack of ability among our ancestors. I hope I may promote a better understanding of (and respect for) not only the everyday peoples of this period but also for their leaders. I am personally convinced that the master-race characterisation of the Normans is pernicious, teaching upcoming generations that might and superiority are always right.

We also need to understand the characters of the two opposing generals, Harold and William. Reading the Tapestry has taught me to respect their very individual leadership characteristics. Great commanders have special qualities, that is axiomatic, and both of these commanders were, in my opinion, deserving of that accolade. Each of them had great stature and so deserves to be better studied and understood. It has led me to ask, what really made William's victory in 1066 possible? I try to answer this.

The Bayeux Tapestry tells three separate stories. The first is the main frieze, the schema, the obvious story that is always chosen by historians to tell the tale. This, of course, was wholly dictated by the victors, who were the clients of the Tapestry.

They presented a brief to the embroiderers. The second is the superscript in Latin with its English spellings and, at times, French phrasing, for this has been well-read by scholars and variously tied to the schema. It was clearly intended for a very, very small, select and clerical audience, those who could read, which meant those who could read Latin. These were also victors. The third story is my starting-point divided into two, the margins top and bottom, a language of their own. Subtract any one of these and the story told is incomplete for each of them complements and at times supplements the others. So far, we have never read all the evidence.

Most commonly ignored is the mystery at the margins of the Tapestry. The graphic language contained in these margins is equally at the margins of scholarship, dismissed as wholly or partly decorative, at best esoteric, seen as irrelevant to the other two stories yet without them the others remain mysteries, as you will see. We can also, I think, claim another sense of being *at* the margins, for they tell of those who have been forgotten by historians, even ignored – the people who were conquered. The margins are their story, the words, we might say, of common people who embroidered this language. This is not just the language of their conquerors. It is a sort of esperanto coming from the minds of English embroiderers.

So how did they construct this language? The schema is essentially the brief in pictures, but the margins are the running commentary, certainly more emotional. We have consistent use of a series of images that are far from random. We might call them signs and, as such, they form a language of their own. Not one with an alphabet of precisely spelled orthography, demanding an accompanying lexicon, but a truly every day, practical or demotic set of signatures, an informal system or shorthand. This was the way in which the overwhelming number of people anywhere in Europe learned to communicate. The concept of alphabet, learning to spell words, then acquiring a vocabulary in a given tongue, is a very recent and formal educational construct. In the absence of such a construct the majority of people (and infants) learn to speak a language pragmatically and empirically. They learn to speak sounds 'as they come' in order to express ideas. They make noises and see if they are recognised. It is a working approach to communication and that is what we have at the margins of our Tapestry, figural noises.

The margins are not a confusion of images at all but instead a pattern of known fables, metaphors, allusions, soundscapes and emotional empathy designed to engage the viewer. It is the voice of the everyday population rather than their educated betters. One struggling to be heard, struggling to explain the terse imagery (cartoon) of the main frieze, a record seen through English eyes. We cannot expect to learn everything from our Tapestry of course, for it is not an unbiased record. Neither will it contain top secret information. It is basically down-market, but this still gives us an enormous resource to explore. It may be the only such common record to survive intact from this period.

Our other written records are exclusively victors' histories, speeches praising the conquerors, victors' accounts, because chronicles were the official records preserved for posterity. A record simplistically presented as the Norman Conquest when it was actually effected by a force of Normans, French, Bretons, Boulonnais, Flemings and rag-bag mercenaries. In the hands of historians, it has become a parody-conquest of Normans versus Saxons. Maybe we should instead speak more often of French and English in order to be inclusive in a modern sense. Duke William of Normandy emerged from the decisive battle to be King William, though he was perhaps fortunate that another did not replace him. A Norman dynasty was founded and family and friends were rewarded. The soldiers who effected this conquest were not exclusively one thing or another and those who maintained the new kingdom's independence and monarchy after the Conquest included Englishmen.

The parody has, in the author's opinion, caused an unhealthy creation: supermen who were omnicompetent and ruthless, so that the fact of a successful foreign invasion has psychologically encouraged a master-race syndrome. We encounter it in everything, in serious histories, Hollywood, television, novels. It is us and them seen as lords versus peasants so that, subliminally, we accept the superiority of nobility. The margins, of themselves and because they amplify the other strands, tell us a story that is not in the victors' histories, not in the encomiasts seeking to puff the achievement. They are marginal because they so often speak of the conquered through their own everyday world. The purpose is not simply justification, unlike the schema. The margins speak to us directly of their creators and speak the only language common to all participants at that time – picture language.

There is now, a fairly general academic consensus that this embroidery was made in England, though there are those who would wish it not to have been made by the English. The schema was designed to flatter, as a portrait does, while the occasional script was designed to inform the very limited, literary élite, also foreigners, allowing them to show off by translating it to others. But the margins were for common men to appreciate, whatever language they spoke. And though these margins are vernacular rather than designed as a work of art in bullion and silks, it is nevertheless also a work of art because it engages the viewer and was always intended to engage. It was never merely wall-decoration. It was not laboured and embellished, it was immediate, it was like a modern work of art, of the here-and-now. Its cartoon quality intrigues and invites inspection, discussion, analysis, while it also entertains and explains. It teaches us about emotions, about people, it teaches us about the world in England where it was made, and it takes us into places, both geographically and metaphorically, where we never thought to go. An old word encompassing both art and science is mystery. It even has religious affinities. Now we have the mystery at the margins.

The story told leads us from our embroidery into an analysis of the psychology of those who made the Tapestry, also into that of our own more recent evaluations

of it, partly inherited from the Victorians. It seems that on the broader canvas of the Tapestry, events and illustrations weave themselves into a Ringerike-design network where, all too often, beginnings and endings are elusive, illusionary, and peopled with dangerous and duplicitous serpents or, to apply the terminology I now advocate, with 'wyverns'. They are sinister, but they are fun. Here is the turning point in English History, some have said the one memorable date.

This is the 'real' story of the Conquest and, no doubt, not at all what you expect. *The Domesday Book* gives us the evidence that Odo was arrested for high treason, which alone provides an entirely new perspective for the Tapestry, while we finish with an astonishing revelation as to who actually embroidered it. On the way we explore features that provide unique, never before isolated, pieces of information – but for our Tapestry we would never know them. Up to now they have been overlooked and even (at times) denied!

In order to access all these things and all this information we must first get to grips with the language of our margins. This will enable us to think like contemporaries, though we will need to forget things we have all at some time been told. When we have our new language in place we can translate the story and fill in the gaps.

'What is the point of another book on the Bayeux Tapestry?", a colleague once asked. Let us call it 'progress'.

Chapter 2

# Methodology, Bestiary and Division

## Methodology

These margins always deserved more consideration than they have received but perhaps they have always looked too jolly and too simple to be taken seriously. The allegorical, metaphorical and fable elements, it has to be admitted, are often neither easy to interpret nor to dissociate and the great difficulty is for modern thinkers to enter the contemporary mind, to see things with early medieval eyes. The training and education of scholars today prevent such empathy. It confines us all. Not only do we lack that empathy with the natural world and acceptance of the supernatural world our forefathers automatically possessed, but we have also been taught to seek simple meanings in most things, 'this equals that'. We need greater sophistication than this. We have lost our sometime mental subtlety for comprehensive analysis, just as we have lost our ability to grasp layered verbal structures in such authors as Shakespeare, which students have to develop afresh.

We certainly do not expect the cartoon to present a palimpsest, a cryptic clue or a graphic riddle. Even Wormald, the expert who identified the Tapestry as English[1], missed the significance of this pictorial commentary, as did Dodwell, who identified it as secular.[2] We have to learn to think and see once again, with the sophistication of our ancestors. James Thurber's simple surrealistic drawings and cartoons were distillations of observation rather than polished illustrations and as an acclaimed writer he also featured anthropomorphised animals and presented the precarious unreliability of the world along with memorable quotes. Let us suppose that the apparent simplicity of our margins could also be like these.

Scholars have entirely forgotten that most medieval men read pictures rather than words. This was the rationale behind church-painting and other decorative elements. In a world where only the Latin-speakers could become what we call literate, because they alone could comprehend basic writing lessons, alternative and pictorial symbols involving oral traditions and demotic expressions of memories actually became the medium of transfer for ordinary thoughts. We have evidence enough of this subtlety from antiquity. The Roman Empire being long-gone by 1066, we will in due course discuss the economics that replaced it, a new model that developed along

different routes. It took a long time for what we call literacy to return with the demise of Latin, also for a money economy to redevelop, things we today take for granted. In the interim picture-languages and barter became the substitutes.

Picture languages are, of course, non-alphabetic but they can still encompass two meanings in a single picture, like the written *double-entendre*. Our margins may play upon the main frieze or they may have self-contained, even multiple, messages of their own. It has been assumed that we know all about the social and political histories of Normans and Saxons having read contemporary (propaganda) sources so we have no need to look further. Usually, therefore, only the prosopographic and dynastic elements are held by scholars to be deserving of further research. They concentrate on tracing lineal connections to such sources as the *Domesday Book* and thence to such rarities as our Tapestry. The sheer brilliance of all Norman achievements together with their admired ruthlessness, the model for so many business-like attitudes and claims, has made them ideal role-models for modern leaders. What is the point of discussing anything else? Surely the reality of history has been signed, sealed and delivered many times over? Maybe not.

The message of the Tapestry's schema seems to fit all the assumptions (even modern myths) made about the Normans. Such things were apparently always obvious. Just because we see a picture of events on this embroidery does not make it a photo-documentary. It is still subject to hyperbole, even to lies. We should also remember that events in one place, described in florid terms, are (at this time and for hundreds of years to come) like economic information, devoid of validity outside a very localised context. The BBC's news service did not exist and neither did newspapers. As a result, reportage and general accuracy of information in most of the past (even commodity prices) varied from village to village. Also important to us, only now can we see proof that Odo, Bishop of Bayeux, half-brother to Duke (King) William was a traitor, giving an entirely new perspective to this period and the eulogies and commentaries left by both sides[3]. As we shall see his treachery has real relevance to the Tapestry.

Then again, those who attempted to read the margins of the Bayeux Tapestry before encountered a problem similar to the reading of *Domesday Book*, not one of translation but of meaning. What would it have meant at that time? It is often essential to understand the events of the period when dealing with allegorical elements. The explanation must present the original audience's own appreciation and not ours, so I will briefly run over some of the *real* political background of the years 1066-1086 [4]. We should also accept that many have said that this unique textile (the Bayeux Tapestry) was designed and executed in England under the patronage of Odo, Bishop of Bayeux, making his treachery very important, though there is an alternative and very convincing claim to patronage that we will come to in due course. It certainly does not obviously flatter Duke William, as some historians have tried to claim, and this in itself should raise questions in our mind. There are strong suggestions by scholars that it was created in a workshop

in or near to Canterbury.[5] Now we know Odo to have been a traitor that must surely change our view of the embroidery, whoever dictated the brief.

It was commissioned and completed somewhere between 1067 and before 1080, that is soon after the actual Conquest and before Odo's fall from grace in 1082. I think it was very close to 1067 and I do not accept that he had it made in order to decorate the cathedral he built at Bayeux and consecrated in 1077. If he wanted it made he must have directed the general and approved the final schema, or some close associate did in order to flatter him. I think we can discount claims that it contains some secret English resistance message based on a tenuous Old Testament link[6] and rabbinical legends apparently unknown in the Christian Church, all collated by academic embroiderers who then included both English and French indicators in the Latin superscript. Patrons do not pay for portraits devoid of flattery and are likely to have taken violent exception. Even if these legends had been known by someone, rabbinical teachings are not likely to have met with the approval of an anti-semitic church or have been presented to a bishop. Although Odo played a key part in the battle at Caldbec-and-Battle Hill[7] and no doubt wished to record this, he also became justiciar in the immediate post-Conquest period and was an important earl. Yet, for all this, by c.1076 he had fallen out with Archbishop Lanfranc and was called to a trial on Penenden Heath. After that things got worse. In 1082 he was arrested by the king in person and from then-on imprisoned in Normandy until the king's premature death in 1087. Bishop Odo, though one of the most powerful magnates in the land and the king's uterine brother, had powerful enemies including the King of England. This was not in any sense a band of brothers, as historians have so often claimed.

During Odo's imprisonment King William ordered a series of surveys and audits, now known to us as *Domesday Book*, commencing with Odo's principal fiefdom of Kent. These surveys disclosed tax evasion on a massive scale by Odo, his associates and henchmen and many others[8]. No magnate embarks on such massive defalcations for legitimate or loyal purposes and he certainly had treachery in mind. He also had a dangerous, major interest in England's armaments industry, located in the Weald[9]. Odo was therefore not a loyal subject or brother and this in itself should make us suspect the content of his Tapestry. It appears that the whole of the Norman upper hierarchy was shot through with jealousies, rivalries and ambitions, which helps us account for the shaky beginnings of the Conquest. William had more to fear from Normans and Frenchmen than from Englishmen after 1066[10]. For most of 1067 he was 'on holiday' in Normandy leaving his brothers to rule England – and things started to go wrong.

The Bayeux Tapestry and *Domesday Book* are, beyond doubt, our two most important sources, as well as being our only two pictures, of the Anglo-Norman world in 1066, though both were actually executed a few years later. Now, the very complexity and wealth of detail in each is bewildering – where to start? This has been the predicament for so many scholars over the years. There have been many false by-ways, what else could we expect in just such complexity? It is this

very complexity which compels me to stop from time-to-time in order to explain some special aspect of the Tapestry, even though others have covered it before. My primary interest has been in the margins, but these are, in truth, part of the whole because they are not just decorative borders. Each part is important to the other and read together they are greater than a simple sum of the parts. We unlock the full archive of information once we can read all strands simultaneously.

Superficially this Tapestry tells the story of the invasion and events leading up to it, also the promise of the English throne made to William by Harold when under duress and, supposedly, by King Edward, though neither is shown as a formal event and the Tapestry names no such promise by either of them, nor was such a promise valid in English law. Only swearing on holy relics made it (if true) binding in this superstitious (Christian) world. The accuracy of the story the Tapestry tells has, from time-to-time, been questioned because, as an exercise in propaganda or justification, distortion of the facts is going to be inevitable. We clearly see some of Aesop's fables included, as others have noted, and also creatures derived from the bestiary known as Isodorus of Seville's *Etymologiae*, book XII[11], the one available at this time, though there was also the *Historia Naturalis* of Pliny the Elder[12] and Hrabanus Maurus's *De Rerum Naturis*, an ecclesiastically approved source often reliant on Isodorus's original.[13] All these could be sources. The anonymous Roman text known as the *Physiologus* was also, apparently, well distributed (in Latin) across Europe,[14] though Aristotle's *De Animalium* seems to have been of no use for physical descriptions. One problem is that early bestiaries had few pictures, relying instead on descriptions, while another is that later bestiaries sometimes altered the pictures and descriptions presented from those in earlier bestiaries and therefore need to be avoided. We cannot identify the creatures described in 1066 with those depicted, say, in the fourteenth century, for ideas changed.

My perception is that these margins are entirely narrative rather than decorative, that they tell a story throughout. I suggest they provide *double-entendres* and a sound-track to accompany the superscript Latin running commentary added to the main frieze. The animals and birds provide the sound-track and they also seem at times to speak directly to the viewer, to us. For the majority of viewers these margins would provide a visual commentary enlarging upon the schema which, in itself, tells us of the educational level, or approach, of the general viewer, for this marginal, visual narrative was planned *ab initio* and not added later like the Latin superscript. Do we really accept that Normans all possessed a higher education and the ability to read Latin? Of course not, what mattered most to the majority of viewers speaking any language was the visual narrative in one form or another. That is why the superscript is so basic in its commentary, at times a little uncertain or even ambiguous. It was never intended to be comprehensive. The margins are the commentary on the necessarily succinct schema or frieze.

Did the religious and academics who saw this Latin have any need of the accurate, fine details of the pictures or even any experience at all of such specialisations as agriculture, shipbuilding or warfare by which to judge them?

Of course they did not. Such a suggestion is ridiculous, ignorant and modern. The blandest of images would have sufficed for them. This in itself tells us that pictorial details on our Tapestry had very special importance, being designed to engage and persuade viewers of all degrees of expertise, whatever their status, designed to speak to those who were not monks or clerics of any sort. Yet this narrative is more than just a comic book for the illiterate, for the margins also allow the main frieze to be conveniently condensed by enlarging upon the main depiction. When we read all three strands together we have recovered the complete picture and the Tapestry's information is finally unlocked and decoded. That is what we are now going to attempt. Think of it as a comic strip with separate commentaries, in fact commentaries in two languages and one of them at least for all tongues.

The medieval world readily synthesised religious and classical traditions in its scholastic circles but the layman, or non-scholar, further synthesised what was presented to him, in pre-digested form by religious scholars, with his own everyday life, with the natural world and rural life, including popular superstitions. The esoteric was reality to him. There *were* angels and devils (unseen) all around him. He was told so by the religious. God had him under permanent surveillance, so did the Tempter, there were legions of elementals filling the air and hiding behind bush, briar and hedgerow. If scholars conflated older (classical) learning with their religious training, then whatever also, consequently, filtered down through them to the large non-literate level in society was certainly accepted at face value. Who could doubt the existence of dragons and gryphons? And what of the lingering vestiges of older religions? So, we can distinguish five possible strands of instruction woven together in the margins of an artefact like the Bayeux Tapestry, strands formally defined by contemporary religious education but to which we can put more everyday descriptions.

We have the literal interpretation as allegory, the moral or tropological presentation (often a fable known to the audience) and the anagogical (the historical or religious prophesy) presentation, yet with some typological (Old and New Testament) linkage possible, and finally we can also expect animation, which has the effect of anthropomorphising the creatures depicted for the ordinary man or woman close to the natural world – viewers who would not be looking for the same esoteric or elevated didactive imagery as the religious viewer, rather for something direct, everyday, familiar and informative, animals like themselves. Nor should we forget that older folk-tales would persist. Thoroughly cleansing the mind of the effects of modern education is probably, as George Bernard Shaw famously observed,[15] impossible but for these academically untutored people, only aware of the natural world and its rhythms surrounding them. The received wisdom they absorbed was inextricably woven into their experience of everyday life, rural life. I suspect that their world was the richer for this inclusion of fantasy elements, though tormented by the religious and the supernatural.

In spite of this vernacular level the biblical hermeneutics, those officially approved beliefs and stories told to ordinary mortals from the pulpit, would be strictly channelled by the church's insistence on remaining within the Catholic

theological tradition. Clerics could not stray from the narrow doctrinal path without becoming heretical. It is interesting and instructive to see that at times a purely secular element intrudes into our embroidery, suggesting that however learned the designer of the Tapestry was, he was not an ordained cleric but someone very much in touch with the world beyond the cloister, capable of creating imaginative picture language for people like himself, free to express things because he did not realise they might be theologically wrong. This is why I maintain that this was always intended as a purely secular and vernacular artefact, one with something for every man. This flies in the face of received (academic) wisdom but it is self-evident such cloistered and unworldly brothers and bishops as those of medieval reality would not wish to see the rustic, vulgar, lewd and unedifying matters our Tapestry contains presented to themselves, and it is very doubtful that they would permit the presentation of such things to their impressionable public.

## The bestiary employed

I have treated each depiction or vignette, whether fabulous or truly animal (contemporaries could not distinguish one from the other), on its merits and I have tried to be consistent in my identifications. Some fables are now much better known than they were then, some were better known than others (so bore repetition) and the attributes of creatures, and possible metaphors, also changed with the passage of time. The medieval bestiary at this date is imperfectly known to us, though we can recognise that many elaborations arrived only in later books of this type and that surviving evidence, such as Isodorus book XII or the descriptions provided by Pliny, is clearly imperfect for we encounter creatures on the Tapestry were not recorded by them, not recorded in any surviving texts until much later. They could not have been copied from any known book. Already we can say that the Tapestry is telling us of lost texts and, in this respect, it becomes a primary source in itself. Clearly Isodorus and Pliny were not the only sources of beasts available to the Tapestry's embroiderers, but we know of no others. The embroiderers were not just copying pictures from ancient books, though they may have done this at times either consciously or unconsciously. This originality is so important that we will come to it again in due course. It undermines any claim of clerical or cloistered origin for the embroidery.

Medieval bestiaries recorded both the real and the fabulous together, that was their reality. Though you had not seen a certain beast it could still exist, as learned men, clerics and scholars insisted that it did. Depictions also depended on individual artists, so that when dealing with the natural world there is likely to be much less standardisation, certainly from a secular artist, than when depicting the fabulous world, for in the former case the artist was free to use his memory and imagination. Scholars declare that representations of birds are scarcest in the eleventh and twelfth centuries, but only because they have ignored this source. They also say there was 'little attempt at accurate representation' though sources

such as Harley ms 603 and our Tapestry show, for example, well observed ducks.[16] They are confused by the use of birds and animals to provide human attributes, expecting natural histories instead.

The Tapestry was the product of a team (detectable in several ways) so the depictions of animals and birds are not always consistent because they depended on whim rather than a pocket guide and because several artists were involved. Birds, in particular, are a headache to identify for each embroiderer obviously had his or her own opinion as to the distinguishing features and colours to be employed from the limited palette available (eight colours), yet on a significant number of occasions we can identify them. Birds and beasts are used to convey anthropomorphic reactions and, in such cases, it is expression and animation that counts for more than identification, habitat or attributes. These embroiderers were not cloistered and certainly had not been oblates without access to the outside world from childhood or they could not have known such things. They would all have copied the same creature or bird in the same way from the same source as scribes were trained to do, yet they did not.

Herons may have context to add to colour and shape, geese look goosey, hawks and eagles are not always separable but, as both have similar attributes outside a religious context, we may choose by size and by association. The birds of ill-omen and dark in hue will be vultures, corvids or kites, all carrion feeders and a few, being red, are very probably kites, the traditional scavengers of any remainders, so I have divided them all into vultures (carrion birds) and kites. The carrion crow was widely feared as the harbinger and companion of war, not just a carrion-feeder but also intelligent, vicious and especially fond of pecking out the eyes of corpses and the dying. Anyway, all these are carrion-feeders and unwelcome as omens or portents. I have guessed that the large, largely black and gold birds shown in association with royalty and sickness were intended not as raptors but, instead, as the fabled caladrius. Had they been shown in outline only, to make them white, they would have lacked emphasis and, indeed, would have resembled portents rather than real creatures. Yet real they were to contemporaries, even when not visible, and a double association with golden eagles would also be apt for kingship. Finally, the strange variations in colours sometimes seen might not just have been there to provide variety of expression, or artistic license. There may have been other influences on colour choice and use, even perhaps medical reasons. We will examine such matters much later, when we have told the whole story and can unlock and decode the secrets of the Tapestry.

We have a similar problem with big cats. Lions seem self-evident. They have manes, they are commonly encountered in the margins though their aspects do vary (variations are important indicators of mood), but 'pards', leopards and tigers, are not so easy to separate as later bestiaries depict them all as spotted cats, and so we should expect them to be depicted in this way in c.1070. Nevertheless, on the Tapestry we can observe some variations that suggest greater discrimination and they have no lion-manes. We can say that pards are big cats without the noble status of the 'king of the beasts', the lion. They are intended as the lower retainers,

knights and sergeants, fierce rather than born noble. The lions represent the truly noble. This is a society proud of birth, of blood, but not yet truly feudal. Stags and horses seem easier to identify, dogs look 'doggy', wolves can usually be identified by their context and have appropriate colour and form and foxes also, as a general rule, have their colour and their distinctive tails. Aesopian fables in particular help us to identify them by context.

When we come to fabulous beasts we are on much safer ground. Their recognition and their attributes depend on formulaic descriptions. Who has actually seen a fabulous beast in life? Yet we have to admit that someone standardised the depictions made on the Tapestry, for artists mostly depended on descriptions at source. The representational physicality was usually left to each reader of a source, because of a lack of illustrated bestiaries. Nevertheless, someone knew what to depict in given cases and so ensured consistency throughout our Tapestry, even though we have no other contemporary template. We can, I think, identify him as the designer. Lions with wings are obvious and gryphons are a cross between raptor and predator. No problems there. Dragons are rarely shown, have four legs and can breathe fire. Wyverns (related and equally evil) have only two legs and knotted tails and they spout bile, lies and venom instead of fire. They are common and often have forked tongues, and when given more imaginative treatment look quite Nordic in design. I have elected to call these creatures wyverns as they have consistent associations, though there was considerable confusion in later manuscripts as to the precise aspect of wyverns, due to the imprecision of earlier descriptions. Generally, in the later illustrated bestiaries, we see pictorial confusion with 'vipera' and 'hypnalis' (viper and a kind of asp), neither of which in such illustrations ever looked like snakes. That is why we, like the designer of the Tapestry, must have a lexicon of some sort. He and members of his team obviously had one, even if of his own devising.

These fabulous beasts are some of the most important indicators for our analysis as they convey especial allegorical significance. It seems that many ordinary and presumably unlettered people were familiar with such images and also with their meanings, even the anagogical aspects. On the other hand, though some education should have been required in order to understand Aesopian fables, they had apparently already passed into folklaw via the clergy. Of course, only the practised cleric would recognise typological allegories. We must not forget that laymen were used to having the Bible interpreted for them and into their own tongue. There was no access to it other than through a priest reading and translating the Vulgate, so they probably expected and accepted a clerical exposition of anything scholastic The *double-entendre* might, therefore, have been, at times, more obvious to a scholar or cleric than to a layman, especially when it involved biblical texts. One might call such things layered meanings, that is layered even within one of the three main communication vehicles employed by the Tapestry. I would expect all birds and animals shown to be intended as allegorical and/or anthropomorphic, occasionally topographic indicators,

rather than merely decorative. When we come to the battle they become a sort of emotional sound-track for the action shown. Where we are in doubt as to the exact creature intended we will need to invoke both context and a basis of probabilities (within contemporary evidence) in order to come to a reasonable conclusion. In the absence of dictionaries, it is just the same with any written language, we cannot always translate with absolute certainty. We are dealing with a dead language, one that has been lost. Nevertheless, our menagerie is always suggestive of mood and emotions, even when indicative or predictive, which is why I call them anthropomorphic, and, by-and-large, it is a standardised and a fun menagerie.

## Division

Our embroidery, although composed with eight sections of woven linen-cloth all sewn together, is remarkable for its continuous length, its conception as a single artefact and, then again, for its survival intact down the centuries in this respect. It is true that we are missing the tail-piece but we have no reason to assume that this was separately worked from the rest of the embroidery. This artefact was, and still is, of inconvenient length for all concerned, so long that it had to hang in a very extensive room, inconvenient also for the embroiderers who must have had some special apparatus devised for its working. I think that for convenience of analysis we can divide the length of the Tapestry into three sections or chapters of the story, though we might also call them acts of a play. These are not of identical length but do account broadly for thirds, the last being incomplete because we do not possess the tail-piece.

The first chapter concerns what has been called 'Harold's mission', his journey to France, sojourn in Normandy and return to England. An enigma. The second chapter covers the events of his return and Duke William's preparation for, and his accomplishment of, invasion. This is 'the Norman version'. The third, final, chapter starts at Telham Hill, where each side sights the other, then it runs to the conclusion of the Tapestry: substantially the battle. Here we find other questions and the action shown is selective, not comprehensive. I will come to the missing tail-piece and conclusion of the Tapestry in due course, for its possible content will provide us with a clue to the overall original length of the Tapestry. I believe this to have been rather longer than previous analyses have suggested, and I don't think we should make assumptions as to what it showed. It did not have to show Duke William crowned as king. The Tapestry does not tell us that Edward promised the throne to William. That is an assumption made by historians based on the claims made elsewhere by Norman encomiasts. Just because it is in our history books and because historians have said so does not make it the truth. Where is the evidence in the superscript? Nowhere is William given the title of king. All these things will unfold as we excavate and unlock the evidence. This is hands-on archaeology as well as code-breaking. Enjoy!

Chapter 3

# The Opening Chapter Begins

Our embroidery commences with a fine vertical band of foliage under which we see two black lions debating. This, it seems, will be a black tale of nobility and royalty and the animation of these creatures invites us to add 'let me tell you a good one' … 'you don't say?' The building under which they stand is quite splendid, we will return to buildings later on. This one has invited much speculation with scholars proposing that it is the relatively new palace at Westminster.[1] There is, of course, no evidence for this and the ancient seat and pre-eminent palace was at Winchester. All the Tapestry tells us is that Harold went next to Bosham and the shortest route to there would be from Winchester. Whether the embroiderers had ever seen either palace, or Bosham Church, or Harold's feasting hall at Bosham, we cannot know, but they are likely to have had a very good idea what such places looked like and how they were embellished. So I think we can take all the structures shown here to be generically accurate even without a given location.

From the outset of the Tapestry we have lions, for they are symbols of high nobility, including kingship, earthly power and strength, the king of beasts, fit for King Edward. Beneath his feet are large (golden) birds, which could be eagles, as kings of the firmament symbolising courage and perspicacity, birds that only kings can tame. But I think, because they are so dissimilar to other raptors shown and because they only occur in such contexts on the Tapestry, that they are caladrii, fabulous birds that frequent kingly dwellings and indicate both health and mortality. So it is that they could be either and they could be both, quite simultaneously, two sets of metaphors in the medieval mind, for how would an ordinary person recognise the consort of kings? They are an important allegory that could be seen as (golden) eagles, raptors who, in falconry, cannot be trained to 'wait on', but must always either rest or pursue, just like kings. As we shall see later, eagles could even symbolise Christian superiority and, so, Edward's sacred nature. His godliness, age and frailty are essential to the Norman cause and to the story they wish us to believe. No source other than this Tapestry tells us that Edward was anything but hale and hearty at this date. But here he is shown as a frail old thing and yet the caladrii regard and guard him (looking each way), and so he lives. It is a simple message for those who know what these birds mean.

It is also a message in the design to say that the king might need a successor and this, after all, is the entire Norman justification for everything that follows in the Tapestry. Edward, said the Normans (but it is not said on the Tapestry), offered the throne of England to Duke William of Normandy. Whether he was the only one he promised it to we will explore in due course. The offer to William had been made, it is said, some time before.

Harold departs, supposedly a couple of years before Edward's death and his own kingship, in 1064, praying at Bosham Church as he goes, his entourage shadowed by ill omens: dark birds, sinister as vultures; startled birds and lions biting their own tails; symbols of nobility and courage now false, undone, maybe cowardly, certainly signifying the ignoble. One of his party points upwards to the birds of ill omen. This tale will obviously be black with dishonour and disaster. Below them other dark birds cover their heads with their wing and look at the ground, in shame or remorse. Under Harold's hounds are seen a pair of winged centaurs, creatures caught between two worlds or natures, ambivalent or duplicitous, anciently lascivious creatures in need of governance. The *Life of St Anthony* said that the saint had once been challenged by one he forced to acknowledge the power of the One True God. They could, therefore, signify the need to acknowledge direction and governance by superior authority. Harold could not have gone without King Edward's permission and he must have had

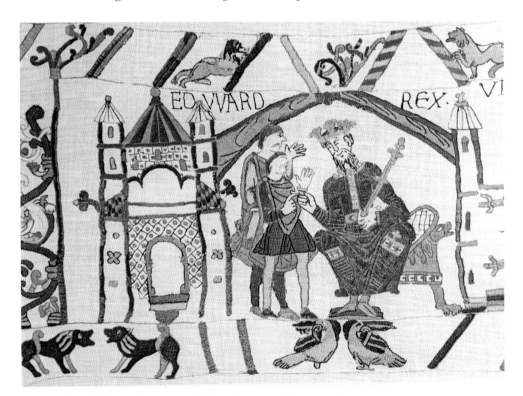

King and caladrii confer a commission. Let me tell you a tale.

19

direction or a pressing reason to offer. But did he go for that reason alone, without any other reasons? Where was Harold going and why? There has been much speculation. Clearly, Edward permitted or even commanded his journey, but what was Harold's own, motivation? Surely, we are being told at this point, that Harold needed and received governance by some superior authority? The winged horse Pegasus was famous and when Bellerophon, in his pride, attempted to ride him to Olympus, he was thrown to the ground. Was Harold secretly attempting the impossible? Look carefully at these winged centaurs. They have wings for arms, not from the horse's body, which seems strange to us, so I suggest that they represent an attempt to depict a description rather than being copied from another illustration. Here we can say we also have an anagogical (historical or religious prophecy) aspect to add to allegory and yet all these associations could be woven into one. This embassy of his has a secret and hidden, even an over-ambitious, purpose. That is the message from the margin.

Birds of one hue or another are, like lions and pards, recurring motifs. They gesticulate and interact in ways whose meanings invite speculation. The two vultures, crows or kite birds beneath Bosham Church, are plotting something. Maybe Harold and his brother Tostig are doing the same? The colours of birds, like the costumes of men or the colours of horses, seem at times capricious. Is this the embroiderer's imagination, or are we too far removed from basics not to want to distinguish (say) a strawberry roan from a bay or a chestnut? The range of dyes employed was limited. Can we identify the creatures we see in some other way? The dark animals beneath the feasting hall at Bosham are unlikely to be lions

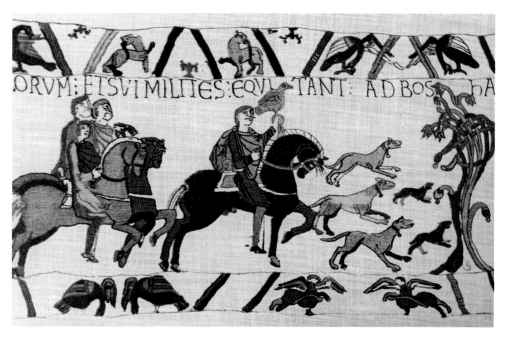

Bosham with centaurs and (predictive) ominous omens

20

(look at the tails and they have no manes). But they could be pards, fierce but not self-governed creatures, representing Harold's companions and retainers. After all, the master may be recognised in his men. These pards lick their paws, they savour a feast, here or elsewhere, and we should not rule out the occurrence of humour, or even a subliminal sound-track. Do the colours of the hawk-like birds above the feast have significance? They are not 'birds of a feather'. Could one be a kite, ready to feed on anything offered, and maybe the other an eagle, even the king's caladrius? Is the caladrius/eagle the king's purpose and the kite Harold's? This new language enables and even invites us to debate and interpret meanings, in the same way that creative writing does. They are obviously having a lively time, so we have a sort of sound-track here as well. We are involved in the activity.

As the party descends the steps to embark for France they are in high spirits. The amicable lions and birds indicate noble warriors and brothers-in-arms, but in the lower margin is something different. Here we have Aesop's fable of the fox and the crow. Flatterers thrive by telling stories to the gullible. Is this predicting that it will all be fine words? The crow is dropping the cheese into the fox's mouth: Maybe wishful thinking? Anagogically someone's vanity is to be tested, for surely if Harold himself was the dupe this scene would have occurred before? Harold, it seems, is the crafty fox lying for personal gain and other sources tell us that he was a master at disguising his intentions.[2] Surely, then, he has a private agenda as well as his commission? The action quickens for next we see the fable of the fox and the lion – according to scholars a fable not set down until much later and that should have been unknown at this date. But here it is. It says that when the fox first meets the lion he is very wary, but when he meets him again he becomes increasingly less circumspect. Fox Harold is acting incautiously. He has been to France before now and returned. He is less wary of the danger on this occasion than he should be.

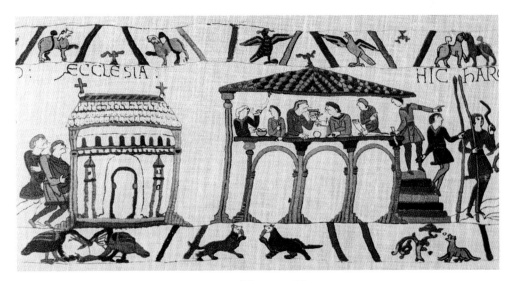

Plotters pray while comrades carouse and fox Harold appears

Next, we see a cave where the animals are hiding from the lion. A wise decision. Best to keep a low profile when he is around. Also predictive. Then we have the fable of the crane and the wolf. The crane removes a bone from the wolf's throat and asks for a reward, only to be told that surviving such an experience is reward in itself. This is again predictive, anagogical as the clerics say. Is Harold expecting some special treatment or reward for a favour done when he steps ashore in France? What favour has he to offer and to whom? He would have done better to stay hidden. On neither side of the Channel were strangers welcome to step ashore unless at designated ports.[3] Land elsewhere and one needed protection from arrest. He seems to have taken acceptable gifts in the shape of hawks and hounds. Above the ships a pair of pards either lick or bite their own genitals. Is this an allusion to the fabled wisdom of the beaver, prepared to take the desperate measure of biting-off his genitals in order to escape his hunters? Pards may be fierce creatures, but they should still prepare for the worst. They too may be hunted. The danger is serious and appears to involve the retainers and not Harold. We should note that Harold has taken hawk(s) and hounds with him on his ship(s), but they do not accompany him back to England later on. Were these gifts, designed to dispose someone to accept him as a friend, maybe even an ally? Such expensive gifts must be for someone special for these trained hunters did not come cheap. On the other hand, Harold may have envisaged a winter sojourn in France. Autumn is the time for passage birds and so for hawking, and winter is the season for hunting. Campaigning would be suspended for a few months.

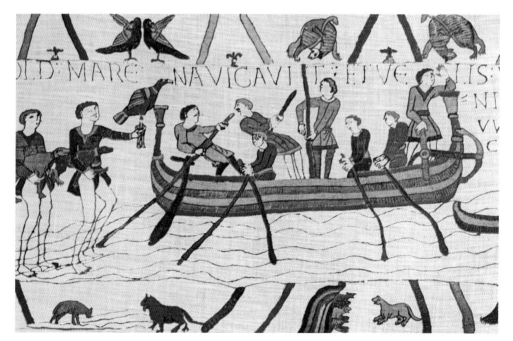

Poling-out and stepping within drastic warnings: better to have stayed safely hidden

Then we come to a curious vignette. The Aesopian fable of the sick lion. Here he lies, in his cave, surveying all the animals, who have come to see him. Leading them, says the fable, was the monkey, but here we have a man. He points to the assembled animals as though offering them to the lion? Do we have a conflation here? Pliny observed that a sick lion could cure itself by eating a monkey. Is the Tapestry telling us that Harold (on King Edward's behalf?) would offer all the peoples of England as a bribe to someone powerful, only to fall victim himself? Is the sick lion King Edward or someone else? Wait and see. Harold seems to have set out with a fleet of ships befitting his status, though if we discount the one poling carefully out of Bosham harbour on sweeps, and the moored vessel unloading in France as repeats, there may only have been two. Harold, it is said, is steering the second in line of these. It does look like him, but then so do many Englishmen. The men look alike but the ships are all different. Draw your own conclusions. It has been claimed that the sails might be triangular rather than square, but closer observation reveals a larboard sheet and the steerboard (today's starboard) sheet is somewhat serpentine. This is a square sail, depicted to show it filled with wind. Still, both ships are clearly on a steerboard tack with the wind full in their sails and most of the kite-shaped shields (they are obviously so) are stowed inboard to secure them against the weather. Whoever sewed this section knew ships and the sea, oar-ports, rigging, sails, stowage, which sounds unlike a woman or anyone in a monastery. Sure enough, the superscript caption says, 'with the wind full in his sails'. Perhaps the banquet was a little too good for the prevailing weather and they were then forced to run eastwards? The ships in the centre are different yet both are steered by a moustached man and another similar man holds the stem of the moored ship. So we are in doubt as to who is Harold. In one of the sailing ships a crewman is either remonstrating and pointing to the sail or holding on to the throat halliard. In the other they have a masthead look out with a relay below. They are bracing (even perhaps about to lower) the sail and sweeps and anchor are out, so they are navigating inshore and seeking safe landfall. As the embroiderers are so obviously relishing the fine detail of sailing these ships we may deduce that they are experienced sailors.

Some historians have said that Harold was shipwrecked[4], but no wreck is shown or mentioned in the main frieze, only an unstepped and moored ship, and we know that he was on a mission to France with King Edward's permission. Perhaps his navigator made the wrong landfall? A tiny vignette shows a bird, maybe a duck, taking wing, so the landfall is marshy and perhaps estuarine? For some reason, instead of making the direct southwards crossing, Harold's ships sailed for some time due east, maybe blown off course by a southerly gale, though such vessels could sail close to the wind. Or was it a westerly, prevalent in September and October, and they were actually aiming for further up the coast? We shall return to this, but if they took a strong westerly on the beam they would have to run before it, as such ships were very prone to swamping, due to their low freeboard. We shall very shortly see confirmation that it is late in the season, when

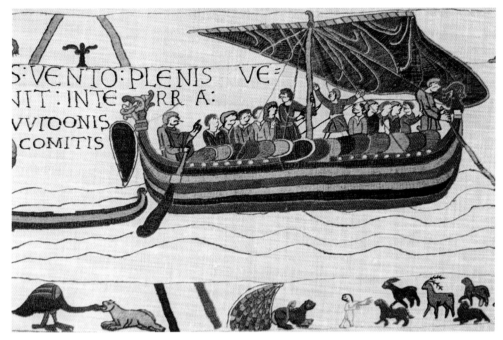

S:VENTO:PLENIS VE=
NIT:INTE RR A:
VVIDONIS
COMITIS

Square-rigger with inboard shields, but someone is selling the animals and may be lucky to escape?

such gales might be expected, maybe early October? Thus, the action on the main frieze is only a very condensed story, in fact the full tale is told by the margins for, sure enough, when Harold is seen ashore in France he is immediately arrested by Guy of Ponthieu's men. He should have shown greater circumspection. The predictions have all come true.

Yet arbitrary as this age is supposed to be, surely there had to be some pretext for arresting the most powerful earl in all England? He would soon be identified and nowhere is he shown to be abused for he rides off with hawks and hounds. Ransom might provide a motive, but surely not one so powerful and potentially dangerous, on a mission from his king? Surely some process of law was required if Guy detained him? Large, black, ill-omen birds look down on the scene and the lions above Guy indicate his noble power. But beneath them all we see huntsmen with hounds pursue goat, pard, bull and lion, a part-fabulous menagerie. Surely there is meaning here and there could be more than one. All appear to follow a stag. So we can say that we have the circumspect, the fierce, the strong and irresistible, the strong and noble, all pursuing the symbol of the hunt, which is also a symbol of noble solitude. The hunting of a stag was sometimes used to symbolise the persecution of Christians. Alternatively, it could be the fable of the lion's share. All the animals help the lion to hunt but when the kill is made he takes the lot, because he can. The meaning is obscure, but once again it could either be a reference to all the guardians of England becoming sacrifices, or pawns, or

24

instead a reference to some event in the past? In France all degrees of men seem to be against Harold for some reason. Hence the warning to be wary of returning.

As the last huntsman looks back he sees behind him a threatening wild goat, a creature who can tell from afar whether men are innocent travellers or, instead, threatening hunters. According to Isodorus such a goat will pursue 'difficult matters'. Which of these is Harold's expedition. Threat or innocent mission? We are being asked a rhetorical question. Immediately before this vignette we have the fable of the wolf and the goat (and this we shall see repeated later on), the moral being advice to stay on the mountain where the hungry wolf cannot reach you, even if he says the lower pastures will make for an excellent feed. Did Harold submit to Guy without demur? Our goat may signify more than one thing. He can be a set of attributes or the actor in a fable. It would seem, from all these vignettes, confused though they appear to us, that we (the viewers) are being told that Harold had some inducement beyond his orders to bring him to France and that in the past Harold had possibly contravened some prohibition, some law, and that is why he has now been detained. We have seen in the margin that he has been to France before. Finally, we see a lion and another animal, perhaps a hound, wrestling together violently. Has the lion killed a hound or vice-versa? Has an insolent hound given affront to a vengeful lion? Is it a homicide or do we dismiss it as just a contest between a noble and a dog? I think that both Harold and Guy would be lions and a hound would be a servant, that is he would not even be a pard. Did Harold resist an arrest? 'Harold and Guy speak together', says the terse superscript. Obviously, they had something to discuss, compensation for a death might well require lengthy negotiation.

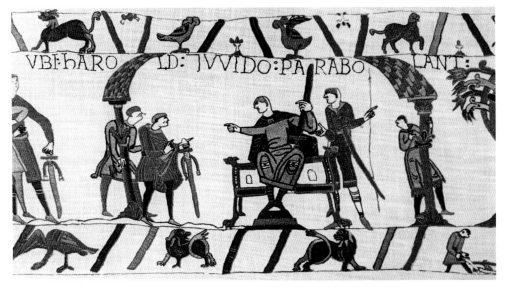

Guy in judgement with shape-changers about: Meanwhile a peasant ploughs the year to its close

Gryphons, symbols of strength and vengeance, strong lions and also kites, carrion-feeders, are above and below. Was there a homicide to answer for? A hound a lowly servant, a lion a nobleman, who killed whom? Or was it some other offence? What matters is honour and recompense. Lords were responsible for their retainers just as families were for their members. Harold would have to account for the actions of his men, on the other hand, Guy would demand compensation, even for a servant. (This is how *Domesday Book* gained its title, from Bede's treatise on Domesday, when it was foretold all would be held responsible for the actions of their inferiors or their superiors, because households were a community in the sight of God).[5] We should now note that no horses were shown in Harold's ships, yet here he has one. Treated with all deference to his rank, Harold has ridden, hawk on fist, to his detention by Guy. When they meet he proffers his sword to Guy who is accusing and sits in judgement, sword of justice in hand. The lions beneath Guy's seat are passive, their tails curled (a good sign), and surely, just before Harold entered Guy's hall, there was a knot of English and French men (their haircuts are distinctive) each accusing the other? Look for yourself. This conversation between Harold and Guy is more involved than a simple surrender, there appears to be some business transacted. Was it compensation? Lions and also kites seem to converse overhead: one debating pickings; the other legalities perhaps. Whilst underneath we have agricultural vignettes to tell us of time passing.

It is late autumn and the harvest has been carried, for now we see that ploughman and sower are at work on winter wheat. A slinger scares the birds, the harrow covers the seed-corn. Here we have our earliest, medieval evidence of horses at work on the land and of the horse-collar in use. No other source confirms such practises. This is unique. We also have a wheeled plough with mould-board and not an ard, or scratch-plough. Once again the Tapestry is a primary source of evidence and so we may say it is proven not to be derivative. These scenes were not copied from elsewhere and whoever designed these vignettes most certainly was a farmer. Later we will return to this. And if all such illustrations can be claimed to be copies, how come these scenes exactly reproduce those shown in the book known as the *Golf Hours*, which was not written until the sixteenth century? No, the Tapestry's evidence is genuine and novel[6].

If autumn is drawing-on to winter then it is perhaps no surprise that word of Harold's disappearance and detention reach Guy's feudal overlord, Duke William. He sends messengers to Guy, observed by hawks and passive lions. One man in squamatid armour carries a long axe. The only other time we see similar armour it is being worn by Bishop Odo. Is this one of Odo's bodyguards? Such armours belonged in the eastern Mediterranean and the long, Danish battle-axe was the weapon of choice of the professional warrior. Did Odo surround himself with such elite, mercenary troops returned from service in Byzantium? Did he yearn to be a warrior as Rowley has suggested?[7] The tree behind this warrior is Ringerike (a form of Viking art) in style. Did the same person embroider both, someone

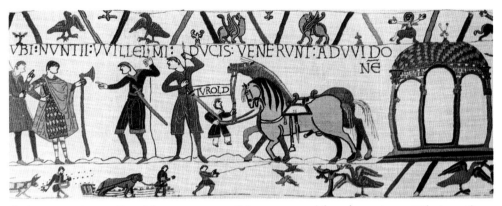

Autumn sowing, collared horses, squamatid armour and female centaurs. What next?

competent to depict this rare armour type and who knew Nordic designs? What other explanation could there be?

Above the cupola of a grand building we see female centaurs, their arms flung wide, symbols of the need for the ungoverned to acknowledge superior power and authority. But is their gender also important? Does some woman need to be governed? Is it predicting something we will soon learn? The duke's messengers to Guy are insistent. In the lower margin is a muzzled and tied bear being threatened by an armed man. Above are cockerels, birds wise enough to be able to tell the time, but birds also known to duel. Are the man and the bear an enigma or do they point to the moral that however strong you are you can be caught? There is always someone stronger than you. It is no duel if you are muzzled and tied ready for baiting by a stronger opponent. Who is the bear? Harold or Guy? Is Guy being reminded that he had once been held prisoner by William? Or is it predictive, a warning to Harold to do as he is told now that he is an honoured guest?

These marginalia are narrative, predictive, at times perhaps retrospective and with a strong moral message. We have a story delivered by the main Tapestry and then a return to its theme, much in the way that an allusion prepares the reader for the unfolding of the whole plot. Cockerels may duel over who shall rule, but they are wise. Two rams, beasts of mettle and stubbornness, but destined for sacrifice, support the messenger's return to Duke William while below we return to the theme of the hunt. Huntsmen and hounds now chase the wary goat, but he is headed-off by a mounted huntsman with pards and they take him. Has the accuser been detained himself, or is Harold the goat, not wary enough to avoid force-majeur? Guy was taken before. Must he now submit to a higher authority's demands? Might Harold be in the balance between two powerful French lords? Let us leave that question until later. The messenger returning to William and pleading appears to be English. Has Harold sent an ambassador to William having now chosen to speak with him rather than to another? Messengers have already been despatched and the look-out in the tree seems to suggest that the duke is determined to see his instructions carried out. But such retrospective details are to

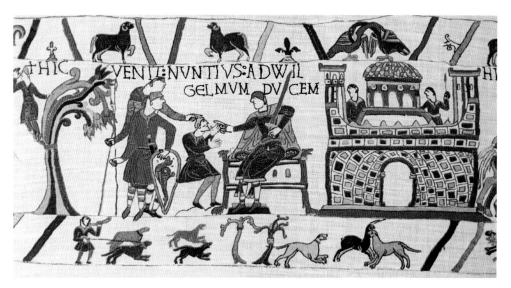

The hunt concludes, concord prevails, but the artist didn't understand masonry

be seen later. They could be intended as a form of emphasis by the designer. This is what happened, this is why it happened. There is, of course, another possibility. Supposing Harold was on a different mission and did not initially want to see William. William saw and seized this opportunity and consequently, because he had to, Harold reconsidered his position. Did he need to become enthusiastic? Wait and see. But remember, our embroiderers were not privy to state secrets.

Over a castle, which is partly masonry, a great rarity at this date and has always been presumed to represent the Tower of Rouen,[8] we see two eagles intertwined and grooming, then a pair of noble stags representing solitude and piety. We may note that if the embroiderers had been working within a stone building, such as a monastery, they would have made a better job of the masonry. As it is they have shown it as an ever-expanding arch. Such a mistake suggests they cannot have been familiar with masonry construction at all, however familiar they were with ships and sailing. This does not sound like female embroiderers or anyone cloistered in a stone building does it? 'Here Guy conducted Harold to William. Perhaps he did not really want to go. Over both Guy and Harold, each with hawk on fist to emphasise peaceful nobility, are vulture-like birds and they sense something, while beneath Harold a naked man gestures to a naked woman. They could of course be Adam and Eve, but I think they indicate that Harold has some salacious report for the duke's ears as bile-spouting, forked-tongue wyverns are also shown, one facing towards Harold and the other towards William. Has Harold intimated as much already to Guy, hence the female centaurs, a story about an ungoverned woman? Do they perhaps predict a future need to govern some women, or a certain woman?

Above Duke William we see camels, strong beasts known for their ability to carry heavy loads, and under his feet, with sheltering trees and holy crosses, the

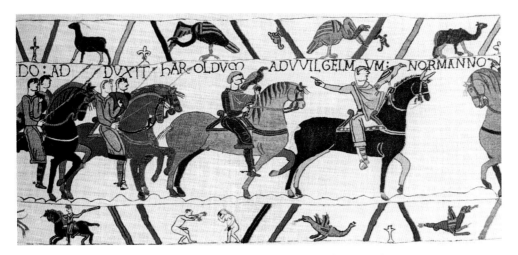

Friends 'on a jolly' while slanderous wyverns spin a Rabelaisian tale

perspicacious goat who knows how to assess men. The duke is being heavily flattered. There is also the fable of the fox and the goat and with this we are being told never to trust the words of a man who is in difficulties. That would seem to be Harold.

Between margins of noble lions and winged lions of destiny but also ominous vultures, crows and kites waiting for pickings, William conducts Harold to his palace and the black vulture birds bow low to William. He has power over such creatures, whether men or birds. This is a place defended by fierce and wise gryphons who guard sacred and saved souls and it is crowned by peafowl, signifying the omniscience of God, the guardianship of the royally noble. (Peacocks were shown much earlier in the *Book of Kells* over a figure who could be either Christ or God the Father, so they have been recognised for a long time[10].) Passive pards and holy crosses sit beneath the duke. He is well defended both physically and spiritually it seems and here, with the onset of winter, Harold will remain as an honoured guest. Perhaps he always intended this, as winter was the hunting season. Here Harold weaves his tale, an animated figure before an audience. Beneath him a naked man with a side-axe pares a board.[11] So this is a well-prepared (close-shaved) and vulgar tale rather than a rough-and-ready invention, while above the story-telling sit happy, startled, animated pards. It is a public performance and they like it.

Here we come to an enigma, the simple legend 'where a clerk and Aelfgyva'. Some scholars have declared that this represents an event at Bayeux, some have said she was William's daughter (in spite of the English name)[12], that he sought a betrothal with Harold (in spite of her youth). But we now know from our margins that this is instead a rude tale told by Harold. There is nothing strange about the tale he told but the surprised birds and venom-spouting wyverns leave us in no doubt that it was well-told by Harold, that winter, by the fireside in the magnificent feasting-hall and it might just have come as a surprise to some of the

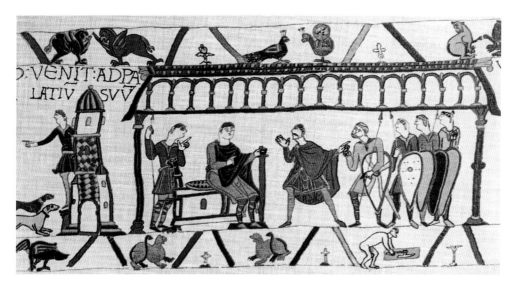

'Hiver retourner …' and a close-shaved tale in a jolly hall entertains panoptes and pards alike

hearers. I think there can be no doubt that the lady is Aelfgyfu of Northampton who mysteriously disappears from historical records c.1040. Harold is providing a history lesson for William, who probably knew something of it already. The naked man beneath Aelfgyfu emphasises the scurrilous nature of this close-shaved tale and also clearly indicates a lack of religious censorship. Is this really what he came to tell William or is there more? In itself this might be no more than a vehicle for other discussions, a prelude, even a Trojan horse. Harold might have more than an old history lesson for Duke William's consideration, a sequel that was surely delivered in private?

We will start with the basic tale, the public performance. Aelfgyfu was taken to wife, or concubine, by King Cnut in 1013 or 1014 and for safety she and their son Svein went to Denmark to join Cnut in 1015 or 1016. Here she gave birth to a second son, Harold Harefoot. When Cnut conquered England in 1016 he found it expedient to marry the widow of King Aethelred, Emma, so Aelfgyfu was left to rule Norway from 1030 to 1035. To add to the confusion, this Emma (of Normandy) was known as Aelfgyfu during Aethelred's reign, and was still named in this way at the beginning of her second marriage, to Cnut![13] So we have two of them. When Cnut died in 1035, Aelfgyfu of Northampton returned to England, seizing Winchester and the royal treasury from under Aelfgyfu-Emma's nose. Svein died in 1036 leaving Aelfgyfu's son Harold Harefoot as king, his mother regent. All this was accomplished with the help of Godwin (father of Harold) who had changed sides in order to help Aelfgyfu of Northampton. To secure her position this Aelfgyfu is next said to have sent a letter to Normandy, where Aethelred's sons by Emma had taken refuge, luring Emma's son Alfred to England with the promise of the throne. On his arrival Godwin apparently greeted, cozened and

then barbarously murdered him in 1036, though others blame Harold Harefoot for the crime. The Godwin family were, therefore, deeply imbrued and might even wish to plead innocence. Well, that is not all, though it might have been all William's pards were told. Now we will consider what might have been said in private, so not entered on our Tapestry.

By 1051-52, events had moved on and Aethelred's other son Edward was on the throne of England, and Godwin then tried to raise a revolt but failed. As a result he had to give up Harold's brother Wulfnoth and his nephew Hakon as hostages for future good behaviour and these hostages were taken to Normandy and into William's custody. Now according to the monk-chronicler Eadmer, writing rather later than the events,[14] Harold Godwinson actually went to Normandy to secure the release of these hostages because he was fearful of what might happen to them when King Edward died. But this is being wise after the event and was, anyway, written under Norman direction. Eadmer tells us several times that he wrote under the kind direction of Archbishop Anselm (who had his own agenda). Why this apprehension of King Edward's death? There is no contemporary evidence that Edward was in failing health, or anything but hale and hearty in 1064. There was no anticipation that we know of in 1063 or in 1064 and his death at the end of 1065 was, therefore, sudden. It is only the Tapestry that depicts him as old and frail. He was, in fact, about 60 years of age in 1065. If Edward had already promised England to William, then why would the hostages be in danger? That makes no sense. Harold may indeed have wished to secure the hostages and so was happy to go to William. But it seems certain he had other reasons and so combined his purposes, hence the story of Aelfgyfu, which really had nothing to do with the hostages. It was a means of introducing more confidential information. Very few, certainly not the embroiderers, would have been privy to the rest of the conversation. The Norman version of events subsequently justified William's invasion by claiming both Edward's long-term and then his deathbed nomination of Duke William and that Harold was sent to Normandy to remind William of this promise, as if he would need a reminder. Can you believe it? So why is no claim made on the Tapestry? Edward was not dying in 1064. Going to William may have been Harold's choice, once he had been detained by Guy. The question remains, what was so special about Aelfgyfu that she had to become an introduction to a secret communication?

A well-known rumour, repeated in the *Anglo-Saxon Chronicles*, said that neither of her sons were Cnut's, maybe not even hers, though it seems likely that Emma had a hand in such defamation. Rumour said that one of them was the offspring of a priest and a serving maid. They could be the figures on the Tapestry. We do not know why Aelfgyfu should have adopted such a child (unless barren and needing leverage), but clearly the children of Emma and Aethelred would then be the heirs to the throne, not those of Aelfgyfu and Cnut, so Godwin or Harefoot had murdered the rightful king or claimant by disposing of Alfred. The succession was not certain without the agreement of the Witan, but the claim

would have been pre-eminent. Eventually Emma's other son, Edward, became King of England it is true, but on the way he had become wholly Norman-Breton with little knowledge of England and apparently even less interest.[15] Good governance certainly did not concern him. He enjoyed his privileges instead. The English appreciation of kingship was alien to him (even his formal documents betray this immaturity)[16]. For him the king owned everything. Common-weal and democracy meant nothing. Had it not been for the power of the Godwins during his reign this period might have presented a very different aspect to history. When he died he would, undoubtedly, feudally nominate his successor, causing a constitutional crisis. An English nominee was a better idea and maybe this was in Harold's mind, but how to ensure it?

Then there was the problem of Queen Edith, King Edward's wife (and Godwin's daughter). What would she do when Edward died? She had put herself in the position of heir to the throne, which for an Englishwoman was quite feasible and likely to be approved by the Witan.[17] If not, when Edward died she could still claim an heir 'in utero' and so strengthen her hand by claiming regency. On the Continent such a monarchy was unthinkable. In England it was possible and, when widowed, if she remarried, then who would she marry? William of Normandy was already married and devotedly so, so whoever it was would be another contender. Bad news for William. Edith was sister to Harold and to Tostig, favouring the latter, but neither of them would have wanted her on the throne. Remember the plotting vultures at Bosham? Were they Harold and Tostig planning to thwart Edith? It is quite possible that the ambition of some French monarch to seize the English throne was suspected and, at this point, William was probably the strongest candidate, though there were others. It is possible that Harold was sent by Edward to warn William (or someone) of this female possibility, in which case freeing the hostages would become important. King Phillip of France was only a minor, so he was not yet a strong contender. Flying in the face of centuries of propaganda and the ancient Norman whitewash, my own assessment is that Edward was a far from saintly king (*Domesday Book* hints at this and at the young ladies who received favours for 'feeding [his] hounds'), and that in return for keeping quiet and out of the way, whilst lavishing false praise on him, Queen Edith received her special position as an eligible heir, her status being supported by her own celibacy. She had no children by him and openly declared that she had no relations with her husband, which gave her great moral stature in that age and she certainly did all she could to enhance her virtuous reputation in the eyes of the English church.[18] Of course, she might be barren as well, but there was always the chance she was not and that she might remarry. She had received enormous estates and wealth from her husband too, and these also meant power. Given just some of Aelfgyfu's determination, with her resources an ambitious Edith would have had no difficulty finding a champion and it would not be either Harold or William.

We have adequate testimony as to Harold's cunning and ability to cover his intentions, even if he was not downright devious.[19] The ability to appear urbane and circumspect was as important as martial prowess in his world and from the outset of the Tapestry we have seen reference to his deceits and inventions. Perhaps Harold wished to privately appraise William of the danger posed by an enormously powerful Edith and sound-out his reliability. Indeed, King Edward may have sent him, and he may not have sent him to William. We will return to this later. Normandy had given refuge before to English refugees (like King Edward) and yet, as Edith could call upon powerful Scandinavian friends for aid, she might even offer them marriage rather than fleeing to Normandy. It was in William's interest to forestall any Scandinavian connection. Yet if Harold himself aspired to the Witan's nomination it would never do to let William guess this personal agenda, so Harold could trust no third party with such an embassy. He had to trick William into either giving him support or denying it to any other claimant. The problem was how to do this, and playing on William's fears of a Scandinavian-Edith alliance would be one way of achieving such ends. Its inclusion on the Tapestry does seem to indicate a degree of mischief? Who would know what was said at this time? Who else who might wish to discredit both Harold and William?

So it is no surprise to see, just beyond the tower, fierce pards biting their own tails, symbols of dishonour and of courage undone, while the section closes and runs into the next with a repeat of the fable of the fox and the crow just for emphasis. The fox is holding the cheese. Flatterers and story-tellers gull their listeners. The message here seems to be that Harold feels he has succeeded for there is an adjacent wyvern, just for disreputable emphasis. Or did he succeed, for a lion appears to look back directly at this fable. Knowingly? Someone noble has not been taken in. The obvious, but not the only, choice is Duke William. Anyway, pride comes before a fall and all things are mutable. The pace of our story is about to alter.

# Chapter 4

# The Opening Chapter Concludes

Our next frieze is of debating wyverns in Ringerike/Urnes, or Nordic, style, and quite different from the ones that concluded Harold's tale(s). The style has significance. To claim a Scandinavian connection is too strong but they are indicators. They are above a column of soldiers setting out. It is a spring offensive, winter is over. One in the middle appears to wear a turban, but it may actually be a harness-cap and if so is another unique inclusion, another piece of primary evidence. Nowhere else do we have any evidence of a padded cap to wear beneath a helmet at this date. What is happening now? Once again the campaigning season has come around, though the apparently debating and non-standard wyverns shown might hint that the impending attack was not entirely justifiable. Or was it a deceit? Just possibly the whole thing has been contrived. Would the embroiderers know such things? Maybe, if someone boasted of them. William of Poitiers later claimed that Conan of Brittany had corrected his vassal Riwallon and Riwallon then appealed to Duke William for help against his lord. Not really grounds for action but possibly convenient for William. So this might make sense of these marginal hints. Anyway, fighting seems to have been close to many hearts and one did not need much of a reason to go campaigning. Warfare was a popular hobby of the rich and powerful. For Norman nobles this was just another form of hunting and what more natural than to invite their honoured guest and known soldier to participate?

Strangely contorted, conjoined dark birds are above the dominant figure, the figure always presumed to be Duke William. Is it him? These again appear to be not real birds but shape-changers, parandri, unless they are attempts at Pliny's description of the ostrich, which imagines itself concealed if it thrusts its head into a bush?[1] No one in England had ever seen an ostrich so this description was all they had. If, however, it is our cygnus-cum-ferende gæst, or swan, then it might be either black or white and furthermore known in fables to sing a sweet song. If this is the case I wonder who is doing the siren-singing? Maybe William is hiding a secret purpose as well? Maybe he dissimulates? Maybe the siren-song is sung by someone else and for Harold? As we pass Mont St Michael, gryphons rejoice, fierce, strong, vengeful guardians of the souls of the dead. For them and for the Normans, this is a Christian parallel of Valhalla.

The Mont itself is no more than an arcaded and turreted charpoy on a molehill Ararat, so I doubt the designer had ever seen it for he certainly makes a better job of all the individual castles shown than he does of this notable building, whatever some historians say.[2] Therefore, I doubt whether the small, seated man-in-the-margin who points towards the Mont is actually telling us he was a cleric from there,[3] the designer of the Tapestry. He is not, for otherwise he would have known the place much better and given it greater prominence and realism. Rather, I think he points back to emphasise a figure in the mounted column, a figure distinguished by his lamellar armour and his cudgel (in fact his marshal's baton), supposedly William, yet it is the same picture we have of Bishop Odo of Bayeux later in the Tapestry, at the Battle of Hastings. He also rides the same black horse. Are we being told that the real hero and general of this campaign is Odo? We shall see such pointing at him for emphasis repeated later, and the seated figure could he then be Duke William, directing events through his sibling. If Odo played such a part I have no doubt he would want it recorded. And what about this strange armour of Bishop Odo's, a suit from Outremer, more suitable for a Varangian. Is it no more than a coincidence that the wyverns noted above have Nordic styling when we have this as a possible Nordic – Varangian connection? Was one of the embroiderers Nordic? Remember the squamatid armour? Next to that was a clump of trees also in Ringerike/Urnes style. Maybe the Nordic embroiderer also worked this section? Go back and look. Anyway, wherever we have a certain identification of Duke William he is wearing western European mail armour and not something outlandish. This figure is *not* the duke, we can be sure of that. It cannot be anyone but the wealthy Bishop Odo and he wishes to be noticed, to be emphasised. And we shall see this confirmed several times.

The column fords an estuary with tides and sandbanks, the dangerous estuary of the River Cousenon. Horsemen raise their feet to their saddles, foot soldiers hold their shields aloft to minimise the drag of the waters, men and horses tumble into quicksands or tidal races while fish and eels swim, ravens or carrion crows and kites look down and scream delight and (hero) Harold rescues men from a watery grave. Two fish are seen connected by what appears to be a cord, exactly the same symbol as is shown for March in the Duc de Berry's *Book of Hours*.[4] If this is the sign for Pisces, then we have further confirmation of spring, say late February to March, just the time of the spring tides and tidal bore of this river. In the water one man grasps an eel by the tail while in his other hand he seems to hold a knife. A pard pulls him ashore and (fierce) hawk and camel, the beast of burdens, assist him while a centaur, a creature living between two worlds but given to licentiousness, pulls the camel's tail. Are we being told of some foolhardy attempt at fishing but also, in these several bestial attributes, given a parallel character composition of the expedition? Or is this a comment on Harold? Breughel's Flemish proverb 'to catch an eel by the tail' signified a useless endeavour, so perhaps the proverb is as old as this. Maybe his display of bravery will all come to nothing. The knife would be for skinning – more than one way of

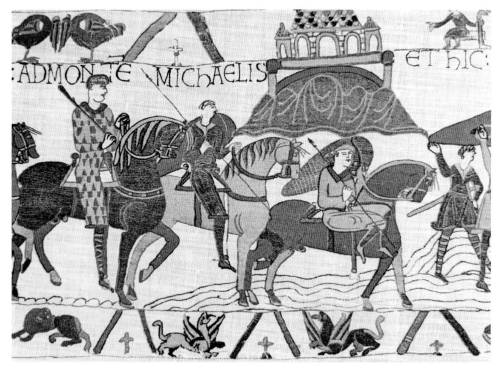

Leadership in lamellar, the marshall and Mont St Michael (with added emphasis)

skinning anything also comes to mind. If so, not everyone was impressed. Maybe only the fierce, aggressive, burdened and licentious soldiery were, that is the pards, hawks, camels and centaurs. They are the ones obviously impressed but the parandri have already warned viewers of the plurality of Harold's character, so his actions could also be calculated to impress, or it could just be a comment on these (possibly contrived) events. It also begs the question as to how much help Harold received. Did he manage it all on his own or did he lead a rescue attempt? Let us move on.

Looking down on them all we next see boars and badgers, fierce and dirty creatures with dangerous bites, then thought to be fatal. Were these opportunist brigands menacing the column's stragglers? The castle at Dol, where Conan hides, is assaulted by dragons (firedrakes), but below it are two rejoicing hawks or eagles who congratulate one another (William and Odo or Harold and Odo) and a wyvern lies dead. Sovereignty and courage have prevailed over bile and the diabolical, and the castle appears to be on fire, so Conan makes his escape by sliding down a rope. Is it my imagination or is this a rather poor quality castle? Just how genuine is this expedition?

Winged lions of destiny pursue the fleeing Conan, crow and kite look down. The expedition comes to Rennes, but we can see that this has been guarded by faithful mastiffs and by geese (warning, tenacity, keeping faith), the best watchmen of

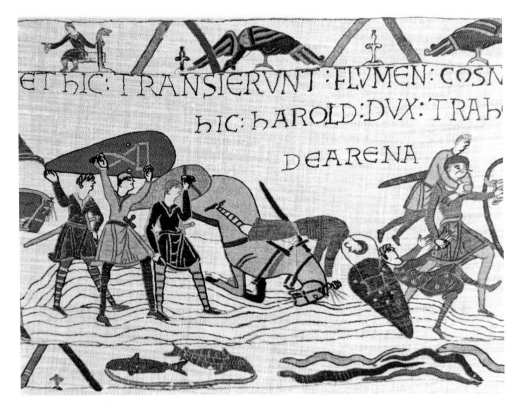

Twin fish and a heroic turn

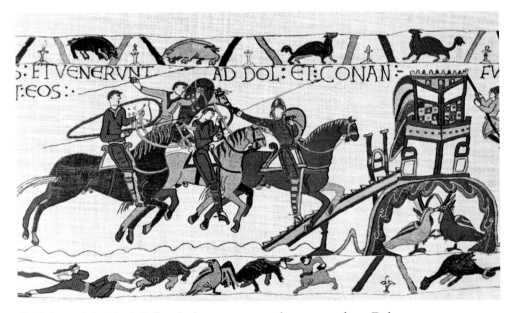

Catching eels by the tail, fire-drakes, wyvern and an escape from Dol

all. Conan has been foiled. He carries on, having no choice, to Dinan. The pursuit has lions and winged lions confronting one another, lions are noble and brave but winged lions suggest St Mark, virtue, strength, destiny as well as bravery. Vultures look-down on Castle Dinan, where Conan finds refuge. Now the hawks bow down to William's forces and after a fierce resistance and threat of fire Conan hands over the keys and dishonoured lions bite their tails while winged lions and an eagle rejoice. Is the eagle significant? As we shall see later, it might represent Bishop Odo himself. That would give it special significance.

Here we should pause to remember that the Tapestry is undoubtedly the product of an English workshop. This is an important, if overlooked, consideration. Remember, there were no cameras, no records and how could the most assiduous of observers possibly remember every detail of each and every structure? Yet these castles we see are all architecturally feasible and individual. What does this tell us? The embroiderers were not given an all-expenses-paid trip to France to observe and record the castles and other buildings depicted. Neither were they given security passes into secret, military installations and, as we have seen, they were not able to say what Mont St Michael looked like, which confirms they had not visited Normandy. Nevertheless, all the castles shown are both individual and plausible structures and this can only mean one thing: that the embroiderers saw castles for themselves. These castles were, therefore, undoubtedly English and not Norman in location. We are too close to the Conquest for anything else to be possible. This really is primary evidence for it flies in the face of all the fantasies built up around Norman castles and Norman genius. Although we have no certain written or archaeological evidence of any Conquest-period Norman motte-and-bailey castles, these embroiderers (in England) had seen several castles *and* they had seen them before c.1070, at very latest 1080.[5] Were such castles in reality always English and not Norman? That would also help to explain why we cannot prove any motte-and-bailey castles in Normandy before 1066. Let us consider this possibility before we move on.

Historians constantly dismiss all the Tapestry's castles and buildings as conventional or schematic,[6] which completely fails to explain why they are all shown as individuals. Why not just use a castle symbol? The only possible pre-Conquest motte in France – though the motte itself is not certain – at Chateau d'Olivet Grimbosq, is mentioned by Rowley as evidence for motte-and-bailey. He accepts the suggested date of pre-1047 for the whole castle complex. I cannot find any proof of this. Some writers' views have been extreme. 'None of these places in reality ever looked remotely like their depiction on the Tapestry,' said one.[7] Such negative and clairvoyant rhetoric is inimical to scholastic application and scientific analyses. One might as well dismiss the whole story of the Tapestry as a fiction in order to be consistent in one's interpretation. Why then do we not have one symbol for each building type? It is, in fact, the structures and artefacts that are most likely to be faithfully portrayed, consider that. While the storyline shown will not only be subject to individual understanding,

memory and presentation, but also to political propaganda, there is no reason for structures to be falsified. It therefore stands to reason to accept these highly detailed and individual structures as just as accurate as the artefacts and clothing shown, validating them by marrying together surviving structural elements, archaeological evidence and the research of eminent architectural historians, such as the late Cecil Hewett,[8] who devoted his life to early timber structures. We can only write them off as inventions if we write off everything else, pictures, stories, the lot, as pure fiction and fantasy. Where then would be the point of the Tapestry?

Years ago I determined to explore the engineering possibilities of these Tapestry castles, especially the splendid example shown at Bayeux, to see whether they could be validated as timber constructions by surviving structures and how they compared with the secular buildings shown on the Tapestry. Bringing together pre-and early post-Conquest structures, stave-churches, aisled barns and timber belfries, all with common antecedents among aisled halls, walling elements and spire-masts, I was able to construct an entirely plausible, detailed structural model of the Tapestry's Bayeux Castle, which not only accommodated surviving archaeological evidence from the eleventh and twelfth centuries but also explains anomalous features in the succeeding phase of stone-built donjons, such as the internal galleries and the fore-buildings they feature, which otherwise appear to serve no real purpose and to have no pedigree.[9] From this practical realisation, building from the foundations upwards in stages, I was able to conclude that the Tapestry's castles did not represent cosmetic towers within ringworks, as often claimed, but instead integrated tower and box-work structures entirely conformable to the description of the fabulous tower built by Arnold, Lord of Ardres c. 1117.[10] This reconstruction I believe to be the first accurate synthesis of all the available archaeological and pictorial evidence from the period. Moreover, the secular structures on the Tapestry often mirror exactly the same technical details of timber engineering that we see in the castles. From this mass of evidence, I concluded that the structures shown on the Tapestry, including the castles, were accurate observations of buildings seen in England c.1070. There is one very special caveat proving that these were English castles: the castle at Bayeux never had a motte. Neither the embroiderers nor the writer of the brief ever saw one at Bayeux. No Norman ever saw one either.

Finally, after reviewing the archaeological evidence for motte-and-bailey castles in England, Wales, Scotland and in Europe, I came to the conclusion that the concept of a motte – Old French for turf – as an artificial hillock on which to place a castle-tower probably evolved in Britain, not in France, in spite of the linguistic debt, and it evolved from fortuitous or serendipitous exploitation of natural, topographic features, probably in the immediate pre-Conquest period. Then, post-Conquest, it particularly evolved from the raising of protective and stabilising berms of turf around the outer box-works of such timber castles.

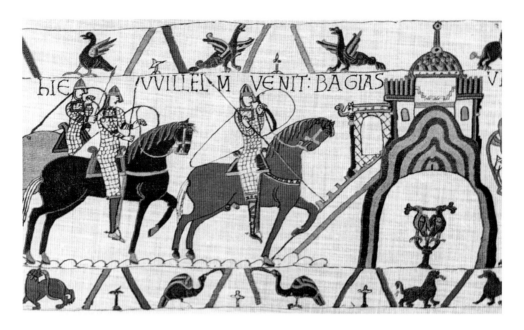

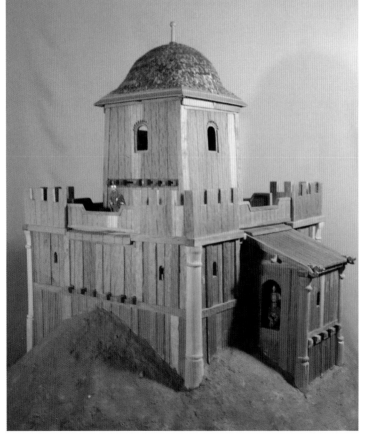

*Above*: Bayeux (yet *not* Bayeux)

*Left*: A reconstruction of a motte castle

Subsequently these castles evolved in two directions: the sinking of a tower into the up-cast earth-and-turf motte feature, or the raising of a berm (alias motte) around a wooden tower, or even a later stone donjon. Whether timber or stone buildings, berms helped to resist attempts at mining. As stave walling, an integral part of such box-works and illustrated on the Tapestry, appears to have been exported from England to Europe and Scandinavia,[11] in churches and hall-structures, long before 1066, I conclude that the use of mottes might also have been exported.

The Continental use of the noun castellum is by no means synonymous with motte-and bailey – anything can be called a castle. The addition of a bailey to a motte was simply the combination of a burgh (ringwork) with a turf hillock (motte) of natural or of constructed form. Many Conquest-period Norman castles actually exhibit nothing more than just a burgh or bailey (as the post-Conquest language insisted) all of them being initially devoid of a motte of any kind.[12]

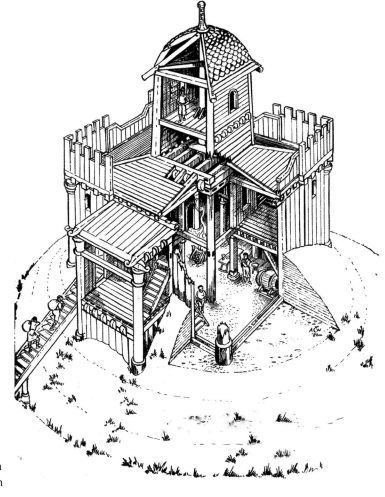

Possible structure of motte castle with box-work and berm

In both England and France there seems to have been too much enthusiasm among historians to christen all mounds 'Norman' and 'mottes'. Some are undoubtedly earlier mounds (even prehistoric), some are recent garden features, and many are rather later mottes, especially in England those raised during the Anarchy. While some were castles and some were re-used as such, others were and are nothing but tumuli. It is strange that this was never noticed and investigated before.

Next on the Tapestry, Duke William confers arms on Harold, not in fact to confirm his warrior-ship, for he has already been a soldier in battle and trained from birth to warfare, that is why he had been invited on campaign, but as a special gift and, more sinister, a symbol of overlordship. Harold's skill and bravery have been reported and the duke has found a suitable reward, a feudal gift and we can be sure it was the best available armour. However magnificent it was, in reality it was a trick. By accepting the gift, Harold became that man's man, yet how could he refuse such an honour without giving offence to his generous host of the winter? Lions bite their tails and alarmed birds witness the ceremony, confirming that it is a clever device on William's part. As they next approach the Castle of Bayeux (guarded by dark geese, or are these cygnets, cygnus, warning of shape-changing?), wyverns rejoice, though not for Harold's contribution this time but for William's. But not all is ominous for so do pards and winged lions. They all know that William has scored. They tell us that his retainers are rejoicing, and destiny is fulfilled. Harold is surrounded by deceit, but also by supreme power. Could there be a better description of an honoured prisoner? A pair of eagles or hawks sit on one perch, as though in a mews, grasping a sceptre-like object. Could they be Harold and William or are they William and Odo as successful plotters and raptors? Anyway, someone is professing shared regality. They might even represent another happy couple, but for clarity's sake I will come to that later. I suspect they might represent regal promises by William to Harold, promises of shared power and continued close friendship, but only if Harold acts in William's interest. Who would trust such promises in this eleventh-century world? Alfred (Emma's son) had been betrayed in just this way and perhaps murdered by Harold's father. It seems a cynical even cruel and malicious assurance on William's part. 'Trust me, I will be your friend.' Once again there is ambiguity. We may choose the explanation we wish or anticipate a conclusion later in this unfolding tale of power, duplicity and ambition. 'Here William came to Bayeux where Harold gave his oath to Duke William' comes next on the superscript. It does not say *what* he swore.

As Harold swears on the holy reliquaries the winged lions of strength and destiny (here shown above William) knowingly suck their wings to stop their mouths, the eagles cover their heads with a wing, doves hide under branches, even the cunning foxes are surprised. What has he sworn? Although this is not a grand ceremony with ritual, pomp, and the presiding bishop would be Odo, it does appear to be a significant pact sealed between friends or fellow conspirators.[13] Wace believed that William also tricked Harold by concealing the relics under an altar cloth until the oath had been sworn. We have to admit that some of the details

in his account ring true. Of course, the embroiderers would not have been told this, so the reliquaries shown here are in full view. Are the two Englishmen next shown behind Harold the hostages? It appears that Wulfnoth was never released. Harold has had no choice in any part of these matters. He is certainly under duress. The fox has been outsmarted. Whatever oath he swore, he swore it as 'that man's man', as hearth-troop member to Duke William, yet an oath extracted under duress has never been binding in law. This, however, is different. Even under English law this holy oath could be a binding obligation. If William should make a play to become king, Harold cannot plead that he was only obeying the orders of his lord or the advice of his counsellors in opposing him, for now he is bound to William. The bones of the saints add weight to the promise – a stitch-up for sure.

Swiftly the English party take ship for England as lions bite their tails and hawks or eagles cover their heads in shame. When they make land, we see a repeat of the fable of the wolf and the crane – seek no reward, you are lucky to be allowed to live – just to add emphasis. Landfall is at some castle-like building by the sea where a lookout stands on a fore-building and there are faces at the windows, keeping watch. Could this be Dover? It has never been noticed before because the English are not supposed to have had castles. But this certainly looks like a castle, one with a large garrison at the windows and possibly part masonry, the 'gateway to England'.

So ends the first part of the Tapestry's story with Harold's return to England, ostensibly successful. But the margins tell us it is really in shame, a schemer outwitted, a compromised claimant. William now has the moral high ground that Harold had hoped to win for himself and, we might say, has the non-aggression pact that Harold had hoped for in his favour.

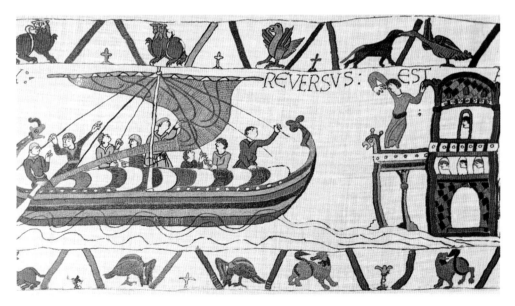

The return – to Dover? Is it pharos or castrum?

43

# Chapter Two

The journey to London is marked by surprised birds and, yet again, the fable of the fox and the crow, so we know that the account Harold will give to King Edward will be flattering rather than entirely honest. Or is it really the fox and the crow, I wonder? There is no cheese in sight and the fox has a very doggy look, without a proper brush. I wonder if a different hand is embroidering a different story. Ademar de Charbannes (989-1034) was a scribe in a monastery who left us a fable that has now come down as *Chanticlear and the Fox*, wrongly attributed to Aesop. This fable originally said that a fox saw a partridge on a perch and then flattered her into descending and closing her eyes, whereupon he seized her. Quickly she begged the fox, as an act of mercy, just to say her name, before consuming her. Then she escapes when he opens his mouth to speak. The fox was cheated by partridge's quick wits. Could it be that fox–Harold has also been cheated, that he now has to tell King Edward that he let the partridge go? For so he did, when he became 'that man's man', one of his 'heorð–werod'. It might signify any sort of failure to deliver his commission, supposing he was instructed to make the offer of the crown of England to someone other than William. We will come to that possibility in time. Harold has also been cheated, tables turned and he now has to tell King Edward he let the partridge go. For this he undoubtedly did when he became William's man. He failed to deliver his commission. Just supposing he had been instructed by Edward to make the offer of the crown of England to someone else. Harold looks obsequious and shifty and if he switched embassies on his own account he might well have much to hide. Birds appear to be at a loss for words. Pards (royal guards) cover the interview with King Edward while the bird beneath his throne, our suspected caladrius, bites its wings and turns away from the king, the sign that a sick man will die and so it happens. It is prophetic for now the king has died and next we will see what he did before he died.

Kite and vulture look down. Over the bier bearing the body of the king are winged lions of destiny, of beginnings and endings, of fact and potential. While birds call, a pard prowls and howls and tiny figures ring tintinabulae. So we have a sound-track for the king's funeral. Then a gryphon, guardian of the souls of the dead and especially of the most sacred souls, retrospectively announces the scene

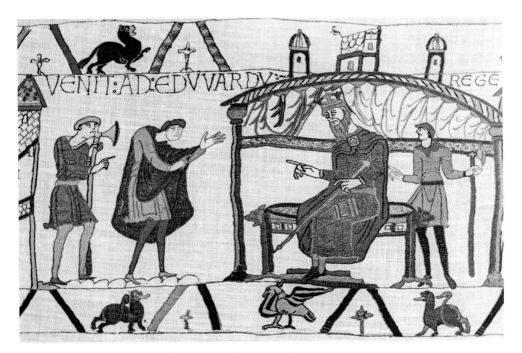

VENIT:AD:EDVVARDV: REGE

Harold explains and a caladrius resigns his commission

of the dying bedridden king, the day on which he was both alive and dead. This is what he did before he died. Doves (ordinary citizens?) and Queen Edith lament the loss and Stigand and Harold are present. This is not the first time we have encountered such chronology, so why have events been replayed? Is it an attempt to suggest that Edward did nominate Harold before he died? It is Harold who is present and Edward stretches out a hand to him. The divine burden of kingship and many dangers will rest with him now. It could just be that the embroiderers of the funeral sequence jumped-the-gun, put in their scene before the designer/ supervisor was able to provide oversight, so the death-bed team were told to follow-on. This would suggest that the work was proceeding rapidly, too fast to guarantee it was error free. Was there a deadline? I think that if Harold had been sent to offer the throne to someone else and failed, then Edward might have nominated Harold to avoid leaving it open for William. This would prevent a squabble between, let us say, two French claimants. To provoke a civil war on English soil would be worse than anything else. Could the embroiderers have slipped this in?

Then 'they', we assume the Witan, offer the crown to Harold and both lions and birds appear to lament. There are birds apparently caught in cages or in traps. Maybe as a valiant man Harold was not seen so much as evil by his enemies as misled. It is an ancient truism that the king's counsellors are always to blame for royal actions. Has his Witan led him astray (in Norman eyes)? When he is enthroned lion and pard bite their tails in shame and there is a clamour of birds,

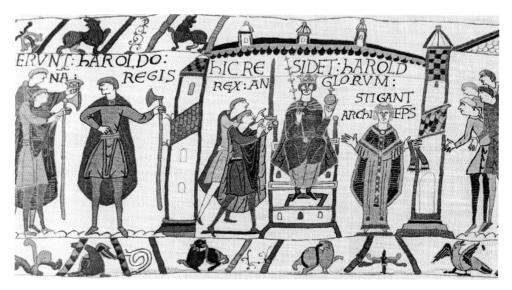

The right deed for the wrong reason? Harold crowned

the Norman response to his accession. Now a portentous star appears in the heavens: These men are looking in wonder at the star. Do they wonder whether this is a good or a bad omen? It was ultimately a good one for William.

As Harold sits enthroned under disputing birds (significant omens or just divided opinion among his counsellors?), news is brought to him and he sees before him a ghostly fleet, a portent, in the margin. With such a rich and civilised kingdom at stake it is predictable that there could be several attempts at invasion. He would do well to anticipate as much. England was *the* rich prize of Europe for many reasons, especially her land-tax, though the mechanics of this tax were certainly not understood by most contemporaries.[1] We will carefully examine this wealth in a later chapter. A watch is set, looking out to sea, anticipating invasion from somewhere, maybe the North Sea, but it overlooks a ship that sets out for Normandy. We cannot say whether the beasts shown watching in the margin are anything more than trusting sheep (they look apprehensive), but the birds have the familiar red colour of scavenging kites. Sheep may safely graze, but they are under threat when carrion feeders sense rich pickings. Perhaps this ship bears special intelligences to William, a Fifth Column in England? It may be that it set out from Sussex, for the South Downs have always been famous for sheep runs. I will speculate on the intelligences they might bear in a little while for I believe they were very important and that nothing shown on this Tapestry is without purpose. Once again, in the margin, we see the twin fish of Pisces. It is, again, late February or early March.

Passive pards guard the Norman shore as we see Duke William or, more accurately, as we see Bishop Odo, ordering ship-builders to work. This is interesting, William seems content to let his brother take the lead. Winged lions of fact, potential and destiny, sit below and hawks or eagles above. Now either

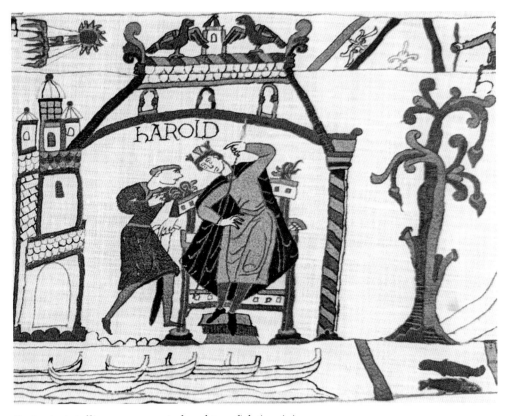

Portents, intelligences exported and two fish (again)

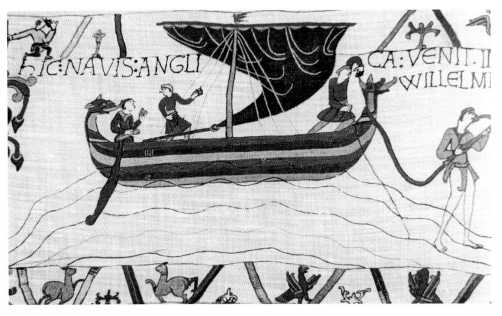

The Fifth Column

the invasion process took several years (and we know it did not) or the ships were built well before the spring of 1066, because they could not have been built to sail when the keels were still of green timber, even though most authorities agree they were built with green timber strakes. Moreover, we know that Olaf Tryggvason's long serpent took a whole winter to build. So did William have hundreds of shipwrights in his employ to build hundreds of ships?

The Tapestry is suggesting that some at least were specially built, so the trees used must have been felled and converted before 1066 and then the ship's caulking, fitting and sea-trials at the least would have to be commenced in the spring. What about the cordage required and the seasoned ash for the oars? Was all this planned from 1064? On the other hand, if most of these ships already existed many obviously came from outside Normandy. Once built they would need months of seasoning as well as time for fitting. Where did the sails come from? Weaving them was a skilled and lengthy process. We should consider that such a purchase of ships, or even of materials not to hand, over a wide area would become prime and common intelligence. Were these intelligences, were such reports of a fleet being assembled, the ghostly fleet seen by Harold on the Tapestry? Some writers suggest that Harold did not know of this fleet being assembled, doubtless everyone knew of the demand for chandlery. If he knew it, then why no pre-emptive strike? That was because he knew the Norwegians

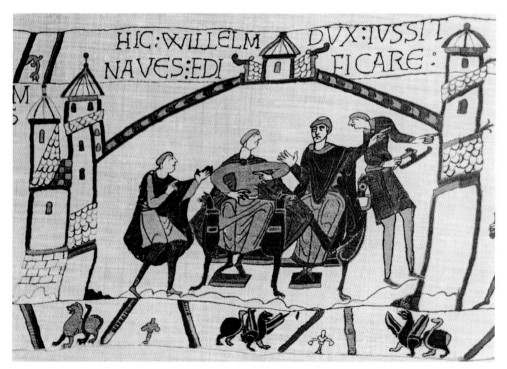

Just who is directing this destiny?

48

were doing the same. With the benefit of hindsight we may marvel at the amount of European seaboard shipping, so many along the coasts of Aquitaine, Brittany, Normandy, Ponthieu, Boulogne and Flanders and even more are destined to sail from Scandinavia. With so much competition for ships and chandlery, not to mention skilled craftsmen and women, prices must have soared, and the war-chest needed would have been enormous. It is almost certain that English chandlers would have supplied some of the requirements.

Then, as now, the truth must not be allowed to spoil a good story. So we have a rather 'afterthought' scene of ship-building – perish the thought that it had all been planned in or before 1064. Woodsmen on the Tapestry set to work felling trees watched apparently by sheep, possibly quietly grazing woodland 'lawnds' (mature oak woods), and birds that surely, delightfully, are woodpeckers. The ship-builders have breast-auger, possibly a 'T' auger, long-handled felling axe, adze and side-axe. Once again, this special assemblage is important primary evidence. There are mastiffs, no doubt to guard, and winged lions and pards (nobles and their vavassours or retainers), while some birds peck the ground (as birds do when seeking-out insects from felled woodland, so they might also represent requisitioning parties), and others call to one another as the ships are berthed. No doubt news is spreading of rich pickings available for bold hawks who will join the enterprise. Then comes the quartermaster's train with armour and armaments, including a small spindle-sided wagon, another piece of primary evidence not encountered elsewhere or before and often supposed to belong to the sixteenth or seventeenth centuries, not an object copied from an earlier source. Passive lions begin to jump around in anticipation (though one bites his tail in shame, I wonder who, for it must allude to someone in particular), birds call excitedly, kites look down in anticipation. A pair of lions bite their tails but above them is a pipe of wine, so Dutch courage is at hand. Who would not be apprehensive at such a colossal and risky undertaking but think of the potential rewards? The duke's entourage rides up under some colourful raptors and below them we see a very strange metaphor indeed – a pair of flamingos?

No bestiary of this date has survived to tell us of them, but here they undoubtedly are. At this date they can only be the greater flamingo (*phoenicopterus roseus*) of southern Europe and Africa. Perhaps the artist saw them in some classical source where they would not only be noted as strong defenders but also the living representatives of the gods. Well, that would become 'God'. Of course, given the other evidence accumulating from afar they could be a personal observation by one of the embroiderers. I wonder. Are they included here, perhaps, due to confusion with the legendary phoenix (a better recorded fabulous bird at this date), which renews itself through fire, from 'flamma' (flame), hence the glowing colour as well as the name 'flamingo'? Do we have here the flamingo as 'phoenix', representing the allegorical Christian life, the born again hero? If so it would be quite a compliment. The Tapestry has now provided us with the earliest medieval representations of this bird, of the flamingo. Yet a question remains, all we are

told is that the duke embarked in a great ship. We have no certain indication of the ducal presence among these riders. Do these remarkable birds appear in order to reveal the duke or is there someone else in the group, maybe Odo? Surely a bishop would be a much better candidate for the Christian life. The lead horseman is a gonfanonier, or standard-bearer. Is the duke himself carrying his own flag? If so, he is only accorded winged lions for the flamingos come under the entourage. Noble destiny, winged lions, sounds more appropriate to a duke, or even possibly to a standard-bearer. The hero is lost somewhere in this crowd and, perhaps intentionally, we cannot quite place him.

So as the duke takes ship the winged lions of destiny await him, excited birds call, passive lions are nevertheless excited, and a hunting dog chases a hare, so the game's afoot. Some lions are passively reflective, others are fearfully biting their tails. Then birds call and gesticulate as they all make land at Pevensey, as if to say 'here we are'. What the Tapestry itself says is 'Pevensey'. The *Carmen de Hastingae Proelio* (Song of the Battle of Hastings) also appears to confirm that Pevensey Bay, or lagoon and marshes, was the landing site. A duck springs skywards for safety – this was an extensive and marshy bay adjacent to the South Downs – and there are lively wyverns (malicious rumours?) around as masts are unstepped, for when operating on inland waters they would be a hindrance, and horses leap ashore. This last is a piece of artistic licence, for how would an artist know how bloodstock

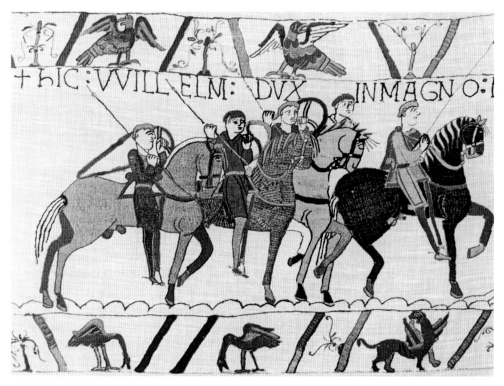

Flamingos – Isodore's Phoenix

was landed if he was not there at the time and if it had not been attempted since Roman times? The embroiderers of the Tapestry had no knowledge of merchant ships I think, or of loading and unloading cargoes. Thus no knowledge of the need for proper wharves and some sort of cranes, which would be rare facilities indeed in the days when men generally did leap ashore from ships. Perhaps the fleet carried its own landing tackle? Quaint as the horse's heads peeking over the gunwales of the long ships may be, they are pure guesswork by the embroiderers who had no more experience of such practical shipping than recent historians, so I am not counting the horse-heads per ship in order to assess how many were carried in each. The embroiderers plainly did not know and writers who claim that other features are not precise are plainly inconsistent when they claim that the embroiderers were now giving exact totals.

Livestock can never have been carried in such shallow draught and open boats, especially horses. The low freeboard would make any sudden shift of ballast, when the animals moved, fatal to the vessel and its occupants. Gunwales needed to be raised and such ships would be forced to sail, having few thwarts for rowers. Even with a full complement of rowers it is exhausting to maintain 5 knots, yet even 5 knots is very little with which to navigate dangerous waters and currents. Sails were essential. Bloodstock would be even more of a problem. Even converting the deep open holds of special merchant ships they could not be carried loose or even boxed. These mettlesome stallions did not develop sea legs. In fact, legs were their weak point. Quite apart from breaking a leg, any destrier who could contact the hull would kick the planking apart in short order, even when cradled in a sling, so they could not be stowed transversely to look over the bulwarks, not even with their legs bound together in hobbles. On the other hand

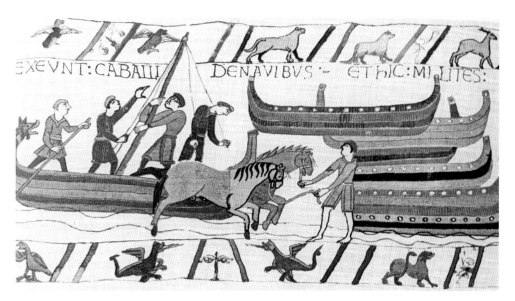

Ducks take wing and destriers leap ashore: Pevensey

51

stowed in-line they would, if at all in reach, kick and bite their neighbours. So a good deal of space would be needed, reducing the numbers to be carried even in a 10-ton burden vessel and many of the ships must have been smaller, even if available.[2] Bolstering between them with hay rations would have some effect but then, if any sort of sea was shipped, this super cargo would be saturated and the increased weight would diminish the freeboard even more. The sea crossing probably took at least twelve hours and could have taken much longer had the weather changed, though given the size of the operation many ships would have been loaded and waiting-on long before the convoy set sail, even perhaps for another day, which means that these beasts had to be watered regularly, fed, reassured and mucked-out. They would need their familiar grooms in attendance as well as stowage for food, water and tack. As each mount would need 10 gallons of clean water every day, any number of them together would soon inundate the ship with urine so, if only by bailing, the hold or garboard had to be cleared and of course the slings enveloping them would need to be especially designed to cope with bodily functions.

It must have been extremely difficult to know how long ship-borne horses could be safely subjected to such conditions. Loading and unloading would have involved cranes or sheer-legs and the same would be required for any barrels of liquids, such as wine, carried by the ships, preferably also for the ('slack') barrelled rations of dry-salted meat or fish, and the martial equipment such as arrow heads. We should envisage as many vessels used as merchant-men as were fighting longships proper, the former riding when not at wharves to unload, the latter capable of rapid movement, of beaching and, therefore, of carrying infantry. We may also envisage a run-in to the lagoon and adjacent beach heads by swift assault craft, anticipating local resistance, with the transports standing off until signalled into Pevensey Harbour. Duke William needed beach-master, harbour-master and quartermaster. Pard, wolf and stag (the fierce, the bloodthirsty, the noble solitary) and a noble lion, perhaps indicating the composition of the invading force, are now shown to face a heron, a marshland inhabitant and also one who shuns the disorder of the world, cringing pards and other pards who merely look on, so there is no immediate opposition though there may have been a small garrison.

There are sent out 'soldiers [who] have hastened to Hastings to seize food'. The description 'Hastings' probably signified the whole district, right around the bay and as far as modern Hastings itself, for the army would need to secure several weeks' supplies. No seaside town of that name appears to have existed. Therefore, any village of Hastings (actually unrecorded) would certainly not have had supplies for an army. Odo's own vavasour[3] requisitions sheep and oxen for slaughter, and gryphons (strength and vengeance, maybe debating the merits of the expedition leaders) confer. Excited lions romp, doves, possibly inhabitants of Pevensey, and vultures wait in anticipation, while excited birds watch the cooks at work. There are shamed (fearful) and romping (eager) pards with hawks (the bellicose) over

the tables. A splendid specimen of a winged lion of destiny is over Odo as he sits at table and blesses the repast and we see an eagle speaking to the lion, that appears to point to the bishop, once again emphasising his importance.

The similarity to any iconography of the last supper is remarkable, with Odo in the place of Christ. On his right sits the whiskered and unmistakeable figure of Eustace of Boulogne, supping from a mazer and looking across it, with meaning, at the viewer, as if recounting some story, an avuncular figure. This is the place normally occupied by the apostle Peter, next to John, who may well be Odo's brother Robert. Surely this cannot be William in a subordinate place at the table. So did William eat alone? It is a strange and presumptuous iconography. Next we see the three brothers seated together, Odo, William and Robert, the others with lions but Odo now apparently under the eagle we have already seen. Is there significance in the choice of an eagle? And it is Odo who is doing the talking, maybe the planning. If he commissioned the Tapestry, he can place the required emphasis and if he did not, then someone is 'laying it on with a trowel' as Disraeli said. Everything emphasises Odo. His brothers and Eustace seem to be subordinated to him. If he ordered the embroidery, then he detailed this subtlety in the brief – and who else outside the church would know the message hidden here?

Here is the explanation. An eagle signifies both valour and the spiritual and apostolic element – we see them as church lecterns – very appropriate for a bishop you might think, yet he has already been accorded a winged lion, signifying potential, noble destiny and bravery, while his brothers, including William, are only brave and noble lions. Surely William should have received at least as much honour as Odo. He should have had winged lion and eagle. Shouldn't he be the one directing events? As a bishop Odo, though worldly, would know the biblical significance of this eagle and lion presentation, the 'allegory of the theologians' as it has been called. The lion is power and strength but is also ravenous because it is prone to the evil 'love of self' (Isaiah 35.9,10) or even be malevolent (Daniel 7.4; Jeremiah 4.6,7). The Lord destroys lions (Nahum 2.11-13). The eagle, on the other hand, can be God's vengeance or even His salvation (Deuteronomy 28.49,50,51; Exodus 19.4; Isaiah 40.31). The eagle, theologically, trumps the lion. A bishop should know this, though others may not, but in a world where observance of social degree was all important, such allusions are certainly dangerous challenges to the royal authority, the supreme earthly power. At this point in the story the bishop is only accounting to a duke, but when the Tapestry was finally made for display the duke had made himself into a king. Oh dear. Perhaps the king's clerical brother had other intentions.

The raising of a castle, which is actually no more than a burgh or breastwork of timber and earth, at Hastings is obviously exciting for both lions and 'vultures' and there is time for horseplay, while the goats may be there to tell us that watch is being kept afar for any approaching enemy. With their triple tails they are curious, lion-tailed beasts suggesting Aesopian alternatives. A lion and a goat disputed over a fountain but seeing vultures hovering decided instead to unite forces and share. Maybe a reference to the burghers of Pevensey. Hawks and pards excitedly greet

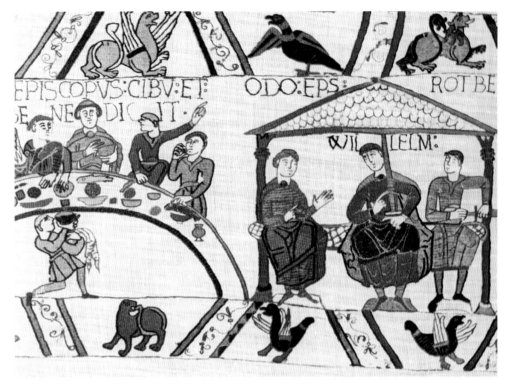

Road to Emmaus or Last Supper? The 'allegory of the theologians'

the news of Harold and yet under the burning house is a shamed, cowardly lion. It has been suggested that the refugees from this house are Harold's family.[4] Yet, where is the evidence? It is a substantial building, for example a possible royal complex at Eastbourne, which we will come to in a moment. That would make the event noteworthy and even, perhaps, shameful. Rowley advanced a very convincing argument[5] that William's invading army landed at a place within the Hastings purlieu, Pevensey, the Saxon Shore fort of Anderida. Exactly where the Tapestry says they landed. This would be a much better base of operations allowing William's forces to take ship across Pevensey Bay, as it was then, to the Hastings shore and beyond in order to forage. The burgh said to be constructed at Hastings therefore was probably an internal earthwork division within this 8-acre fortress site of Anderida rather than the motte castle at modern Hastings as so often claimed. In fact, Pevensey has no motte and the picture on the Tapestry is only a burgh. According to Wace there was a prefabricated wooden structure or castle, which Count Robert of Eu transported in his ship. But this defies belief or comprehension. The ship involved would have needed to be enormous in order to carry so many tons of timber, for a flat-pack castle would stop no one. No such vessel existed for centuries to come, and reused ship's timbers would have offered no significant strength.

Let us also be practical about the location. No sensible general would debilitate his only part-professional army by ordering extensive earthwork fortifications to be erected within the first few days of landing when all are busy with reconnaissance, requisition, shelter, horse and camp lines, latrines and cooking facilities, workshops, supplementary ammunition and the essential checking and fettling of equipment. This alone suggests the site was not the supposed hamlet of Hastings, for to make an entirely new and distant site safe would require great exertions, greater than those required to secure an existing fortress, exertions to no advantage. Even if it existed the site of modern Hastings had no strategic significance or economic value. Pevensey certainly did. For Duke William the immediate task was to find a secure base against surprise attack, to requisition sufficient food stocks and remounts/transports, to reassure his motley and polyglot troops, to scout the locality extensively and finally to ensure their continued high morale in a desperate position. He would have been a fool to leave such an egregiously strong fortress as Pevensey Roman fort open to an enemy and equally stupid to detach any large garrison from his army in order to guard it while he paraded elsewhere, trans-shipped, debouched and built a dirt castle. Hastings, if there was anything on the modern site, certainly had no proper harbour or wharf facilities and it would be foolish to abandon one of the few places on the coast for miles around that possessed such facilities and that offered secure horse-lines within a defensible, walled perimeter. No, Pevensey, held by a small garrison in an internal strongpoint when the army had departed, was the ideal fall-back position should major opposition be encountered inland. It was one of the very few real harbours on the south coast. Harold had left it apparently undefended and William must have received this intelligence from his spies. We have already seen them. Whoever sent the main English garrison north to support Harold surely deserves to be called a trusting, and silly, sheep. Perhaps Harold was lulled into a false sense of security by misleading information and perhaps the northern threat was seen as really the most serious one of all. Such things are always a matter of judgement and often, in hindsight, are critical.

Neither Hastings nor Pevensey are given comprehensive entries in *Domesday Book* to help us and it is evident that by 1086 both the Count of Mortain and the Count of Eu, the new landholders, were themselves evading geld payments in a big way, which explains why both Sussex and Kent were so imperfectly recorded in 1086. Technically, these noblemen were traitors by 1086. Their financial interests at these two places, obviously personal, focused on recording burghers and the burghers' cash tribute payments to their own lordships, for cash was not taxable under the geld. So, we learn that in the borough, or burgh, of Pevensey in 1066 the king had twenty-four burghers and others had twenty-eight, a total of fifty-two burgher properties. But by 1086 there appear to have been 110 burgher properties. So there had been a considerable expansion of commercial activity after the Conquest. There was also a mint, so considerable trading interests had always been there, with reserves of silver and a wealthy clientele making use of them.

Indeed, this mint at Pevensey seems to have been the real site of the Hastings district mint, which ranked thirty-fourth in England in the reigns of Ethelred and Edward,[6] for there is no record of a substantial settlement further along the coast at the place known to us more recently as Hastings, which is only mentioned in 1066 as under the more prosperous and better documented Rye. Lack of any physical evidence for Hastings has always been excused as coastal erosion with longshore drift, but we will discuss this again later. In terms of berthing facilities and defensible position, let alone comfortable quarters for the senior officers in burghers' houses, Pevensey was the obvious headquarters for the invasion.

Any army needs to requisition over a large area, even more so if it includes a large cavalry contingent, and no one knew how long it would be before they joined battle with the English or where the English were. Control over a large territory was therefore essential both for intelligence and for provender. That William's forces subsequently transhipped seems unlikely as Pevensey/Anderida was more prosperous, better provided and, on its promontory, far more defensible. It would be much safer to march overland, requisitioning on the way, once the English opposition had been located. Besides which, if William was relying on his heavy

cavalry arm he would certainly not take unnecessary risks with their mounts. He would not attempt to move them yet again by sea. With his fleet William had an amphibious force that could dominate both sides of the Pevensey lagoon. One other possibility remains for the castle said to be at Hastings and that is a ringwork thrown-up on the Hastings Rape side of the lagoon (say Ninfield or even Ashburnham) in order to secure a beach-head and crossing on this main river running inland through the Rape. We must also remember that there were no maps and so neither military nor communications references were possible, outside the ability of the invaders to reconnoitre the countryside and so piece-together any haphazard intelligences they may have already possessed

Pevensey provisioned?

56

from locals. The invaders were feeling their way forwards, knowing they would meet opposition. Only a fool would rush in without a secure base and full reconnaissance and also without local guides while leaving his rear unguarded.

It is, of course, a fact universally acknowledged that the Normans landed at Hastings and this is verified by the name of the battle, the Battle of Hastings. Every school child must repeat this fact that doesn't stand scrutiny because the battle wasn't fought on the beach at Hastings. However, it was fought within the overall district of Hastings. The Tapestry shows horses leaping ashore from a ship. The mounts that were shipped were bloodstock, vastly expensive and essential to the success of the operation. Yet such transportation cannot have been commonplace.[7] If so it involved tremendous forethought and careful planning and it would certainly have been unexpected by the English. The vessels converted to these transports could even be sail-vessels of large tonnage drawing some depth, so virtually impossible to beach or easily re-float: That, and for safety, is why the mounts would need to be carried and moved in slings and slung ashore by crane or sheer-legs onto proper wharves. Leaping ashore is not the only inconsistency for, as one writer has put it, if the Normans landed at Pevensey, and the Tapestry says they did, the Norman heavy horse then had to make a 12-mile dash to secure Hastings, probably along the beach. That does stretch credulity[8] as the nearest opposed dry landfall would be Bexhill. It would also exhaust the cavalry. The entrance to the lagoon was very wide and what is now the Hooe Level was at the time under water and marsh. Why would any sane commander detach his crack troops from his main and vulnerable beach-head to take up positions in an insignificant settlement on an open shore when he had landed at an intact and ungarrisoned fortress with dock facilities, plus a bay and an internal lagoon giving rapid access both west and north? Why exhaust them on unknown and unfavourable territory before they had even met any foes? What would be the benefit compared to the risk, especially without precise knowledge of enemy dispositions and concentrations? An effective, enfilading ambush on a column strung out along a beach would only require a modest force of attackers to be stationed anywhere along the cliffs, anywhere that the passing cavalry could not surmount as they galloped, or floundered, along the beach. That would be the end of the invasion.

The landing and provisioning of William's army was a major undertaking in itself. In review, landing at Pevensey would not only provide a fortress but a harbour with an anchorage in the marshy lagoon that was to become the Pevensey Levels of later centuries. A long spit of land with a narrow neck gave landward security to this promontory, otherwise there was water all around the fortress. The springing duck has already told us of the nature of this area and the fort also being in commission, the burghers and the mint confirm a harbour with proper wharfage. Estimates of the size of William's invading army have varied enormously and probably the most reliable authorities are Poyntz Wright[9] and Furneaux.[10] The former thought 3,000 infantry, 2,000 cavalry and 800 archers and

the latter 10,500 men in all of whom only 7,500 were soldiers. I am inclined to think that because of the practical problems the cavalry contingent was probably only 1,000 to 1,200 in all, to accept about 800 archers and perhaps 4,000 infantry, as this last would be the most versatile arm, useful for defence or attack. This might give us about 200 ships as horse-transports and up to 500 for the troops, sailors and camp-followers, for we must imagine that noble cavalrymen each travelled with some servants and there were farriers, armourers, fettlers and saddlers who would also add to their numbers. Also many miscellaneous followers, while the ships involved would not be of a standard size. Indeed, the Tapestry shows some assorted shipping and for clarity and expedition we will work with these figures for the present. A total military force of possibly 8,000 men (mounted and unmounted) with followers might be the result. But it is all speculation and would depend on the size of the baggage and munitions carried. Such a limited force with which to effect an invasion makes it all the more unlikely that a sensible commander would either divide his forces in order to garrison more than one location or change landing places. The one he first chose would be the strongest. Meanwhile, he needed to provision his forces, who would probably have eaten parts of Normandy bare while they were waiting.

For arguments' sake let us presume that there were 1.000-1,200 mounts of more-or-less bloodstock type, though the invaders would undoubtedly requisition all the local horses available as remounts and transports. To remain in battle-ready condition such mounts would require good lines, fresh water and a dry ration diet, not grazing. If we assume a height of 15 hands, or possibly more, then each would require 24lb of food consisting of 8-12lb of concentrates and 12-14lb of bulk. Let us opt for 12+12lb. Now 1,000 mounts at 12lb will be 5.36 tons of concentrates with 5.36 tons of bulk, to be found each day. Oats weigh in lighter by the bushel than barley, peas or beans, though all make suitable concentrates and a pessimistic yield per acre[11] would be 10 bushels, or 1¼ quarters, of concentrates. The medieval concept of 'good measure' (quantagium) is involved here for the quarter of barley or peas is less than a quarter of a ton, so at 4.66 x 1¼ quarters we have a requirement of 5.825 acres per day dry feed (12lb per mount) plus an equal weight of hay, where the quality and the acreage involved are much more variable.

This is October, the time when all harvests are gathered-in against the winter and the hungry spring to come. It is a good time to requisition. The men of the invasion force would certainly need at least a loaf of bread (1¾lb) each day. As the 1266 'Assize of Bread'[12] gave 579lb to the quarter, making 329 loaves of this weight, we can estimate that 8,000 men will require 24⅓ quarters (say 5.2 tons) of wheat or barley per day for bread or the product of 30⅓ acres. Therefore, the cereal/concentrate-requisition each day will be equivalent to over 36 acres of arable produce. In the sixteen days that separated the landing and the battle itself the produce of perhaps 576 acres of arable was consumed by the invaders. If we add to this some dry feed for the requisitioned remounts, who would probably

be set to grazing, we could easily be looking at the products of 600 acres of arable, which is 5 carucates. Noble participants would expect a more varied diet and even the common soldiery would want more than bread and they certainly would not need to risk constipation. Not only would the fenland and marsh provide good grazing, *Domesday Book* also lists superior meadow-land here. So the slaughtered cattle shown on the Tapestry would have been a happy reality for the soldiers. There would also be fish and fowl aplenty in the fens, especially in the autumn.

It would appear that William timed his invasion if not initially for October then at least for harvest-time and that he also planned a war of movement, presumably because he feared the outcome of a conflict with English infantry. He also planned the point of disembarkation very carefully for his choice of Pevensey was not just the wharfage alone. The lagoon and marshes seem to have had good circumferential communications, or at least they did in later centuries, but by commanding the inner waters with his ships he could cut across the lagoon to bring supplies to Pevensey from the Hastings area, whatever the weather out at sea. Moreover, Eastbourne was a massive royal estate – a Terra Regis – just to the south-west of Pevensey and such estates were invariably located on the most valuable landscape. This one comprised 46 hides, or 11,040 acres, yet in all with arable land within this for only 28 ploughs (3,360 acres), so it could well have included a royal stud, being so light on arable and given the downland topography. We will return to this in a later chapter. If it was the case that it functioned as a stud (horse farm), then not only would William have seized numbers of remounts he would also have acquired large supplies of dry feed (cereals), for undoubtedly there were outlying farms supplying such an establishment and we can be sure that there would also be plenty of hay available in stacks at this time of year. As I have already said, the burning house may be related to such an estate. Perhaps it was the royal lodge we would expect in such a place. If so, the Norman-French commanders would not be pleased to lose it. However, it follows after the news of Harold's advance and someone may have acted hastily. Autumn, as the passage season, would offer splendid hawking from the lagoon to the downs. Another reason for a royal lodge and Terra Regis.

*Domesday Book* indicates that the Pevensey side of the lagoon fared better than the Hastings side, and Pevensey itself certainly benefitted from the invasion for the fifty-two burghers of 1066 rose to 110 burghers by 1086. It seems that William had the sense to bear most heavily on the surrounding districts and not on his temporary caput. There would be practical sense in this for the lagoon was a large extent of marshes, fens, water and eyots and it would be essential to acquire local knowledge (e.g. guides) and so deny them to any enemy approaching the area. It would also be sensible to deny provisions to an approaching army while ensuring (in necessity) that one could return to properly secured and fresh supplies. The local burghers would be the factors and carriers for all local trade and it would be foolish to interrupt such a service in any way. On the Hastings side, however,

by which opposition would enter, it would also be advisable to drive away the population and they needed no encouragement to take to the roads. After that it would be easy to detect enemy scouts or columns, but these would have little hope of sustenance. There would in fact be a buffer zone as well as a water obstacle for the English to cross or to skirt around if they tried to attack the Norman army at Pevensey.

Today the municipality of Eastbourne comprises 10,900 acres and in 1066-1086 the Terra Regis at this place was recorded as 11,040 acres. I offer no claims for this coincidence other than to observe that such things occur across all the shires of England. The handful of tenants here could indeed have included shepherds, though probably too few in number for the large flocks of the Downs, but the South Downs and Willingdon Down, with the Bourne Stream, now rising in Motcombe Park Meads, and the cliff springs of Holywell, would be ideal country for raising and breeding horses. If this is correct, and we are never likely to discover definitive proof, the seizure of a major royal stud as well as a still intact major, peninsular, fortress and harbour in a *coup-de-main* shows William to have been a brilliant strategist and well-informed by his intelligence service. They, presumably, were the ones who told him that this backdoor to England had been left wide open. How did it happen? Probably in the panic to stop the Norwegians in the north the main garrison was withdrawn. Of the few deep water ports of southern England, such as better-known London and Southampton, the strategic potential of this one was overlooked. But it did not go unnoticed.

This was Harold's blindspot and perhaps he presumed that any attack across the Channel would focus on London, for as we have seen, Dover was defended by a strong garrison and a castle. And, of course, for the invaders Beachy Head would also make a marvellous sea-mark by which to locate Pevensey lagoon and then a marvellous vantage point from which to survey the extent of the lagoon and all its approaches. It was the best look-out point available, whether looking out to land or to sea. It would be easy to see any movements on the Hastings side of the lagoon, given visibility, long before they could become a threat. As for the invading army, probably on straightened rations before they set sail (the bloodstock would always take priority), a diet of downland mutton and fat beef for several days would surely not be unwelcome. Certainly, someone told the embroiderers of a feast that took place soon after the landing for we see it celebrated in detail. It was obviously a memorable occasion. Nor would they be lacking for fish on Fridays.

As the army column next sets out from Hastings (Pevensey) on the Tapestry there are wyverns and the birds of ill-omen cover their heads. Marginal dogs bark in excitement and winged lions of noble destiny (fate) sit over the trees. Has news of Stamford Bridge arrived? The well provisioned building with the sturdy door may be Pevensey, a secure fall-back position. The gonfanonier, or flag bearer, shown instructing a servant holding a black destrier is probably Duke William himself but, once again, why should he carry his own colour when, later

and elsewhere he has other weapons and concerns? Commanders do not lead divisions, they lead armies, so they have subordinates to carry divisional colours. Maybe he is presenting it to someone. Neither is this the gonfanon shown at the embarkation, though sometimes attributed to him. Not every gonfanonier can be the duke. The figure in question does, however, have mail chauses, a rare feature shown on William in particular, though not exclusively, and this figure also has strange tabs at the back of his helmet. These have been called 'rank tabs',[13] but we do not see them later. William Wace[14] said that this black mount was an Andalusian stallion that had been presented to William. Maybe he ordered it to be taken back to Pevensey for safety or maybe he lent it to Odo for the battle.

Now ghostly vignettes appear in the margin. A man armed with a housecarl's axe appears to hold and present a bag or purse while a naked man, with an English moustache, advances on a naked woman. It would be easy to dismiss these as Norman atrocities, designed to bring the English to battle or even English debaucheries that might delay their return. Are they rumours of an English victory at Stamford Bridge, or are they the thoughts of soldiers dreaming of a time after the battle is won, the rewards of victory? There are now pacing lions

William directs his dispositions for battle

and birds. An ass who is grazing is stalked by a pard – the fable of the ass and the wolf perhaps. If he is not careful the predator may himself be lured into danger, kicked as the wolf was. Ambush is a real possibility. Then there are undoubted wolves, perhaps representing ambuscades set for stragglers from the Norman column. The countryside at large is surely against them even though it does not or cannot oppose them. Be on the *qui vive* for the enemy, stragglers beware. Dove and hare flee before the column. Could these be fleet messengers taking warning to Harold or are they frightened inhabitants fleeing their homes? If doves represent burghers then the hares might represent country people.

An interpretation of these details that would fit the situation could be as follows: The Crowhurst-Hastings side of the lagoon appears to have been more heavily requisitioned, plundered, than the Pevensey side, judging by the recorded poor recovery noted in *Domesday Book* by 1086. By the time that William's army moved off from Pevensey, in response to Harold's advance to Battle, this area could have been quite depopulated (timid creatures fleeing). Yet an advancing army has to be sure of its safety as the vignettes also testify. Supposing Harold had sent forces by sea to Hastings, or overland from the north, to work round behind the invaders as they advanced on Battle, taking them in the rear? They knew the country better than the invaders did. William's troops had had time to scout the district but they did not know beyond it. The English did. Today the first thing an invading general would want to see would be comprehensive maps, but nothing of the sort existed in 1066 and even quislings might not have an extended and extensive knowledge of the shire. It would be prudent, therefore, for Duke William to have divided his advancing forces in order to ensure that the area south and east of Battle was fully pacified and empty once he knew of Harold's general position. An advance to the coast in the area of modern Hastings by a flying column would further reassure him that no seaborne rear-attack was imminent while a sweep around the lagoon to Harebeating and Herstmonceux and Ninfield would reconnoitre the left flank. Troops, probably infantry, landed by the direct route across the lagoon, at Wartling or Hooe, could advance to Ninfield and also check Catsfield and Crowhurst. The rendezvous for all three columns would then be Telham Hill. Such an advance would offer no clues to any enemy, that is English, scouts, who would probably interpret columns as foragers. So all three columns could close on their objective and leave only a short march for them to cover on the morning of the battle. This would also explain why an advance from Hastings, the obvious route to Battle, would be recorded, for Telham Hill is on it. Another reason for the Tapestry to record an advance from Hastings is because the embroiderers were told Hastings. Remember, they had no maps, the embroiderers were not even there and the whole area was in the Hastings purlieu, the Hastings Rape, territory of the Haestingas. Whether the Norman-French force advanced from the south or from the east onto Battle, they certainly came from Hastings. It was all Hastings.

The duke himself now carries a marshal's baton as he questions another of Odo's men, Vital, about the enemy's movements[15] and screaming geese give warning. Lions and pards look on. Scouts reach what is probably Telham Hill[16] and the ass and pard fable reappears. Vigilance against ambush is clearly now all important for according to the scouts they are almost upon the enemy and they will certainly be beyond the territory they know and control. There is significance in such a hilltop. Such places were deemed magical, places for ritual and 'wyrd' – the complexity of being, even beyond destiny and fate – they were between earth and Heaven. Gryphons also reappear, guardians of souls and fierce creatures of vengeance. We see pollarded oaks, so we are in a managed landscape rather than the Wealden woods yet there is danger here as well for horses love acorns, but they are poison to them and October is the month for acorns. Is this an astute use of terrain by Harold, luring his enemy on into unknown territory and perils?

Of course, it is impossible to be certain of Duke William's approach to Battle and the conventional explanation, that he had already advanced from Pevensey to Hastings, requisitioning on the way, is possible. It would, of course, have been rash to tranship and then attempt to disembark on an open beach and if he had, then English scouts would have known of his movements all the way with serious risk (if he travelled along the beach) of ambush by enfilade from cover or from above. He certainly would not have taken Harold by surprise. Yet that is precisely what the Tapestry says he did, and we would have to ask why, if he at any point beached at, Hastings Harold did not oppose him at his most vulnerable? Harold did not oppose him at this the most vulnerable moment for any invader. The answer is that provided William was confident of the effects of his foraging, splitting his forces was not dangerous for there would no local resistance fighters left and his men would already know the terrain from their expeditions.

We should not imagine this invading army as a modern force, strung-out in an orderly column-of-route, especially as the weather was unlikely to have remained dry. Remember, adverse winds had kept William's force pinned to the Normandy coast for two months and these winds would certainly have brought rain by October. As far as we know there were no metalled roads and marching, or even trotting, especially along a wet beach, would have been exhausting even when possible. Muddy roads and tracks would also soon turn into quagmires under all those hooves and feet. How then to reach his destination with a force capable of fighting? The answer was to close the approach, as far as possible, and to certainly avoid getting bogged-down and exhausted *enroute*. William needed men and horses to be in peak condition when they arrived. Even a morning march from Hastings to Battle was to be avoided, if at all possible. William commanded an army of men, not of supermen.

Medieval roads, when we see survivors, are notoriously broad[17] for the simple reason that when they became muddy, travellers simply fanned-out to walk along parallel lines. Wherever there was a well-used road we should expect it to have included places showing parallels formed over many years and these would allow

an advance on a wider front for the infantry. For the cavalry there is no reason why they should follow a road at all for unless the countryside was covered with hedges and ditches the shortest distance would be a straight line over broken ground. The worst going would be fresh ploughland. Avoiding major roads would probably help to avoid major morasses. Keeping the cavalry off the tracks would help preserve the road-surface for the infantry and the baggage-train. This last was the real problem, the essential food, water, provender, munitions and field-repair units. The most likely form of transport would be pack-mules or ponies and apart from the very large number of such beasts required, they would also soon ruin the road surface for marching infantry. Yet baggage-trains require escorts, so there would certainly be an advance-guard of infantry. The cavalry is more likely to have screened either flank. Under such conditions it would make sense to advance in several columns and as the bloodstock could not be transhipped, to send them on the longer route around the west side of the lagoon and so to Ashburnham and Ninfield. It would also make sense to get as close as possible to the objective, and by stealth, throwing-out light-horse scouts on the requisitioned English mounts.

William knew that he must meet English infantry, superior infantry, so he needed to keep his heavy cavalry mobile but to avoid over-tiring them or diluting their high-energy diet with grazing. If any English forces were met on the way, it would be essential to have the archers in advance yet well-supported by supplies of projectiles, then the cavalry could deal with them from the flanks. If, as we suppose, William had captured a royal stud farm at Beachy Head, then he would have been able to send grooms and squires out as light-horse scouts and gallopers, holding the bloodstock in reserve. As we might think, rather like armoured cars and tanks. Light-horse could guide local commanders while looking out for enemy ambuscades. Besides, an advance through Battle was not the only or the obvious route to London. The Weald was a dangerous environment for any invader and it was in the way when following the Battle route. So we must presume that it was news of Harold's position and the English rendezvous that decided Duke William to advance in that direction, in order to seek a decisive battle before English reinforcements gathered in overwhelming strength, rather than marching towards London by the more direct northerly route. William had been playing a waiting and preparing game and now that his enemy had arrived he was ready for a swift and decisive strike. His resources were limited, his force was small and morale could only deteriorate if he hesitated or appeared to fear engagement.

Sighting even light-horse scouts would have confirmed Harold to prepare a defensive position at Battle. Yet such a screen, being only light-horse and not the Norman foot soldiers he was expecting, would not necessarily suggest an imminent attack by his enemy. Possession of the local terrain to the south of Battle would have allowed William to manoeuvre with reasonable impunity, as the Tapestry appears to tell us, making use of the screen provided by partly

wooded country, while Harold knew that he must not be caught out in the open with but a single opposing, infantry army. Holding William, who he would have known needed to fight a decisive battle, at Hastings would allow time for more English troops to arrive, possibly even a second army if one could be raised. If Harold could lure William to Battle and away from Pevensey, then he might even cut him off from his temporary base and harbour. From William's viewpoint, if he failed in this coming battle he would need to extricate himself and his fellow stock-holders, so a swift ride back to the lagoon and his fleet, maybe to take refuge at Pevensey Castle, would be the obvious course of action. Pevensey, the Roman fort Anderida, was impregnable on its peninsular and with its walls it could easily be provisioned (or evacuated) by sea, thanks to its harbour. Harold would have needed a siege army and a naval force to have any hope of dislodging him. Behind William, therefore, lay his safe zone in an otherwise hostile country. But it would probably only be a forlorn personal hope – if the English did not kill him, his fellow stockholders would. A speedy victory was his only real hope of victory or survival. He had prepared carefully, risked everything, calculated, planned, manoeuvred and made a clever tactical choice of arms. Now was the moment of truth.

# Chapter Three

We should now imagine Harold advanced to the edge of the Wealden Woods, having ordered convergence on the Hoar Apple Tree landmark, itself well placed to command a view to the south and to the east. He is on the outer edge of the depopulated and ravaged zone and refugees will have reported what he would have known anyway, that the enemy had cavalry in force. His own light-horse would not be keen to clash with them and he was, anyway, preparing for an infantry battle and hoping for delay in order to muster even more forces in response to his despatches. William's Norman-French, on the other hand, would not be keen to advance beyond the territory they had come to dominate, wary of ambushes. Probably only the light-horse would be committed to scouting and surveillance and they would be careful not to close their distance further for fear of capture by the English. It is unlikely that they would have advanced to a position where they could see and report the exact nature of the hilly terrain before the Hoar Apple Tree. William would be aware of the English camp and probably of their vedettes, but also generally only appraised of the nature of the terrain that his troops had already scoured. So he could now advance by divisions to a rendezvous with considerable confidence while using his light-horse as a screen. His heavy-horse, his secret weapon, were almost certainly held in reserve. Locals would not know the difference. So their eventual (unreported) appearance would have had an effect on English morale. It would be surprising if William had not thought of this.

The following account of the battle in 1066 differs considerably from the excellent description of the same battle given by Colonel Lemmon in 1957,[1] for he based his assessment on an English emplacement on Battle Hill. He also attempted to synthesise and at times conflate all the existing early accounts, hoping, I suppose, to create a composite picture. Some parts of these several early accounts are now suspect and some always did rather appear to conflict than to confirm. He then tried to relate his conflations to the scenes on the Tapestry. It is rather like matching the victor's press reports and histories to his cinema presentation. Nevertheless, so balanced and measured was his analysis that it has formed the basis of nearly all subsequent accounts and his technical

appreciations, such as the three hours required in order to deploy from column of route to field formations, the implausibility of hastily constructed English field-works and barricades[2] and the impossibility (especially at this time) of recalling and redeploying committed troops can hardly be contested. My own analysis is based on an acceptance that William's forces did not necessarily or exclusively approach from Hastings itself, and that indeed they may have been *en route* longer than previously supposed when coming from Pevensey, and that the battle itself was fought on the slopes of Caldbec Hill, close to the Hoar Apple Tree rendezvous, as suggested by Bradbury[3] and more recently by Grehan and Mace.[4] I would marshal the English lines just a little further forward, at least initially, than they did in order to contain the majority of frontal attacks within the boggy grounds, on either side of the apparent causeway, or saddle between Battle Hill and Caldbec Hill, and their streams. This is for the simple reason that is apart from increasing an attacker's impeder, any volume of traffic over such ground would soon poach it into a marsh, even without cavalry, while the defenders could acquire advantage by then retreating upslope when the carnage became too dense, leaving a barrier of dead and dying for fresh attackers to climb over after they had struggled through the mire. I see the site as cleverly chosen to make best use of natural features, which in 1066 included the crossing of two sets of boggy terrain by the cavalry divisions, first those before Battle Hill and then those before Caldbec Hill, which would make the ground almost impassable to the following infantry after any attack and retirement, as well as destroying the essential water supply required by such cavalry. I also agree with Colonel Lemmon that if a determined resistance was made late in the day at the malfosse obstacle, then this position was not a fortuitous one but had been prepared much earlier as a fall-back, while Grehan and Mace have emphasised the advantages of proximity to the Wealden Woods beyond, masking movements by the English and offering further impedance to their enemies if it was ever required. Given such a template I believe the Tapestry's account now makes even greater sense than before and that my re-evaluation enables the artefact to speak coherently and intelligibly. I certainly do not agree with those who have said that Caldbec Hill was more vulnerable to encirclement than Battle Hill. Quite the reverse. Let us return to the Tapestry.

On the other side of Telham Hill, possibly on Battle Hill itself, forward of the English lines on Caldbec Hill, a startled pard looks round in the margin as an English scout on the schema espies the Normans and makes his report to a mounted Harold. It seems that in spite of their geese (lookouts), the English have been surprised. William has moved faster than Harold had expected and perhaps by a different route. Not from Hastings in the south, where estates had been most plundered, but partly perhaps from the south-west. Excited birds cry-out and pards gambol in the margin. Next, we see William on a chestnut, with two gonfanoniers beside him, exhorting his troops probably on Telham Hill. He tells them that destiny and fame await them if the cavalry are swift and bold (for we

The enemy are coming: Harold's vedette

see winged horses), but down below in the lower margin are wyverns weaving falsehoods, spitting bile. Clearly there are also whisperers against his authority and doubters. By now this invading army will have heard rumours of the fate of the other invaders at Stamford Bridge. But there is no going back. This will be no walkover. Or do we perhaps also have a direct allusion to Pegasus here? Is William over-reaching himself, seeking a personal Olympus? Has this nominal vassal of the King of France now determined on his own kingship? Is it a *double-entendre*? There is no reason why not. We see a pard who regards his or her cubs safely bestowed in a cave, a reassuring and homely reminder that warriors have families to weigh upon their minds when they risk themselves, far from home. Will the warrior ever see them again? Hawks dispute, other hawks or eagles rouse themselves and pards converse, for soldiers will anticipate and debate until they have been committed to action. Authority and destiny cut this short and order the attack. The horsemen raise their spears to take formation. And a pair of remounts are shown in the margin tethered together and waiting. We can say that they will soon be needed, but they probably also allude to the mutual dependence of

companions in battle. There are gryphons shown here, as courage now rises to the inevitability of action. It is too late for regrets and men steel themselves to their purpose. No turning back. Fail and there is no escape.

A tiger – there can be no doubt about it for it is, quite unusually, striped and not plain or spotted like the pards – carries-off a goose. Apparently a fast and fierce rider has taken out an enemy scout or watchman. Maybe he has also scouted the English lines and delivered a detailed report to William or perhaps he silenced an English vedette and so aided William's surprise appearance here. Once again, this tiger should not be here for its physical description is not in any bestiary. It was not copied from any document we know of. My only conclusion is that someone had seen another source or even heard of such things, another hint at the eastern Mediterranean.

Now a fox carries off a hen. To the victor the spoils. That is why they are all here. Surely the margins are telling us that William has moved swiftly to confront Harold, catching him before the rest of the English army can join him, arriving before he was expected and without warning. Birds now clamour, as birds always do when they sight a fox or other predator, so we know that the English battle line has now seen the advancing enemy, and this is the sound-track. The Norman-French army, probably now on Battle Hill, has also seen the English position. A wolf confronts a goat and here we once again have the Aesopian fable. 'Come down to this lush pasture, Miss (English) Goat, for a good meal.' 'Oh no, Mr (Norman) Wolf, for if I do *you* will be the one to enjoy a good feed, I will stay on my hill.' It has its parallel with Waterloo. 'What keeps this Englishman pinned to his hillside, how can I lure him down?' What about, 'the mud's the same for everyone' – but it isn't. The fable is telling us that William is marshalling his lines and his soldiers can see the problem. The only approach is along the saddle occupied by the road from Battle Hill to Caldbec Hill. They need to lure the English out from behind their shield wall here. Though not consistently, the Norman-French chroniclers tell us of attempts made to lure the English from their defensive position. Tactics that would have been quite unnecessary if the English had been easily accessible, vulnerable to attack by the heavy horse, if they had been on the gentler slopes of Battle Hill and firm going.

Did Harold have reinforcements marching to help him? Who knows? Perhaps he did but they did not arrive in time. In the event he had no Blücher. Nevertheless, he has chosen his ground well, opting for a defensive battle in a place where the Norman cavalry can be disadvantaged. Not a place Duke William would have wished for, not with this rough ground, hill and mud. Like many good generals, perhaps Harold has seen and selected it before now, just in case it was ever required, and so 'stolen the march' himself by selecting his ground. These lands, after all, were Harold's fiefdom. The parallel with Wellington is remarkable. The probable wetness of the ground also tells us that Caldbec Hill would be the best position. All commanders need to consider a possible fall-back and had Harold's army been on Battle Hill, the site of the later abbey, then to retire would have

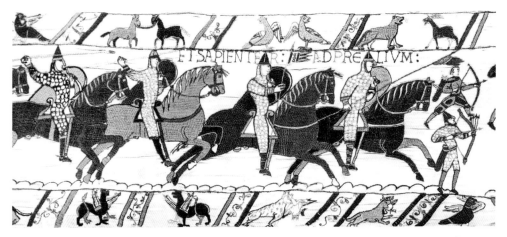

The attack commences: tiger and fox and 'come down to this lush pasture …' – NO!

meant funnelling his own troops onto the saddle between these two hills and their boggy flanks, giving the Norman-French an ideal killing zone for their cavalry. Instead by using Caldbec Hill it was the Norman-French who were forced onto a narrow place or instead directly cross almost impassable mud. Nevertheless, it must have been a severe shock to see the numbers of heavy-horse William had been able to transport to this spot. No, he will not come down. All Harold has to do is to hold his ground and wait for nightfall. By now William must have realised that his cavalry force had been rendered generally ineffective or, if not now he will soon come to that conclusion. Harold undoubtedly wanted William to commit and squander his heavy-horse against a naturally defensible position and William must have known that his only hope was to keep them intact against the critical moment. But when and how would that come?

Now the action quickens, battle is finally joined, riders lift their spears from the trail position (though one couches) to overhead, ready to stab down at the shield-wall. They are charging uphill. This must be the initial stage in the battle, an attempt to turn the English right flank, a fairly standard opening movement against an enemy's flank right down the centuries and a test of their defensive strength. I suspect the Norman-French cavalry formed up on Battle Hill itself and galloped down the slope beyond in order to gain momentum for the ascent of Caldbec Hill. But did they know about the intervening boggy ground? Had they seen it when it was so close to their enemy's lines? I doubt it. They may have run straight into it. Can this frontal assault succeed? All is confusion as hawks scream flap and die, vultures look down and with them winged lions of destiny, gryphons 'watch the souls of the dead arise'. A cowardly lion and cowardly pards bite their tails. Corpses are dismembered. The emotional picture is provided by the beasts along with a sort of anthropomorphised sound-track. Maybe this was the action described by Wace, for he sets his incident early in the day. However, this is not the Malfosse. The attack on the wing fails but Harold's

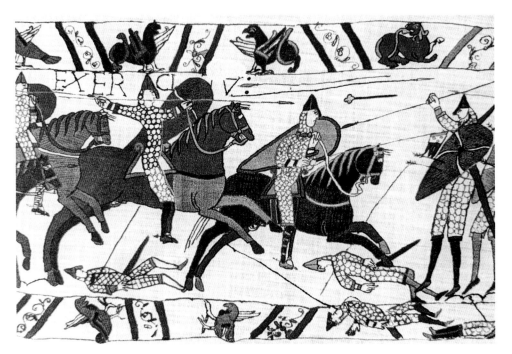

One rider crouches as they attack, anthropomorphised birds tumble, and lions of destiny see a coward as the lower margin changes to bodies

brothers Leofwyn and Gyrth fall as their English axe-men attend to the grim slaughtering of Normans. No wonder fear reigns. Birds are bewildered, and vultures stoop and we reach a critical point in the Norman-French assault. Now the saddle is blocked by the resulting shambles. It becomes impassable to cavalry. From here on in the day is mainly an infantry battle and so it becomes a long day, one for the Norman-French infantry without acknowledgement on the Tapestry. The cavalry is of no use fighting uphill and through the marshy terrain that lies on either side of a restricted approach, even without the dead and dying, and they need to be conserved for a decisive moment, once the English line has been broken. It would be foolish to squander them on other forlorn attacks and they would also be increasingly hindered by this growing wall of dead and dying.

The attacking infantry will also be hindered by horses in their death throes. No one was clearing away the debris. This was not a battle of toys. All the English have to do is hold their hilltop and fight a battle of attrition. Things look bad for the Normans and the Tapestry glosses over the long intervening daylight hours of desultory attack and repulse until finally a desperate attempt is made on the English left wing where the ground looks more favourable and where the equally desperate horses can find some cleaner water (we will come to this). Over the din of battle Bishop Odo, in his distinctive lamellar armour and carrying a marshal's baton, drives-on the young men, applauded by fierce lions (note the manes). But as

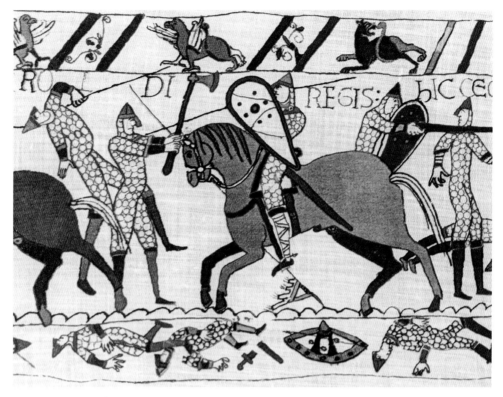

The grim work of slaughter

Duke William lifts his helmet to show his face the accompanying metaphor is not a brave lion but fear. This is a famous and oft-repeated image always described as Duke William showing his face to prove that he has not fallen in battle, a 'follow me men' image. But the margin is telling us something very different from this gloss. Is the conventional explanation no more than a factoid?

What is happening here? Why fear, cowardice, shame? These look like pards in the margin. Are some of the cavalry trying to desert? This is not the place for such a comment, even if it refers to those young men who fight around William. Closest to him are Odo and Eustace of Boulogne. Instead of 'follow me' is it William calling for aid? Did he in desperation, staring disaster in the face, call out promises as a would-be king rather than as a mere duke? Was he terrified of defeat when his cavalry encountered even more boggy ground on their right (the English left)? Was it an apparent suicide attack that finally became a tactical coup by error? Only Odo, or the man who commissioned this Tapestry, could know what the allusion meant and he must have been close to the duke. But look, the immediately following Latin superscript is blank. This requires explanation. Let us pause to examine it.

Possibly the entire Latin superscript was added after the Tapestry had been completed. So why a blank at such an important point and why is this the only later place on the Tapestry where the superscript enters the upper margin? Was some

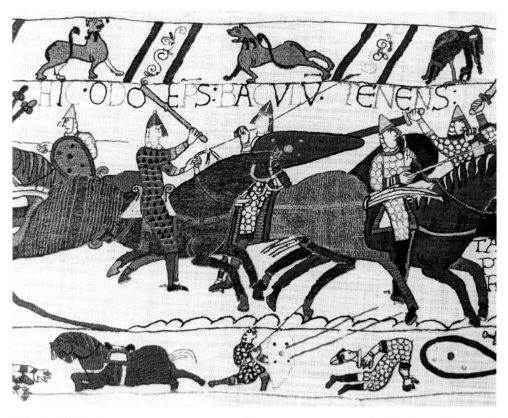

Odo, in distinctive armour, encourages milites to go eastwards (under brave lions and carrion birds)

individual superscript added even later than the rest in order to cover a gap caused by an erasure of something else? Stothard, so meticulous to represent stitch-holes when the threads had perished, even he (in 1818) recorded a physically *missing* blank, but he also went on to decipher a missing name. Whatever was here was actually erased, removed, possibly in antiquity, while the rest remained intact. It was cut-out so that not even most of the lettering remains. For Stothard this was a challenge. Part of an important name, 'E(usta)tius' or 'E(ustat)ius', Stothard thought, was apparently taken away and so we might add was anything else possibly shown here. Anything pictorial that intruded into, or which originally took the place of the name? The only other damage to the Tapestry (apart from the missing tail-piece) was the tip of a sword. The rest was intact in 1818. It does look suspicious, situated as it is over William at just this point, and as emphasis a second, and following, pard is also biting its tail. That the gonfanonier figure was correctly identified by Stothard as Eustace of Boulogne I think there can be no doubt. His whiskers betray him just as they did at Pevensey. His picture and the peculiarities of this section require further consideration that they will shortly receive. But for the moment let us press on with the immediate action of the battle. Let us take stock.

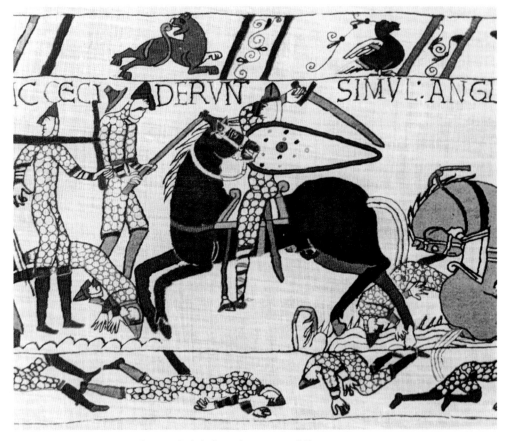

IC CECIV ADERVNT SIMVL: ANGI

The cavalry encounter the English left and its water-lillies

We have now seen dramatic scenes of carnage with horses crashing down in somersaults as they pass over and into even more boggy ground, maybe running into improvised caltrops or submerged lily-traps, as the Tapestry suggests. Perhaps the origin of William Wace's report of a 'foss' and of great loss by the cavalry, a conflation by him of the two main cavalry actions during the day, or even the account given by Henry of Huntingdon. Look at the Tapestry carefully. This can only be the eastern foot of the Caldbec Hill. The English left wing. A late-in-the-day attempt by William on this wing. Perhaps where the English forces appear to be more lightly armoured, attempted but similarly thrown back onto prepared traps in the boggy ground below. So the English left was not as weak as is so often assumed.

We can say that after an initial cavalry attack earlier in the day, which was a standard manoeuvre or testing feint at the right wing, William obviously held his bloodstock back for most of the day, for without them he would be lost. They are his tactical strength and his trademark. His infantry has maintained the attacks through the long day, though failing to lure the English down. For a prudent

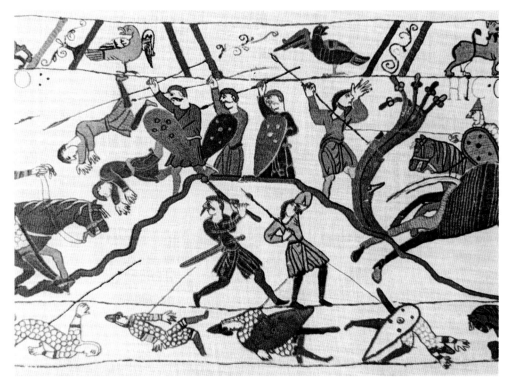

Unable to manoeuvre, it is a forlorn hope and they skirt the steep spur on the English left

general reserves his cavalry for the final push and the essential follow-through. The pursuit and massacre, lest night should fall leaving any formation of an enemy to exploit the cover of darkness, is essential to both victory and safety. Pursuit and slaughter of an enemy was always essential. Now, however, a decisive attack is required before night falls as day was failing fast. It was now or never and perhaps William thought there was more room to manoeuvre or that the opposing troops were less professional. But he finds this flank steeper and more dangerous than it at first appeared and maybe the Norman cavalry hadn't seen the traps in the boggy stream-margins.

I think that the English line was probably a little more advanced and turned just a little more to the south than Grehan and Mace[5] have shown in their study, that is with their left flank more advanced and on the 250-foot contour line. This would deny an enemy any real space in which to deploy on the steep slope before it, over the boggy ground, for in front of the English lines there was apparently very boggy ground. Bad for infantry, deadly for cavalry to cross, quickly degenerating into a morasse once traversed by horses. Harold cannot have been unaware of the Norman cavalry contingent or their skill, even if he had been surprised by their numbers, and would have planned his ground accordingly. Such a disposition would then give us Florence of Worcester's narrow place (the saddle or track) as

the only real approach away on the English right and right of centre. A narrow, head-on assault was the only advance possible over this easy ground with streams and boggy areas on either side, even extending beyond the English right. So the cream of the English troops would be on the right centre of their line forming an immoveable shield wall. This meant that the main force of Normans, French and Bretons *et al* in their line of battle would first have had to cross both the boggy valley in front of Battle Hill (gruelling in itself) and then the boggy ground beyond it in order to attack anywhere else on the English front, and all these wet places would quickly have become heavily polluted and poached, leaving the thirsty bloodstock to drink where they could and so ingest much filth at the same time. This habitat would also be ideal for water crowfoot which, though not fatal, as a member of the buttercup family is poisonous to horses. Horsemen would be aware of such dangers but hardly attentive in action, so there would be no fresh water available and what there was would be highly unsuitable. Men and horses would by now, late in the day, exhausted, floundering, dehydrated and fearful, be mad with thirst and the slopes in front of the English right and centre would be choked with a wall of the dead and dying, including kicking horses. So it was now quite impassable to cavalry. And, of course, the English were able to leave the wall of dead and retire upslope to the 300-foot contour line if they wished, leaving yet another obstacle for their enemies to negotiate and one that was a potent psychological weapon.

Bloodstock, being on dry feed would, by the afternoon, be desperate for water, large quantities of it, several gallons for each mount,[6] searching for cleaner

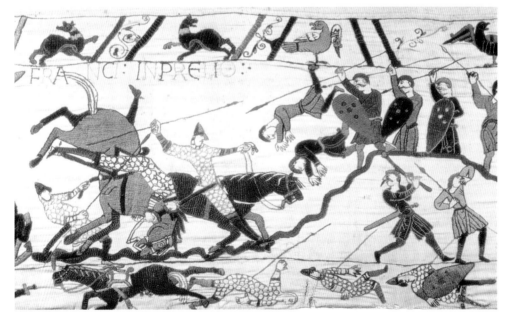

Desperate attack on the English left

sources. The Tapestry is telling us as much. So they entered the Caldbec's marshy streams on the English left, which feed the River Brede, and there the English, possibly men of the Great Fyrd judging by their light armour, assaulted them as they tried to left-face in this narrow front from column to face their enemy in line of battle on the only frontage still open to cavalry, the ground vacated by the English strategic withdrawal up the slope. It has to be a head-on assault. These fyrdmen feel safe with their left flank (possibly refused) on the slopes above and over such boggy ground. They drive the horses downhill onto the marsh where the Tapestry shows a submerged *cheval-de-fris* (water-lillies). Yet of all the aspects of Caldbec Hill, the eastern is really the least formidable, because it is not so steep in every direction. On the hill, in a tree, a cocky English defender appears to thumb his nose at the Norman horse, one of whom stabs at him, as they now ride past, apparently trying to escape from the battle and the deadly obstacles in the boggy ground by riding eastwards. But down in this boggy valley, while they have found determined resistance above them and heavy going below (with traps) the Normans have, accidentally, by going to the east, also found the weak link they need. For if they follow the confluence of streams eastwards onto firmer ground, probably to find running waters in quantity for their mounts, they then clear the defenders' left altogether. Was William himself debating flight to Bathurst and thence southwards, leaving his infantry to their fate? We will never know.

They looked back from here, I suggest as they watered, looked diagonally at the distant English flank and simultaneously recognised an open traverse behind the English left. Now, refreshed and encouraged, the Norman cavalry is sent on a wide, encircling movement of the English left flank (the Tapestry shows this change of manoeuvre as riding onto firmer ground), using the long traverse of these distant and undefended slopes and partly masked by the spur. Soon the English realise their peril and attempt to draw back their left flank and lines in order to receive them in some sort of formation. Instead there is probably confusion, for these are not professional warriors. It seems that the most heavily armed English defenders – the Select Fyrd – are on the steep west and central slopes of the hill (the English right and centre) where the infantry action has been for the greater part of the day. This they must hold and cannot vacate. The whole English battle formation has to fall-back and straighten the defending line, for the boggy valley on their left flank, once so helpful, now prevents them from making any flank or descending attack on the extended Norman-French cavalry line, now passing before them eastwards. William can even withdraw all his heavy-horse from the centre to join the attack in the east. The English realise they will soon be attacked from the east and in their rear. All they can do is to fall-back and consolidate, make a shield-wall. It is of no use, however, for the van of the Norman-French cavalry are now actually on the spur, closing the distance and heading to cut the London road. On the outer edge of the Andredes weald the Normans have finally discovered better horse-terrain to take them behind and so

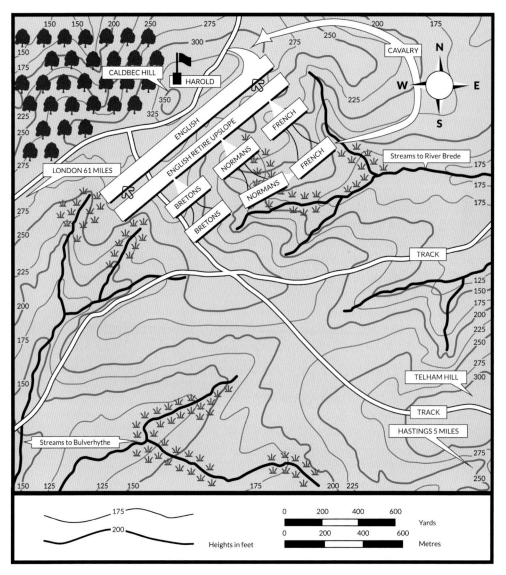

Tactical plan of the battle

turn the weak English left flank and they drive on with new heart. We might even suggest that they adopted formation.

Over to the west and centre on the Norman left flank, the action changes, for a diversionary action is now required by the French and Normans in order to give their cavalry cover and time to form-up. It was excellently well-conceived. Evening is approaching and the English have, up to now, been confident of their hold on these hill slopes so, with the advantage of height and therefore range, they have poured their archery over the barrier of bodies of men and mounts before them and onto the opposing Breton-Norman infantry until they run low

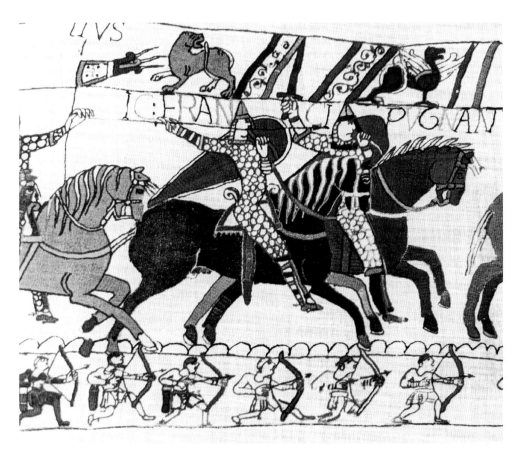

Milites circle round the English left as archers start their barrage

on projectiles. But their enemy did not continue to return fire. It is noteworthy that Norman/French archers have not been shown *en masse* until now. Of course they participated before, but this is the critical infantry manoeuvre of the day, so now we see them emphasised. Perhaps their enemy are dispirited by their losses, holding back out of range, think the confident English. No, for forwards come the Norman archers to pick up the arrows from both sides that the English have abandoned in their withdrawal up the slopes, for each side must have discharged several tons of arrows during the day and could not have continued unless recovering drop-shots from one-another.[7] No crossbowmen are shown on the Tapestry. The embroiderers were English and so knew them not. But we know from elsewhere[8] that the Normans had them as well as archers. With the English fire becoming desultory the Norman crossbowmen, who must have reserved their fire during the day in order to conserve their special and non-returnable ammunition, advanced to short range to fire uphill, almost flat trajectory, with impunity, probably advancing through the wall of dead as the English retired upslope in response to the cavalry threat on their left. Meanwhile, Norman archers dropped parabolic fire by shooting over their own front-line. All the archers

shown on the Tapestry are firing in parabolic mode and from the chest. In spite of longbow claims, I cannot find one man drawing to the ear and the length of the bows is no sure indicator of type.[9] The Tapestry now shows massive reserves of arrows in ground quivers, so the Normans have gathered and garnered their resources ready for just this moment. And firing high into the air these projectiles would drop almost vertically, and the result was murderous. While the English attempt to use their shields both in front and, simultaneously, overhead (which only packs them tighter together as a target), and also to inwardly withdraw and somehow defend their beleaguered left flank, the encircling cavalry of their enemy are goading freshly watered bloodstock over a more helpful slope in order to make a decisive charge, by now in formation, on the English rear left flank. The combined weight of each man and horse, perhaps almost 1,000 of them *en bloc* with a collective weight of well over 600 tons, will become an irresistible force thundering into the too tightly packed English army. As this left wing was probably not composed of professional soldiers, but the General Fyrd, they would

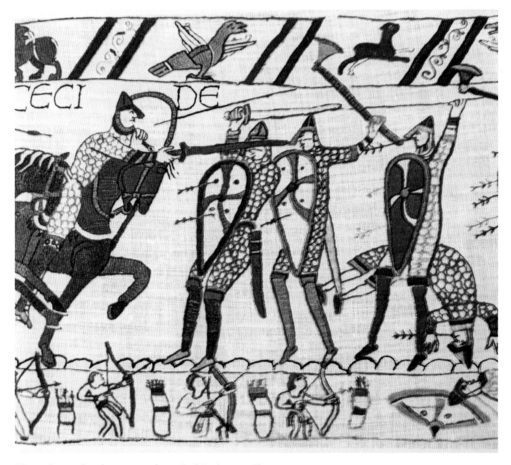

Then they take the centre from behind as well

80

have had no hope of resisting such a whirlwind. Neither would the whirlwind have been able to stop its mad career.

Gryphons now return to hover over the French cavalry: strength, salvation, guardians of souls. This is the key manoeuvre. They crash into the English flank from the rear of their left wing and probably also roll over the centre. Birds scream, the timid hind flees and, in a touch of realism that speaks of cavalry now descending a slope or leaping an obstacle, a stumbling horse throws its over-enthusiastic rider over the pommel, clear of his stirrups, but he retains his seat astride his horse's neck and strikes-down the axe-man standing before him. It is all desperate stuff.

Horses now appear to take breath in the margin, or are they weary companions-in-arms? The cavalry have rolled up the English line from their left rear, partly cutting off any retreat into the Wealden woods. Now we see the dead being stripped in the margin, not something that happens in the middle of a battle.

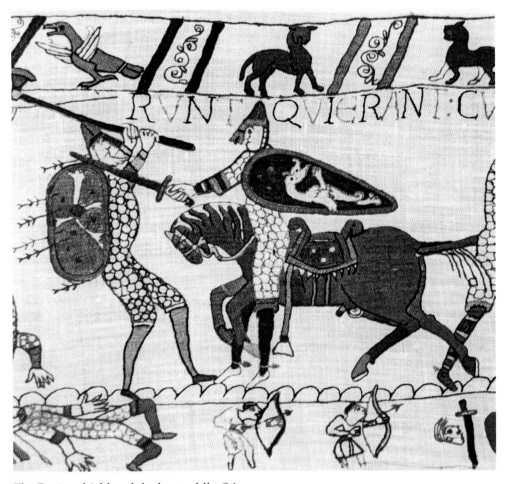

The Dacian shield and the lost saddle. Stirrups

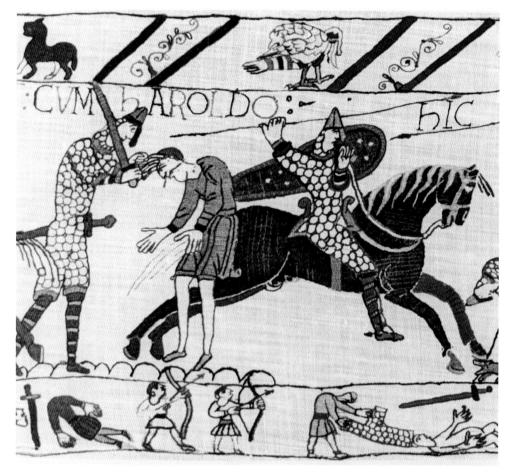

Massacre of the English left wing

Still Harold fights on as his right and centre, in turn, disintegrate on Caldbec Hill. Are we being told that he refused to flee, covering his departing troops by standing his ground though now attacked from front and rear? In fact there is no avenue of escape for the flower of the English army now trapped between the hammer and the anvil. The only avenue of escape from the cavalry is a narrow woodland aspect to the north. Did Harold hold his ground with his select troops and thegns in order to cover the mass of fugitives? A compelling argument has been advanced that Eustace and William, with two others, personally butchered Harold in a ruthless determination to prevent any recrudescence of English resistance.[10] The cavalry attack clearly did not completely destroy the English army. There were fugitives, and the invaders could not afford to fail, whether today, tomorrow, or in a month's time. So they made sure of the leaders.

A drooping and screaming caladrius turns away from him as Harold meets his death, for he is doomed. Though the colours are wrong, one might also invoke the story of the 'sick kite', a false-follower abandoned by the gods. As lions and hawks

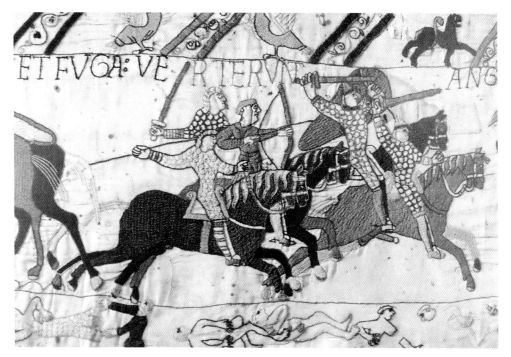

Hot trod and *sauve-qui-peut* as night falls

look on, the battle becomes a rout. English figures run for the woods (these seem to be heavy restorations) and a naked man hides in the undergrowth. And there it ends. No Malfosse incident is shown though chroniclers tell us that in the now descending darkness disaster met the cavalry who were following-through,[11] in a bid to utterly destroy the remaining English troops and hierarchy. In their impetuosity they crashed into a hidden, overgrown fold in the ground, a trench or small valley. Was Harold struck in the eye with an arrow? In 1818, Stothard showed the stitches as a line *above* the eye, to the rim of the helmet, the bend into the eye came later.[12]

No one is sure which figure is Harold for the adjacent warrior on the Tapestry is being cut-down by a horseman. Bridgeford has advanced the opinion that the mounted man is intended as Eustace of Boulogne.[13] Basing his argument on the *Carmen* and on certain marginalia, he names William, Hugh, Robert and Eustace as the butchers who killed, emasculated and mutilated Harold and I see no reason to disagree. Harold's elimination was essential, as was the massacre of survivors. In these battles, the defeated side was always eliminated, if possible. It is as well to recall the fate of the defeated Norwegians at the hands of Harold's English army after Stamford Bridge. There was also the heat of the moment, the possible attempt by Harold to cover the retreat of part of the English force and the panic that must have seized all Norman ranks as the day waned and the English remained ensconced on their hill, for failure to win the day conclusively would not only mean a night attack on the Norman survivors, it would probably bring a day filled with English reinforcements. The Normans, Bretons, French and Flemings

83

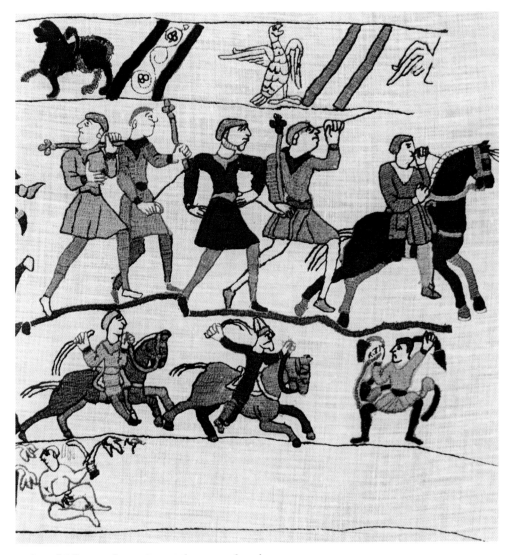

Riding, hiding and running at the ragged end

were an invading army of adventurers, just like Vikings, and could expect no mercy if they failed in their endeavours. Historical and social propaganda has obscured the tawdriness of their expedition, their 'enterprise of England'. Had the battle gone the other way Norman survivors would have been hunted down like rats and their relief now must have made them crazy.

Which is not to say that the man holding the arrow is not Harold, 'holding' because by plucking it out (as the Tapestry original showed) he created the false legend in the form of something that might (or might not) have happened, something allegorical and typological, a religious prophecy or event. Remember King Edward's deathbed scene. He is dead. This is what happened before

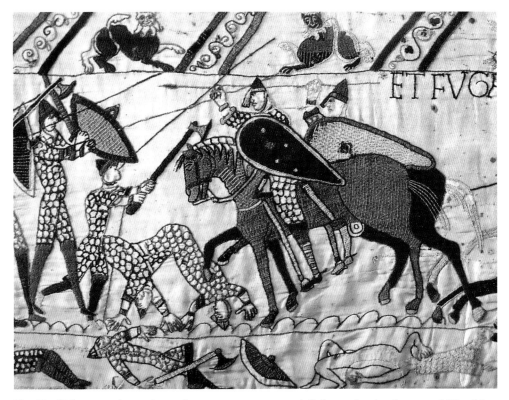

The English centre (experienced or mercenary troops) fight to the death around Harold

he died? I think that if there is an English message anywhere it is here, though it also was to provide both justification for conquest and the eye-myth. In brief, King Ahab of Israel was slain by a random arrow. God permitted it to happen at Ramoth-gilead.[14] His sin was to be enticed by 'a lying spirit in the mouth of all his prophets' (*viz* advisors) and so 'a certain man drew his bow at a venture and smote the King between the joints of the harness…. and about the time of the going down of the sun he died' (Chronicles 18: 19-21; 33-34). The Vulgate Bible, the one then in use, says '*inter cervicem et scapulas*' – the arrow struck him between neck and shoulders – the clavicle, just above the neck of the mail coat – '*et mortuus est occidente sole*' – and he died at the westering of the sun, cut down as we have already seen. The coincidence is too remarkable. The sun was setting. He withdrew the arrow and the loss of blood consequent upon its withdrawal might have decided him to hold his ground and cover his fleeing forces, knowing he was doomed anyway. And if he remained then his loyal thegns would have to die with and defending him or be forever deemed renegade, false and cowards. What is more, we have here an essence of magic, what is called a 'liminal moment', a division between day and night in which remarkable things can happen. In 1066, people believed in such things and that the crests or ridges of high ground were a space that hung, liminally, between Heaven and earth.

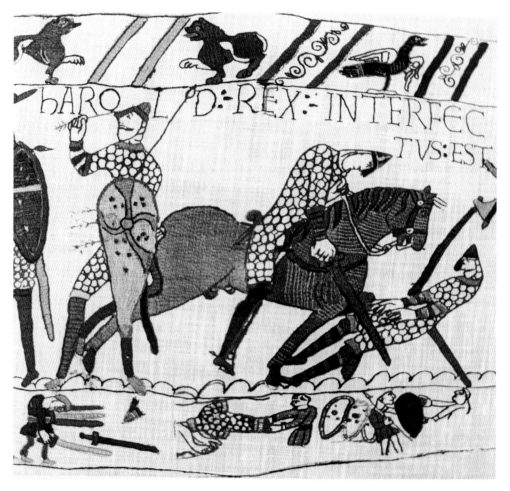

The liminal moment

Knowing that the battle was actually fought at Caldbec Hill and not on Battle Hill has helped us with the tactical appreciation and this, in turn, with the evidence of the Tapestry leads us to a suspicion. Clearly this exceptionally lengthy battle was mainly fought by infantry, the cavalry failing in their opening movement and then being reserved for some opportune moment at the end of the day. For the invaders this would have been an unbearably long and anxious day, for most of them had nowhere to run to if they failed and the exceptional length of the battle and the defensive position that denied them the use of their cavalry strike-force must have made them desperate and panicky as dusk drew in. The circumspect reservation of the cavalry (or was it cynical conservation of an effective strategic withdrawal force, if required, one able to make its way back to Pevensey and to the ships, leaving the infantry to their fate?) also gave the eventual glory of the day to the nobles and knights. So infantry (other than archers, who were a stroke of noble genius) are little evidenced on the Tapestry. William also appears to have

86

been largely written out of the story, and it is Odo, we are told, who rallies the cavalry, or who directs them at the critical moment, even using his baton to turn back one who is retiring, as if the younger knights were then either about to turn tail or to waste themselves in pointless frontal assaults from the boggy valley. The suspicion, therefore, is that Odo was claiming the tactical inspiration as his own and maybe also the leadership in this part of the Tapestry.

The suspicion we now have is that others were claiming the success of the battle from Duke William. Maybe the tactical inspiration came from Odo, or maybe from Eustace. The latter was certainly a leader in the attack as he carries a gonfanon. By this late stage in the day it would be surprising, even amazing, if William was not in fear of utter disaster. Like a later and similar battle, 'it was a damn near-run thing'. Why did William reveal his face at this juncture? Had he ordered the flank attack but decided to call it off when another observed the traverse and then he needed to be sure that all would obey his fresh commands? Redeploying committed troops is, as we have already said, far from advisable and rarely realisable. Was he attempting to flee with the cavalry when the traverse was fortuitously perceived? One of William's panegyrists, William of Poitiers,[15] seems to have invented the story that Eustace was wounded in the back while advocating running from the battle, though the *Carmen*, by comparison, gave him instead the most prominent parts in the whole action. So I am inclined to believe that it was Duke William who was in the greatest fear, and so subsequently this was covered up by the scurrilous inventions of a panegyrist. He was, after all, both commanding general and promoter of the whole, enormously expensive, joint-stock scheme. If the enemy didn't get him his financial backers would. One suspects that his lowly birth made him especially vulnerable to fear of failure and by the afternoon the other stockholders, his noble colleagues, would also have been very anxious to survive. They would have been panicking and vengeful. It had been William's idea, but their ships, their treasure, their discomfort and now, possibly, their lives.

The shamed/cowardly pards look as though they hold a clue, situated as they are above William and Eustace. We should also note that this is only one of four places where the superscript intrudes into the upper margin. The first place is where King Edward is both alive and dead, the second where men wonder what the portent of the star might mean, and the third where it is ordered, possibly by Odo, that a fleet be built. These are three critical events, important enough to interrupt the marginal narrative and all occurring in the centre of the Tapestry. So why is Eustace also included much later on? Nowhere else do we see the superscript intruding into the margin, only in this one place. We should also note the identifying detail accorded Eustace – his un-Norman moustache and the fact that in every other case, except one, of a mounted man astride his horse, we only see the nearest leg. In Eustace's case, both legs and their stirrups are seen. He has been specially detailed. The only other case of two legs is the soldier astride his horse's neck and he, it is shown, has lost his stirrups. I am sure his comrades remembered him and his predicament. Was this also Eustace? Stothard identified the gonfanonier as Eustace and the

subject of this picture by piecing together his name either side the excision, arguing, very convincingly, from 'E…IVS' or 'E….TIVS' for the name 'EVSTATIVS'. I now provide alternatives because the final 'T' is only partial and rests on the edge of the restorer's patch. If it can be proved to be original then that would clinch the name, but supposing it is not? After all, the arrow into the eye was added later and so the name need not be the original detail either.

What else could this superscript have been if not his name? The possibilities are limited. We might substitute 'E(GREG)IVS' – meaning distinguished or outstanding – over William. Though it already says 'HIC EST WILLI DVX' (Here is Duke William), and so could absorb such flattery, such an encomium sits unhappily with the cowardly pards. The only other possibility might be 'E(AMVS) IVS' for 'EAMVS IVSI' or 'EAMVS IVSV', given that orthography was not standardised – which means 'they go' or are commanded to go or, even more tenuous 'E(FFVG)IVS' for 'EFFVGIVM', which means escape. Whatever the original message, this part of the superscript was deliberately removed, presumably in antiquity, strongly suggesting that it gave offense. As even a name would, by taking precedence over the picture of Duke/King William, give grave offense, this detail was, perhaps officially, erased. Given the cowardly or shamed pards almost anything else might give offense. Yet the pards were not removed and for this reason I believe Stothard was possibly right, that it should be read EVSTATIVS for Eustace, Count of Boulogne, and apart from the pards (which could refer to Duke William's knights) nothing links Eustace's depiction here to cowardice. Quite the reverse. Could it be that William of Poitiers, who tells

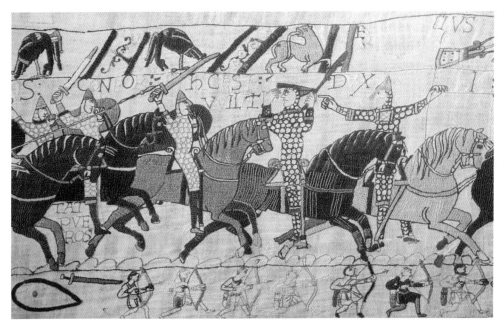

William, Eustace and the missing superscript – note the stirrups

the cowardice story, saw the Tapestry and misunderstood what he saw? If so we might question other parts of his account as being after, not before, the creation of the Tapestry.

One other observation should be made here, and it concerns that old chestnut the English round shield. While most of the English warriors are indistinguishable from the French and Normans, some of the axe-men have round shields and one bearded veteran even carries a sub-rectangular form, which was a Dacian shield. He was presumably a well-known English commander. Clearly, these round shields and the Dacian shield were not typically English whatever has been said or is a common factoid. Do these rarities point to a Varangian connection among the English Houscarles, for that is where we would expect Scandinavian (Varangian) influence, links with Outremer? On the Norman side we see the rare occurrence of squamatid and lamellar armours, which also seems to indicate influence from the eastern Mediterranean. They would not have been known otherwise. Such exotic and effective armours cannot have come cheap in western Europe. No doubt there were returnees and mercenaries on both sides and they would have had personal preferences. They would also bring exotic items for sale. And this also allows us to ask how many on each side were mercenaries and just how far this international trade in men and in their movements stretched in the eleventh century, for the wealth of a nation has always had a bearing on its military capacity.

So, we are left with the iconic image of Harold confronting his destiny, grasping an arrow, and the rest is blank. Here we have a liminal moment, as dusk rapidly turns day into dark night and at a liminal spot, atop Caldbec Hill, and so between earth and Heaven, by the Hoar Apple Tree. It is the climax of our Tapestry and whatever was originally intended to follow as the conclusion could only be a denouement, for here, in the widest perception of Professor Brian Bates,[16] surely we have the deep magic of the real Middle Earth at work? All things come to an end.

# Chapter 7

# The Conclusion to the Tapestry

Of course, once upon a time, the Tapestry had a suitable conclusion, a tail-piece, but why is it missing today and what did it show and say? How much is missing? Everyone assumes it would have been King William enthroned. If Queen Mathilde had embroidered it, that is what you would expect, but she did not. Neither was it commissioned by William and it is very doubtful it was presented to him. The missing portion is, therefore, a matter for speculation and we need to ask ourselves, what would Odo of Bayeux have wanted to see? I think there is a distinct possibility that the missing tail-piece was not lost in the French Revolution, the only part of the whole Tapestry to suffer any significant damage, but that instead it was destroyed in antiquity (like the blank above Eustace), possibly even amputated, taken and presented as evidence to show King William the allegories it contained. Even the earliest record we have of the Tapestry notes this missing tail-piece[1] Using the evidence now before us there can be no doubt that Bishop Odo was arrested and incarcerated for high treason in 1082 and I suggest that the Tapestry may have been one element in this picture of treachery and ambition. The beginning of the Tapestry's story is there so why not the end? There would have been no reason to remove it at a later date when the story it told was largely unknown and ignored. The amputation itself indicates a hasty job with a knife, perhaps while it was hanging. There is also the mystery of Eustace of Boulogne's poor reward and his rapid withdrawal from England, followed by an abortive invasion the following year, to add to this strange picture. Were Odo and Eustace in league at some point? Let us consider the range of possibilities before moving on to speculate on the content of the missing portion.

It has been suggested that Eustace commissioned the Tapestry as a gift to Odo,[2] though Odo remains the favourite commissioner with most historians. Two things stand out beyond the rest to me. In the first place Eustace was descended from the line of Charlemagne, though the Carolingian kingship had passed to the Capetians with the death of Louis V in 987. He was noble beyond his contemporaries and undoubtedly proud of it. In the second place the wealth of England and especially her land-tax (geld) was the envy of Europe and Scandinavia. Eustace had inherited his title from his father in 1047, the Count

of Boulogne and Therouanne and, after 1054, also of Lens. Though a smaller territory (in truth a kingdom) than Normandy this was a very prosperous one due to ancient cross-Channel links and trade. Such links might, indeed, suggest to us that the source of information concerning Pevensey was possibly Eustace himself, hence his inclusion in the picture of the invasion fleet, maybe boasting about his assistance. In c.1036, Eustace married Godgifu, sister of both Edward the Confessor and the Aetheling Alfred, so it was a Boulonnais escort to Alfred who was slaughtered and enslaved by Harold Harefoot and/or Godwin in 1036 in a treacherous attack on Alfred.[3] It follows that Edward, who became King of England, was Eustace's brother-in-law. Eustace visited him in 1051, possibly concerned by the threat to Boulogne posed by the marriage of William of Normandy to Mathilde of Flanders, and there is no reason why Edward should not have tempted Eustace with the possibility of another kingdom, as he is later said to have tempted William. It was one way to make allies after all. All-in-all Eustace was a proud and probably discontented, but rich, man and maybe dreaming of reviving family glories.

Now I will throw another pebble into the pond, one I hinted at earlier on. Consider the route taken by Harold's ships in 1064, not directly south but changing to north and east. Just supposing Harold was not on his way to William but instead seeking Eustace? This would explain his failure to sail south and so, for some reason, he just missed his landfall, fell short and fell into Guy's hands by landing in Ponthieu. The coastline from Boulogne to St Valery is often of a standard aspect from the sea and must then have been devoid of major seamarks. It is, however, a dangerous coast for sailing craft from Cap Gris Nez down to the mouth of the Canche at Etaples. It is always possible that Harold mistook the mouth of the Somme for that of the Liane at Boulogne but it seems far more likely that if he was sailing before a southerly then the wind veering to a westerly gale might well have driven him short and into the Embouchure de la Somme, unable to beat to windward for fear of swamping in a beam sea and at the mercy of notorious tides, obliged to take shelter in this extensive estuary controlled by Guy. Harold might equally have been sent by Edward to offer the throne to his brother-in-law Eustace who, after all, was the best claimant, and it was William's good fortune that instead of delivering the message to Eustace the English envoy was detained and obliged to communicate his message to Guy. Harold, seeing his chance to free the hostages by professing good faith and at the same time serving his own secret interests (no doubt he desired the throne), might then have sought to impress William. If he was ambitious for the throne, he needed to remove one candidate and ally himself with the other: divide and rule. Did it matter which one? The idea that the hostages had been delivered to William as a surety for the throne may not itself be accurate. It is also possible that these were hostages taken from the Godwin family by King Edward as surety for good behaviour and then sent, as he had once been, to Normandy for safe-keeping. They would certainly be in danger if William became vengeful. But what was that to Edward, they were Harold's relatives?

In 1053, Eustace had been at war with Duke William and in 1063 William was responsible for the death of Walter of Maine, Eustace's stepson, so there was no love lost there and it is all the more surprising to see him join William's enterprise in 1066. More than this, he did so in a big way for Flemish knights also joined under his banner – he was a very large stockholder in this enterprise. Maybe Harold sought to engage or befriend William so that Eustace could be sidelined, or at least rivalled, in favour of William when Edward died. Eustace, once aware of this, would need to consider his political position very carefully. I think we can have little doubt that he saw himself as more rightfully the successor to Edward than the illegitimate son of an upstart Viking. We have only the panegyrist's words that William was the sole and principal leader, even that the Normans were pre-eminent. Perhaps Eustace had hoped to be nominated king by the invasion force. He must at least have hoped to secure control of the coast from Pevensey to Dover, the shortest sea crossing for traders. In the event he secured neither of these things. Eustace's settlement after 1066 does not appear to have satisfied him and although he then went back to Boulogne he quickly returned to England in 1067 with personal ambition in mind, attempting a *coupe-de-main* himself. To do this he must have used his mercantile contacts to gain local support. Though Dover had had a bloody dispute with him in 1051[4] when he had visited Edward, the Normans under Odo had made themselves so hated within a few months that in 1067 the men of Dover and its surrounding district were prepared to offer Eustace a considerable force,[5] which also tells us that English warriors were alive and kicking somewhere in spite of their defeat at Battle and in spite of William's accession. Eustace next sailed across in the night with a small Boulonnais fleet when, quite coincidentally, Odo of Bayeux and Hugh de Montfort were absent and at some distance from their Dover caput. Eustace obviously anticipated local support. From Odo's viewpoint it would be circumspect to choose the winning side for he wished to retain his brother's favour and though not there when it happened he could always support the winner. Well, if there was collusion, no one had told the small Norman-French garrison of Dover Castle and they put up a stout defence and then sallied-forth to put Eustace's men to flight, so they must have had considerable help from someone. My guess is that the locals were actually backing both sides in order to weaken the foreign cause. Though Eustace escaped and thereupon sailed home to safety, his men were not so lucky. Not knowing the terrain at night, many were slaughtered, and his losses were heavy. His English estates were then forfeited by William. Moreover, he lost a young relative who may have had a claim on the English throne. Captured by Odo's men this hopeful is never heard of again.[6]

By 1071, King Phillip I of France was an adult and being, nominally, the overlord of both William and Eustace (entitled to their allegiance) he joined forces with Count Robert of Flanders against William of Normandy though not, apparently, against Eustace. I suppose Eustace could represent his failed expedition in any way he chose. William, no doubt insecure after his experience in the north of

England, needed all the allies he could obtain in France and so he now granted extensive estates in Essex, Hertfordshire and elsewhere in England to Eustace. If Eustace had failed to become a king in 1067 there was no reason for him to suppose that he might fail next time and eliminating King Phillip in France, with the help of King William and his geld, on home ground would be a bonus offering real possibilities of clearing the field before turning on William and then reinstating his own lineage in his native land and maybe becoming King of England as well. Why not? He accepted the bribe.

It is, therefore, quite feasible that Eustace commissioned the Tapestry as a gift for Odo, giving himself prominence of course and also flattering the man whose revenues were second only to King William's own.[7] If so it must have been completed by 1067 and probably showed Eustace enthroned with Odo's assistance. This conclusion to the Tapestry would certainly be treasonable to both William and Philip after 1067 and so Odo himself could have had it removed, for safety. It is equally likely that Odo commissioned the Tapestry, hence the prominent role he plays in it, but with two highly flattering inclusions of Eustace, the man of lineage who would like to be king. For whether Eustace became king in one kingdom or in both at some point, the Bishop of Bayeux would need his goodwill and if, instead, Phillip won the contest there would be no harm done. Either way, William would be second-fiddle in the schema of the Tapestry because he was an obstacle to Odo, and this tells us a great deal about the structural state of Norman/French polity during the 1070s. Given Bridgeford's research into Wadard and Vital,[8] my election is for Odo as the patron of a hanging designed for his private and personal amusement, but we cannot be certain. There is no reason why the Tapestry could not be associated with St Augustine's, Canterbury, the current and forcefully presented academic argument, but it needs to be said that the details conclusively suggest a secular rather than a religious designer and a secular and, at the very least, part-male team of embroiderers. I will return to this subject later.

In Eustace's favour, as commissioner, we might add the inclusion of the dwarf-figure named on the Tapestry as Turold. Bridgeford[9] has devoted some research to this figure and I certainly find his proposal convincing, his proposal that Turold was the personal *jongleur* (minstrel) of Eustace of Boulogne. He might have been included at this early point on the Tapestry because Guy and Harold were briefly negotiating with Eustace, a hint that there were more negotiations undertaken than the simple but conventional explanation that William simply commanded Guy to deliver his prisoner to him in 1064. We might be looking at a much more complex diplomatic situation with all three men in some sort of discussion over Harold's destination for the winter. If so, Duke William's military reputation seems to have decided the balance of power though his reputation as a general seems largely to have been accorded to him as a result of the invasion in 1066. Before that he had only met with limited success on the field of battle and might have owed his personal reputation as much to his skill as a negotiator. Nevertheless, we should note the inclusion in the Tapestry's margin of two

rams, for these are stubborn beasts and pugnacious, which are also destined for sacrifice. Would these be two out of three aspirants who will be disappointed in the end? Turold, Bridgeford further suggests, might well have been the author of the *Chanson du Roland* and this begs the question: Which came first? Was it our Tapestry or was it this poem. They are each of them so much the pattern of the other. Of course, if Odo commissioned the Tapestry then Turold was added as a sop to his fellow-conspirator Eustace of Boulogne. The idea that Harold was a pawn between Eustace and William while in Guy's hands is amusing but he might equally have been trying to play both sides.

Leaving aside Odo's over-weaning pride and insistence on, at the least, sharing in the glory (as well as the profits) of conquest, how much of the Tapestry is really missing? Of the surviving textile, the story up to Harold's return to England actually represents thirty-five percent. So if we speculate that the whole narrative was once divided as, say, three chapters, or acts, into thirty-three percent plus sixty-six percent then we have a theoretical 6.8 percent missing from the last third. So, at 224 feet 4½ inches today we should have once had over 240 feet, which in Old French units would be 40 toise.[10] So the sections are 80 + 89 + 55 feet, which last should be, perhaps, between 60 and 70 feet long. At 19 inches high (it actually varies from 18 to just over 21 inches, probably due to 'waisting' of the linen during weaving as it must have been woven in a narrow strip on a high warp loom and so subject to this problem), the Tapestry is slightly over ¼ of a toise high. It all depends on what the tail-piece depicted. Why, we might ask, is the Tapestry so lacking in height, only 19 inches high though so long? I will return to this.

In all it comprises eight sections sewn together. These are two at 44 feet and five at 22-28 feet, *viz* 7⅓ toise twice = 14⅔ toise, plus 22⅔ toise (in units of 3⅔ to 4⅔ toise), in all 37⅓ toise (224 feet), with perhaps another 2⅔ to 3 toise (16-18 feet) missing. Maybe more. A total length of 40 (French) toise (240 English feet) sounds convincing, but it could have been longer. The obvious answer is that it was not intended as mere wall decoration, unlike most of the tapestries we have from later periods, so it is continuous and not in sections capable of being moved to alternative locations. You see it was common for the rich to lead peripatetic lifestyles and favourite possessions were usually moved around with them. Such hangings therefore needed flexibility, as one might say, and this one was not moveable or flexible at all. If it was designed only for a single location then it must have been situated in an important room in that place, one fulfilling a given function. Presence chambers are not known from this early medieval period and instead great halls served general purposes and various functions, especially communal dining. I think we can imagine it as a great conversation piece at dinner and might have been intended for a special feast.

If we allow the Tapestry to have been designed to hang from a level at least 1 toise (6 feet) above the ground then it would remain visible above the heads of any assembled, but seated, company in such a hall. On the other hand, as it

displays no remarkable local wear or discolouration, it must have been hung well clear of the tops of doorways or mural features such as fireplaces yet, presumably, below window level, for it formed a continuous feature. So, let us explore alternatives. Firstly, being continuous the hall involved would probably not be much more than 25-30 feet wide,[11] so the hall would be about 95 feet long, On the other hand, if the service end of the hall was left uncovered, because of its multiple doorways, then the hall could have been about 108 feet long. In the latter case it would be reasonable to start with King Edward and Harold adjacent to the service end and then to finish with the, now missing, tail-piece, so the centre of the Tapestry, that portion enveloping the high end of the hall at the dais, would be the heart of it, showing the ordering and building of ships and the fleet setting out for England. Here, the superscript enters the upper margin, which seems emphatic. We should especially note the depiction here of flamingos, or phoenix-birds, possibly alluding to Odo as the 'remarkable man'. Of course, it is just possible that the Tapestry once had a detached tail-piece which would have hung above the service doors, in which case the whole schema would have been longer and possibly even as much as 45 toise in length. This we will never know.

I wonder if the final scene included William paying homage to his French overlord, the young (or even a new) King of France, or maybe some critical allusion that he had not. There would have been space enough for a coronation in which Odo participated. Wace[12] suggested that Odo made discreet enquiries about the precedent for a bishop becoming a king, so was there some hint of this? The amputation of the final chapter, scene or tableaux, is clean cut, snagged near the top, a vertical line as though sliced while the Tapestry was hanging. That is why I speculate that it might have been used as evidence, shown to King William, the origin of Odo's downfall in 1082, and also the metaphorical preface to *Domesday Book*. Eustace, if he had been involved in any plot, could withdraw to his own sovereign territory, Odo could not, for his territory was in Normandy. To question what would have given offence to King William is also to question why it was ever shown, both the time-frame involved and also the events involved. Let us look at the immediate aftermath of the battle and the coronation.

'When it comes to slaughter you will do your work on water,' said Kipling, and by the end of that long day in October 1066 every water-course leading from the battlefield was running filth. But in the darkness and among the shrieks and groans, the exhausted men who threw themselves upon that field would have been foolish indeed to wander abroad. Watchfires were probably few, and desperate men had to make the best of things until blessed daylight allowed groups to forage safely afield. The duke ordered a strategic withdrawal to Hastings, or at least some more salubrious spot, while he waited for the English to make their next move. After five days he thought it prudent to move on Dover and then Canterbury, making an example of Romney on the way for their resistance. For a month the duke and his army were stricken with dysentery here and while the earliest cases might have been removed to Pevensey, by the time they reached Canterbury they must

have just let the contagion burn itself out. There was nothing glorious to record about these deaths, so they would not have figured on the Tapestry, but I think they can be attributed to the battle.

Nevertheless, the deaths arising from combat and disease were quickly and apparently amply compensated by the influx of wolves, pards, kites and vultures, who acquired whatever boats they could in order to join-in the spoils before winter closed the Channel ports, and victors and recruits alike were anticipating a pleasant season ahead together with a swift and profitable conclusion. Yet if winter was rolling in, the news of the battle was spreading abroad and by the end of November, Winchester had capitulated and no dangerous resistance had emerged. London was apparently filled with military and other refugees, yet the English leaders had no strategic vision. Canterbury and Winchester were certainly worthy of record on the Tapestry. Taking London was an ambitious project for a small field-force, yet its sack would be counter-productive. William tested its defences by attacking south of the bridge and, meeting fierce resistance, he fired Southwark and moved off westwards. To the Londoners that must have seemed ominous.

William crossed the Thames at Wallingford with fire and sword, and Archbishop Stigand hastened to make his peace with the duke. At Berkhampstead, the site of the later castle, the Aetheling Edgar and his advisors submitted 'after most damage had been done', said the Chronicles, though with the 'City', the commercial heart, intact. We do not know of any further resistance by Londoners, but it seems that agreement to William being crowned was not necessarily immediate on the part of his own Norman-French nobles. Nevertheless, at Christmas William was crowned in Westminster Abbey, an event celebrated by his wolves and pards with arson and murder. During the ceremony, we are told, William wore his helmet, so he may have felt unsafe even amongst his coterie. Nevertheless, by March he felt secure enough to leave for Normandy accompanied by a vast treasure, leaving England to the tender mercies of Odo of Bayeux and William fitzOsborn. King William left from Pevensey for an extended triumphal tour of his territories in Normandy. In what was now a lawless England, without a king, a brigand began to ravage the Welsh border, Exeter seceded from the new regime, and Eustace of Boulogne made his gamble for power at Dover.

I wonder which among these events would seem noble enough to be worthy of inclusion on the Tapestry. I suppose the achievement of the invasion can be represented as political spin but even including William's coronation would require the artist-designer to ignore the unfortunate consequences – arson and murder. Had Eustace succeeded in taking Dover Castle (shown, though not named, on our Tapestry) then I have no doubt that Odo would have surrendered the south-east to him, thus conclusively preventing William's return. William, however, returned in December 1067 (a dangerous time of year for a sea crossing) without resistance to take on the West Country dissidents. That might have provided some distinction but did Odo also insist on claiming the credit for

Eustace's defeat? William's swift return at this time of year sounds as though he was not entirely convinced of Odo's loyalty. Alternatively, was the Tapestry completed in 1067 with allusions to Odo and Eustace as rulers, or as regents for the French king? By 1068 it would then be a grave embarrassment.

The survival of the Tapestry is itself miraculous. Once it had been recognised in France and in England as an antiquity it was not only recorded in 1816-1818 by Stothard but he cut a small souvenir from it, which he smuggled back to England, one his descendants gave to the Victoria and Albert Museum. He also made impressions in plaster of Paris of some details. These he coloured appropriately, and they found their way to the British Museum where I saw them and, I have heard, they were dropped and are now (some day) awaiting restoration. Nor was Stothard the only souvenir hunter. Yet for this textile to survive until the nineteenth century was unique. In part this seems to have been the result of stowing it in Bayeux Cathedral, in a cedar-wood box or chest, a natural moth-repellent, even though it was lost to sight until the mid-fifteenth century.

Surprisingly, it does not exhibit the sort of wear we would expect from mechanical abuse while a wall-hanging. There appear to be no local areas of abrasion or bleaching. I wonder, was it ever actually in use for long in a secular setting. If it was confiscated by the crown, how come it was forgotten? Did King William give it to Bayeux Cathedral for safekeeping after his brother had been incarcerated or did someone rescue it. I wonder, did Ranulph Flambard, once a vavassour of Odo's and then subsequently a royal chaplain, the man who devised the Domesday surveys, acquire it as an insurance policy perhaps, against Odo's eventual freedom and success. He, after all, was in a position to warn King William of his brother's activities yet would be in fear of reprisals at a succession.

Might we also speculate as to Odo's personal perception of the part he had played in this astonishing conquest of the richest and most cultured kingdom in Western Europe? He had been richly rewarded after 1066, but did he think it enough? Had it been Odo's cunning that trapped Harold? For he now appears to have led the expedition against Conan that seized on Harold's rescue of men just before the attack on Dol as subsequently meriting a grant of arms from William, a gift and honour that could not be refused yet one which, in Norman eyes, made Harold William's man? Was this all contrived by Odo? Was it Odo who further suggested an oath on holy relics, to bind Harold in Norman eyes and so brand him as a stereotypical oath-breaker should he fail to support a Norman-French succession? Was William the military planner and Odo the schemer, the latter furnishing the political justification and the other the meticulous and calculated practical solutions? Would Odo have been so foolish as to create such evidence for the satisfaction of mere pride? He could never hope to display it once William had been established as king.

It has always been assumed that the subject of the whole presentation was King William. Instead we now need to be highly focused and analytical. There is no reason at all why King William's coronation should have been shown if

the embroidery was commissioned by or for Bishop Odo of Bayeux. We have seen that it contains three messages and by far the most economical is the Latin superscript. This restricts itself to important information and if we do not encounter something in the superscript we are justified in saying that the person who dictated the brief, and so the embroiderers, did not consider it worth mentioning. This is important because nowhere in the superscript does it say that Duke William will be, or should be, King of England. Nowhere does it say that King Edward promised the throne to him. Such claims were made later. Nowhere does it say that he invaded in order to secure such a claim, even though the whole artefact is entirely a victor's history. Surely this would be the most important claim of all to make on an official history. The fact that the embroiderers had no knowledge of crossbows, though we accept that they were used, tells us that our Tapestry was created before any of its artists had had a chance to observe them and that surely must place its creation within the first year or so of the Conquest. Though William was crowned at Christmas 1066, he was absent from England during most of 1067 and his accession may not, therefore, have seemed so certain to anyone who resented this action.

The Tapestry's brief seems to have consisted of no more than an outline of events, a direction often without details, certainly devoid of finely detailed descriptions of buildings, farm equipment or even creatures. Clearly much was left to the needleworkers and their director to infill. Nor can we expect state-secrets to have been revealed to the workers. So where emphasis is given it was presumably the substance of the brief and this tells us who directed the story-telling. So initially we have Harold the *bon-viveur* who sets out on a voyage, with heavy emphasis on his slyness and guile in the margins. Next, if we ignore the humdrum detail and confusion of his arrival, we are shown Harold the raconteur and good-companion, but with heavy hints that he has fallen among stronger characters than his own. He then becomes the soldier and hero, though maybe this has been partly contrived by his hosts. Sure enough, he is outsmarted, and the tale then moves on. Yet even here, as Harold sits enthroned, listening to a report from his own intelligence section, he is outsmarted by the emphasis on a ship of Fifth-Columnists, or agents, leaving for France to report, presumably, to William or Odo. Someone was very proud of the part they had played in this battle of wits.

Though the stage is being set for a sort of record of events, on the Norman side there is still plenty of hum-drum detail within which emphasis is given to one man in particular: Bishop Odo. In the earlier campaign with Harold he was emphasised by direct indication and also by his distinctive armour. Now, as the invasion is prepared, he is the one directing the ship-building. The embroiderers could not have known that unless they had been directed to provide such emphasis. When the Normans land it is Odo who is given prominence and, once again, also direct indication. It is then Odo who leads the discussion among the three brothers. It even appears to be Odo who is favoured by the gift of a special

warhorse from his brother. Now remember what I said about the lack of any sort of maps. Odo would not have known local names and their usage and neither would the embroiderers, who almost certainly lived and worked elsewhere. So the direction given was 'we landed at Pevensey', followed by '(my men) took supplies from (somewhere called) Hastings', and who among any of them could tell place-name from locality name? The workers put down the script set before them. That was all they were required to do. It is also worth noting that at the beginning when Harold set out for France we saw the ship and its rigging in detail. We could see the sheets of a square-rigged sail, in spite of an attempt to show the sail billowing realistically, giving the misleading impression of a lateen-rig. When we come to the Norman-French fleet, with so many ships to portray, note that the sheets have been ignored in spite of the variety of the shipping and the whole fleet now seems to be lateen-rigged. The embroiderers were not required to emphasise here, only to depict a general crossing. So they adopted a convenient convention.

Once battle is joined we appear to have Odo saving the day. William's position is much more equivocal. How would the embroiderers have known such things unless directed to give emphasis of this sort? Note the special emphasis given to Eustace of Boulogne as well as to Odo's men, Wadard and Vital. Note the general confusion of the battle and lack of clear incidents until we come to the attack on the English left when commander Odo, cavalry in difficulties, cavalry triumphant and the master-stroke of archery all follow in rapid succession. Who directed that such detail and emphasis should be included here? The recurring message seems to be that William depended heavily on his half-brother Odo. If so, the Tapestry was not directed at William or at his potential kingship, for he was not even the subject of the story.

We can never know, nor can we hope to find, any hard, scientific, supporting evidence for such suppositions, but the speculations afford new dimensions to this fascinating and pivotal play for political and physical power over England. Denial of lordship, ingratitude and personal pride, as well as the dire consequences to be expected for oath-breaking, were recurring contemporary themes in moral tales, the most heinous of crimes that any noble could commit. We should expect some such material reinforcement in the tail-piece. Yet if the Tapestry tells us anything, it tells us of Odo's pride, ingratitude and oath-breaking, sins, crimes, treachery, later reinforced on the pages of *Domesday Book*. Maybe William could also be accused of as much by the King of France? In politics the justification depends on first obtaining an unequivocal victory, otherwise several possible justifications may need to be presented. Those who win are credible as well as brave and glorious. William triumphed over his own faction just before he died (though he never really knew it), a triumph made possible by *Domesday Book* and the oath-taking of Salisbury, neither of which would have been possible anywhere but in England. Together they set us on the road to *Magna Carta*[13] a document that came in useful several centuries later. It was *Domesday Book* that audited and established

our national taxation, even suggesting new and improved methodology to succeeding generations of royal servants, *Domesday Book* that created a well-founded property qualification for both tenure and service to the crown, and it was the oath-taking of Salisbury that cemented royal power at the centre of the property matrix by making fealty to the crown pre-eminent over fealty to one's immediate lord. The emergence of *Magna Carta* was proof of the effectiveness of these earlier measures in the evolution of a feudal system, for *Magna Carta* was the magnate's act of defiance against royal authority and title, though, of course, it was entirely selfish and self-interested, nothing to do with democracy or the rights of the commonality. These are modern constructs. The recognition of the ordinary individual as more than a chattel or beast of burden, at least by his social superiors, took several centuries more before it was achieved. Whether the creation of feudalism, in England, promoted or delayed that egalitarian process is a matter that might now be usefully debated, now that we have a more accurate assessment of those twin corner stones of Norman achievement – which are *Domesday Book* and the Bayeux Tapestry.

Chapter 8

# The Landscape of Invasion

L ooking out today from Pevensey Castle there is not much to see that is exciting. It is easier to imagine German paratroopers landing here than to envision either William's forces and ships or a profitable Medieval landscape. In 1066 the topography of this part of Sussex, the locality of the invasion, was of a very different aspect. The Levels were not there. Instead a bountiful wetlands ecology of sea and landscapes existed, a view guaranteed to make any contemporaries envious. Some writers speak of a '12-mile gallop along the beach' from Pevensey to Hastings,[1] others of a lack of roads, of the need for an army to march in column-of-route, of dense Wealden forest barriers and limited cultivation. Supermen the

Looking east from Pevensey today

101

invaders may have been, but even they could not walk on water. Neither can thousands of men be expected (in England, in the autumn) to find hard-standing tracks. The principal feature of Pevensey was the lack of land, let alone beach, between it and Hastings, so that had there not been adequate circumferential roads, no one could have travelled from Beachy Head to Bexhill except by sea. I have no doubt that a good circumferential system existed and with ships one had even easier communications.

The great Pevensey Lagoon was a mainly tidal area of waters, islands, marshes and fens of considerable coastal extension and penetration inland. In Roman times, this made Anderida (like Othona in Essex) an ideal promontory fortress beset by water obstacles but with deep-water access. The 'eye' place-names tell us of islands and promontories remaining in this seascape and *Domesday Book* tells us of the maritime interests (even though irrelevant to a land-audit). It tells us of fisheries, salt-houses and men who were merchants. Further inland were extensive arable lands, especially in the Rape of Hastings and to the north of the lagoon right up to the Wealden forest, and these were of interest to the survey. None of these have been examined or analysed before for the simple reason that no one could read *Domesday Book*. But, based on my research, the details of *Domesday Book* appear clear, revealing a picture that shows that what are now the modern Levels were neither impassable nor unattractive. Quite the reverse and they, and the adjacent arable lands, were very profitable by 1066.

It is important to understand that such wetlands were not the agronomic wastelands so vehemently presented by later reclaimers but, just like the Cambridge Fens, very profitable and mixed economies and ecology. The basic statistics of *Domesday Book* allow us to make a broad overview of this mixture of habitats and features in 1066, distinguishing between the remaining tidal waters of a gradually diminishing lagoon and encroachments, both natural and manmade, surrounding and enclosing it. Moreover, it is this complexity of landscape features that dictated the strategic value of the overall invasion site, as we shall see, especially when we can add to this the added security of a monopoly of local knowledge.

So, if we look at the modern area of Bexhill, Bullington and Filsham, an area that included modern Hastings (the place) and that covered that area of the 'Hæstingas' (people, later Hastings Rape), and which fronted the English Channel to the east, we see an already extensive reclamation of the edges of the silting lagoon. Much of this area was fecund and prosperous, having had reclaimed fenny flatlands all around Barnhorn Hill and Hooe and was served by three churches. It also seems to have been on the edge of former Roman iron workings at Beauport Park, which gives us a clue as to its economic importance down the centuries. So, by 1066 it was a rich arable landscape adjacent to good grazing and with many tenant farmers (villeins). So it is no surprise to see that the Normans 'wasted' the area so badly that it only made a very faltering recovery in the years following the invasion.

To the north of this area, inland, was Crowhurst, with Wilting and Catsfield, which were similarly expanding in value before 1066. They were part of Earl Harold's estates and this area was also wasted and once again lost considerable value being in the Hastings Rape, which was a prime area for requisitions, for depopulation and for military control.

If we now move westwards over the north side of the lagoon we find Hooe, with extensive reclamations from the 'inning' of the lagoon and also with rich grazing. This place was similarly despoiled but, despite losing value, then made some recovery by 1086. The existence of a number of salt-houses in this area, places where the burning of reeds and sedge evaporated seawater (a most profitable enterprise) helps us delimit the land from the salt and tidal waters of the lagoon, but it also tells us of the longshore drift of the spit to the south-east which, by slowing and entrapping silt and also probably industrial wash-out from the river, facilitated all this inning.

Across the river at Wartling and Ashburnham, the 1066 picture changes, for here there were no 1066 losses and instead considerable gains by 1086 together with extensive reclamations and three more salt-houses. As these estates controlled the tidal reaches of the main river northwards, with its feeder river at Ashburnham, it is impossible not to conclude that they were in the hands of those who had chosen to side with the invaders. The waterways would therefore allow vessels from Pevensey Harbour to penetrate well inland, bringing them close to

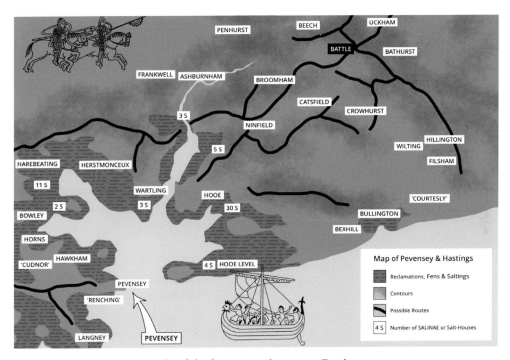

The Hastings Rape (east) side of the lagoon and route to Battle

Broomham and so closing the distance to Battle. If the picture we have on the Tapestry of a castle (burgh) at Hastings was actually located outside the fortress of Anderida-Pevensey, I would suggest that it was established somewhere along this waterway – in the Hastings Rape – as a provisioning point for the trans-shipment of supplies back to Pevensey and forward to occupation forces into the area of military control.

Herstmonceaux appears to have had extensive accretions of peaty fen, silting and the dried bed of the river, which debouched into the basin of the lagoon, for here reclamations were extensive and neither was the place treated unbearably

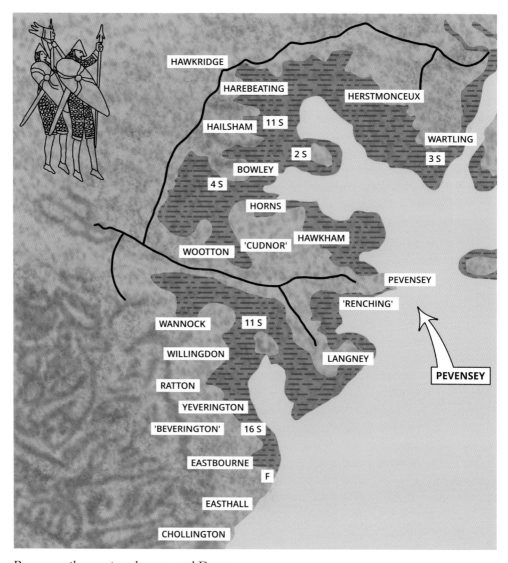

Pevensey, the western lagoon and Downs

in 1066. The salt-houses tell us once again of available fuel next to saltwater margins, so I suggest a complex of pools, reed-beds and grasslands around her innings, while the springing duck on the Tapestry tells us of the general diversity of fish and fowl to be found in such an ecosphere – a gastronomic paradise. Local knowledge of such complex habitats would have been essential and invaluable, both for security of movement of forces and in order to guarantee the exclusion of any outsiders. We cannot doubt that some residents co-operated willingly with the invading army.

On the western side of the lagoon there appears to have been considerable variation of fenlands with some innings and also a large number of salt-houses at the lagoon-edges, around Horsey (no doubt formerly 'Horse Eye'), and although there is some confusion of place names[2] there were perhaps, upslope, at least 80 acres of woodland. Following this western edge downwards we find the peninsular leading to Pevensey itself was well-set with arable land and some salt-houses while to the south, on what became the Bourne Level, and westwards to the Downs, were more salt-houses with arable land, meadows and a (possibly tidal) mill. These estates lost value as a result of the invasion, but they were not wasted, and I think we can say that local knowledge was of less value to the invaders on this side of the lagoon than it was on the north. Equally. clearly the military hand did not bear down unbearably in the Rape of Pevensey. So, we might say that the most valuable land in a general sense was to the north of the lagoon, on the route to Battle, while elsewhere there was general requisitioning and in some few, special cases much more lenient treatment. We have already examined the value and purpose of creating a military zone in the territory between the lagoon and Battle.

The port of Pevensey and its ancient fortress of Anderida sat on a spur of sand and clay that gave clear access to the sheltered anchorage of the lagoon on the north side – in the still, open, central lagoon there was far more than enough safe harbour in which to moor at least 24 acres of invasion fleet. In 1050, the *Anglo-Saxon Chronicles* had mentioned 'Hæstingaceaster', the strongpoint of the Hæstingas, a distinct people who occupied a district still seen as late as 1011 as being quite separate territory from Sussex. This was a district name not a place name and so, after 1066, we find the quite separate creations of the Rapes of Hastings and Pevensey. Outside the walls of the fortress, in Pevensey Port, the number of burghers more than doubled between 1066 and 1086, so it certainly benefitted from the invasion and undoubtedly this was due to the collaboration of the inhabitants as much as to any horse-trading associated with the stud. Place names betray former island features around the lagoon while the loss of arable land values after 1066 around Pevensey may not have been due entirely to requisition.[3]

So, the fist of the invader fell most heavily on the Hastings Rape (as it became), excepting for a few collaborators, and the tidal flow available to shallow draught shipping reached up to the confluence of the Ashbourne, Harley's Stream and the

Nunningham Stream, now known as the Waller's Haven. As for the extensive reclamations and longshore drift, we do not have to look very far for parallels, for the Romney Marsh landscape was also being incrementally inned between the ninth and eleventh centuries along the banks of the Limen, a truncated tidal inlet with marshland creeks.[4] Intense agricultural activity, as in Hastings Rape, probably due to demand by an adjacent industry, has been documented and discussed elsewhere as a process[5] and was here most obviously created by the Wealden iron-smelting and refining industry[6] to the north of Battle. The amount of reclamation itself suggests a long-established pattern of industry serviced by a peripheral agricultural workforce. Such intensive agricultural output probably itself caused silt-washout down the streams and waterways, to deposit roddons and washes, so creating conditions favourable to the formation of fens. Then we have the bricquetage associated with centuries of salt-making that built up on the edges of such fens and would further stabilise the fenny ground ready for inning.

The traditional presumption of a bloody and brutal invasion is therefore inaccurate. Clearly a careful intelligence picture was compiled in advance by the Franco-Norman leaders and the assistance they received might justify us in speculating whether they did indeed introduce a Fifth Column to the Pevensey community. What is certain is that such planning took more than a year or two and was directed at securing the most advantageous beach-head possible. It also resulted in an ideal fall-back position, a fortress approachable only along a narrow isthmus and with its own sheltered anchorage, alternative communications (not an unimportant consideration in autumn weather), extensive and comprehensive supplies and local sympathisers. William surely had designs on this kingdom while King Edward was still alive and moved to realise them from the moment that fortune thrust Harold into his lap. It is also surprising to see that such restraint could be exercised by a composite command and such a diverse military force.

What we have in the Pevensey Lagoon of 1066 is the classic conflict between the hunter-gatherer economy of traditional fenland inhabitants and the agronomists, a conflict not influenced by Malthusian demographics but instead by industrial stimulation. From Roman times, if not before, mineral extraction and associated industrial processes had formed a symbiotic relationship with an arable-service-industry and this in turn stimulated metamorphosis from fenlands to arable reclamation. Nick Austin has presented a case for the real Hastings to be at Bulverhythe[7] (which sounds convincingly like Bullington-Hythe), with a case for Roman iron smelting to the north at Wilting and in the Beauport Park area, which probably tells us of the pre-Saxon industrial limits of the Weald, further south than they were by 1066. Nevertheless, the fortress of Anderida would still be the best place on which to secure a Roman armaments depot and even in 1066 it remained the most egregiously strong and adequate centre for a military force and for the products of the inland smithies. The identification of some other coastal site as a Hastings (place name) landing only works if we presume a stupid and craven race of Saxons on the one hand and master-race arrogance on the other.

William was too competent a commander to take his enemy for granted and, thanks to a succession of invaders, the English did have a formidable reputation for conventional warfare. If another castle was commenced at modern Hastings in 1069, that would have helped to secure the further shore, but without detracting from the overall importance of Anderida-Pevensey. Double-locking this back door to England could well have followed Eustace of Boulogne's abortive coup on Dover. Perhaps he should have opted for strategic predictability or perhaps he already knew of a strong and loyal garrison emplaced at Anderida. It would have been remiss of William to offer any other opportunist the advantage that he had exploited.

Of course, we would love to know more about the 1066 and 1086 statistics in this area, if only to iron out details of the map produced for Professor Morris.[8] We can see from the figures available that the percentage of set-aside allowed as fallow was as low as or less than the small wood and pasture total. Thus, exploitation of the landscape was exhaustive when compared to other shires, as a consequence of industrial activity, and this tells us two things: first that the landscape and especially its road network were probably very similar to that of the mid-nineteenth century and, second, that in choosing such a beach-head the invaders had always had these industries in mind. Harold's selection of a battlefield just in front of what we suspect to have been the main industrial area by 1066, the Weald, has even greater significance in the light of this observation. The Romans had built Anderida to protect their Andredas weald industries and linked it to their British fleet, the Classis Britannica[9], and there is no reason to assume that output was less specialised or less valuable in 1066. Harold, belatedly, was attempting to block the route to the Weald and not the route to London.

*Domesday Book* fails to provide us with any record of this industrial base or emphasis for its money economy because the purpose of this book was to act as a land-tax audit and it was not concerned with cash, and of course what happened in the Weald was very much a secret anyway. I shall enlarge upon this later. But we can be sure that this vast tract was not empty. Something was there and something of value. The man with the best knowledge of cross-Channel trade was undoubtedly Eustace of Boulogne, for his *entrepôts* controlled the majority of it. Did Eustace know of this Wealden industry, did he know of the royal stud on the Downs, did he discover the weakness of the English garrison? He must certainly have known the salt trade and surely the ship we saw setting out for Normandy after Harold's coronation was sailing from Pevensey. Eustace's importance in invasion planning may well have been overlooked before now.

There is yet another comparison we might make with the Pevensey Lagoon of 1066. Not a place which, as yet, belonged to Normandy or to France, a place that was part of Languedoc and which bears very close resemblance to either the Pevensey or the Cambridgeshire fens, given the necessary changes for our more northerly latitude. This area is the Camargue, at the mouth of the Rhone, an extensive and highly profitable wetland habitat, a large area of saltwater fens

and lagoons fed by fresh water from the north, a series of 'etangs' with a history of 'salins' from Roman times until today, and still one of the largest salt producers in the world. Arles became an especial economic jewel of the Medieval church because of the value of its salt-houses, guarded by the impressive fortress of Aigues Mortes, with the Etang de Vaccarés still famous today for its bulls and its ancient horse-breed, formerly also for sheep. One further connection with our Tapestry' is also important – remember the flamingos? As far as records allow us to know, the Camargue and its etangs probably always were the only breeding ground of the pink flamingo in Europe. Were they there in the eleventh century? Did someone among our embroiderers know the Camargue or had he travelled even further in the Mediterranean? Who knows. But surely these coincidences at least allow us to comprehend the value of the Pevensey Lagoon.

Can there be any doubt that on an autumn morning in 1066, the dawn breaking across the Pevensey basin and lagoon would disclose a magical sight? Even in the autumn, the weather being fair, the rain cleared and the winds light, the view from Combe Hill Camp across it and eastwards to the sea, even with 'mists and exhalations', would be delightful.

Far out to sea, as dawn broke at 06.00 hours on 28 September 1066, sat the *Mora* with Duke William aboard, all alone on a wide sea having outdistanced his slow transports and their escorts. So the duke partook of a hearty breakfast on the sparkling waters while he waited. If the shepherd on Combe Hill noticed one vessel so far away, as he gave thanks for the day and safe delivery from the terrors of the night, he probably thought nothing of it. But by 09.00, when he looked up again from his labours, there were 'a thousand' vessels on the sparkling waters and assault craft swift as swallows were racing into Pevensey Harbour. His first thought must have been Vikings! He was not so far wrong. His next thought was, no doubt, to flee north or westwards with his charges. For most of the inhabitants of the lagoon there was obviously no such warning. The tide had changed and with it the destinies of men, the affairs of England and of Europe would never be the same again.

# Chapter 9

# The Accuracy of
# Weapons and Armours

A thorough appreciation of the arms and armour shown and employed in 1066 is, I think, essential, because it presents verifiable accuracy to the depictions and because it helps us understand the tactics employed. The evidence before our eyes, the picture-scape of the Tapestry, is our only real source of evidence for the appearance of both sides in the conflict, though not necessarily for their weaponry, which is also attested elsewhere and especially in the archaeological record. The fact that Norman and Saxon armours are shown as identical (if we exclude Odo) should tell us that the *allé-mode* on either side of La Manche was the same. This suggests that if both sides defended themselves alike, then they probably fought much alike and therein hangs a caveat. Variations in the depictions of mail armour should not distract us as they distracted nineteenth century antiquarians into inventing various technical solutions. Any team of craftspeople will have their own individual variations when it comes to pictorial execution. It is very difficult to represent mail accurately. If other artists in other sources and mediums also made individual attempts, that does not give us diversity of construction, only of depiction. The Tapestry tells us that the best-defended troops on either side looked alike, whether we call their garment a 'hauberk' or a 'byrnie', with shields and helmets also alike. Secondary (light) troops, *velites*, were sparsely armoured, whether archers or common fyrdmen. The nature of the battle, however, differentiates the sides, especially the Norman-French-Breton employment of heavy cavalry. This alone presents one side on foot and the other mounted.

William had placed his greatest emphasis, his real hope of success, on the resurrection of heavy cavalry. I say 'resurrection' because the Romans had had such specialised troops long ago. Many were undoubtedly of mercenary aspect. Why did William place so much faith in cavalry, what made them so special? To the Victorian and Edwardian historians, the answer was simple. They were lancers. Of course, lancers are light cavalry and William's knights were heavy cavalry, but that detail did not matter to them. In c.1900, much of the developed world was in love with lancers. While British lancers were usually light cavalry the German

Kaiser equipped all his cavalry units (whether light or heavy, Uhlans, Hussars, Cuirassiers or Dragoons) with lances and in India the non-silladar cavalry of the Raj now took to the lance. Even the *arme-blanche* French appointed some cavalry to act as lancers. The superiority of the Normans, it was argued, was in adopting the spear over the sword and adapting it as a lance, but it is indisputable that spear and shield were the standard weapons of the age on both sides and for horse and foot alike. The spear was a cheap, simple and versatile weapon, it is no surprise to see it in the hands of horsemen. Just how it was used on horseback cannot be proved but types of spearhead provide us with clues.

In fact on the Tapestry we see few horsemen actually couching their lances and of course the gonfanoniers (who could hardly use it in any other way when defending themselves). The overwhelming majority of riders use their spears overhand or else carry them erect or at the trail and there are mounted swordsmen. The terrifying prospect of a tiny point travelling at about 25 miles perhour, propelled by half a ton of horseflesh, was not then the standard practise, though the sheer weight of cavalry is indeed effective in its own right. The Norman emphasis on heavy cavalry as an attacking arm was special for it relied on bloodstock. The Normans had learned to breed horses for combat. Their requirement was for an endurance mount capable of carrying a heavily armoured man, of responding implicitly and acting aggressively, with man and mount in concert. For such purposes they needed a relatively large, strong beast and not a pony or a cob. It is also difficult to train a horse to trample on a man and it required intensive training and constant attention to develop empathy between man and mount. The 'Norman Horse' is supposedly the breed shown on the Tapestry (today rebred as the Salle Française), but blood like the Percheron, Boulonnais and even Andalusian might have been involved. Duke William is said to have been presented with an Andalusian stallion. I call them 'bloodstock' because only breeding, constant training and familiarity could guarantee the essential unity of each rider and mount. Then, as later, they commanded formidable prices. Like racehorses today, they were specially bred and so specially priced. One of Duke William's inducements to the 'free lances' (mercenaries) in his army seems to have been his large reserve of trained war horses.

None of the mounts shown on the Tapestry have any barding, so the sort of heavy cavalry employment once seen among Roman cataphracts was not envisaged. These horses in 1066 were expected to move with some speed and dexterity rather than just crash through enemy formations at a trot. We do not know what tactical formations or manoeuvres were employed, but the Tapestry shows both magnificent steeds and combined or co-operative tactical developments, with mounts massed together in what look like formations. Clearly William and his joint-stockholders envisaged a war of movement and probably not one involving set-piece battles, which would endanger the bloodstock, certainly not actions against defensive positions. To be adaptable (as Clauswitz later observed) he needed infantry but in a war of movement they become a hindrance. So he

included a purely offensive arm. We might compare the concept to blitzkrieg. The situation that faced William at Caldbec Hill was consequently quite the worst prospect he could have imagined yet, had he delayed engagement that day, the situation would have become even worse. It was touch-and-go. They could not go around the English position to cut Harold's communications because of the Wealden terrain[1] and also the size of the English force, the risk of themselves being caught between two fires. So they could not isolate and bypass them. Having encountered the English, they had to fight them on their own, chosen ground.

The other evident strength of the invading force was its fire-power. Whether it was English practise to use archers merely for skirmishing[2] we really cannot know, but the invaders seem to have brought a considerable force of them and obviously anticipated having to dislodge emplaced infantry at some point. Once again, we have an attacking arm with (at this date) little defensive power in the field unless sheltered behind built defences, so this reliance on offence was nearly William's undoing. From this we may judge that English infantry, men in formation, whether at 'push-of-pike' (spear) or closing for personal combat, had a reputation as good as anyone. For all the reputation of Viking armies we should remember that Harold had just enjoyed a resounding victory over one. William imported cavalry because he did not have the same quality of infantry.

Much speculation has involved these archers of William's and their weapons including claims that they were underpowered, but I see no reason for the range of a self-bow to be much less than ten score yards 'forehand', maybe more, and if any of the archers had returned from Outremer/Byzantium there is no reason why they should not have had composite bows. These Turkish bows hold the world distance record.[3] We are also told of crossbows among the ranks of the Norman archers,[4] which do seem to have been unknown to the English. For this reason they do not appear on the Tapestry, which was embroidered by English workers and, apparently, by workers who had not been at the event. We should not be surprised at this. Common soldiers were commonly ignored by their betters. The advantage of this new crossbow weapon was that it was powerful, required minimal training and could easily be sighted for flat-trajectory fire. The disadvantage was that its projectile was doubly non-returnable: too deadly to easily remove and also incapable of being launched from any conventional bow. The composite bow had been used by the Romans and by the later twelfth century we have accounts in England listing their materials at the Tower,[5] so composite bows are possible, the technology having been brought back by the mercenaries from Outremer.

However, in committing himself to archery William was encumbering his cavalry strike-force with foot soldiers and also a baggage-train. While it was customary for opposing armies to recover their enemies' drop-shots, the inescapable precaution was to supply a sufficient quantity of projectiles to meet the envisaged need, in this case a campaign that turned out to be against an emplaced enemy. William presumably knew after landing, from his scouts, of

the enemy's location and position, even if not its true strength, so his archers may have had enough time to augment their reserves by their own industry, if they had a stock of heads with which to work. Working to the munition standards of a slightly later date, for effective parabolic-fire (the transfer of kinetic to potential energy), arrows cannot have weighed much less in 1066, so each projectile would weigh about 2 ounces (60 grams), with the weight in the head and a sheaf of arrows 24, with a length of at least 30 inches. With minimal spacing each sheaf would require 4½ inches x 1 inch of headspace, so a square foot of headspace would accommodate 768 arrows at best. The most conservative estimate, that of Poyntz Wright,[6] is 800 archers and there might have been more. So if each man only shot one sheaf an hour for eight hours, the requirement would be for 6,400 sheaves or 153,600 arrows (basic minimum) and such a cargo would weigh 8½ tons. That would leave each archer to carry 24lb of projectiles plus his other kit. If a baggage mule or pony can carry 150-200lb, at best, over a reasonable distance then 19,000+ lb (maybe double this) would require at least ninety-six mules or ponies, or half that number if the archers carried 12lb of arrows each. What if even more projectiles were required and what of the quartermasters' allowance for spoilage during transportation across the Channel? What about the quarrels for crossbows. They were non-returnable because the enemy had no crossbows. The crossbowmen would require a much better allowance and I suspect that archers and crossbowmen were busy making themselves fresh supplies from the moment they landed, using heads transported *en masse*, but these all made for carriage weight and volume in the baggage train when they advanced.

A variety of spearheads is shown in the whole length of the Tapestry. They are not of one uniform type, neither are they inventions. Those shown in Guy's escort near the beginning of the Tapestry include fairly long blades with basal collars as well as shorter, pointed, stouter types, though when we see Guy seated and also William's messengers to him, the heads on the spears are barbed and with one, two or three short, basal stop-bars. A longer blade with two inequal stop-bars is also shown. These bladed types with stop-bars were most likely used for hunting. At least they were in later centuries, though they could be used in war and they may have been included to indicate the non-aggressive nature of these interlocatory negotiations. The expedition against Conan shows us plainer points, with or without stops.

Barbed heads are carried by Englishmen and by Normans. In fact the Norman quartermaster's wagon that loads the invasion fleet features them, apparently on short hafts, and at Battle we see the English with barbed, barbed and stopped, and plain leaf-forms, though the Normans generally favour leaf, diamond point or pyramid forms for combat. Of course there is less attention to fine details in the heat of the battle, but two English figures carrying bundles of short, barbed spears are generally described by historians as using 'javelins' despite the fact that we have seen the Normans loading identical weapons (even carrying them

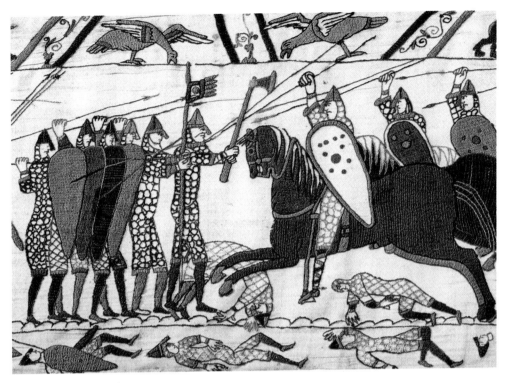

Different spearheads

in England), apparently the source of the assertion that the English preferred javelins to arrows.[7] I think we should see these 'darts' as akin to the Roman javelin, a weapon designed to encumber and unbalance an opponent's shield, rendering him vulnerable. Of course, barbed blades prevented withdrawal and would be suitable in offense and stop-bars prevented over-penetration when employed defensively, the shorter (leaf, diamond and pyramid) forms of spearhead were clearly designed to penetrate armour yet still be rapidly withdrawn and reused. It would appear that our needleworkers were artists familiar with weapons, their types and functions, as well as with warships and buildings of all sorts.

The few longer-bladed spears seen are reminiscent of much earlier Saxon long-bladed (Swanton) forms, the employment of which may at times have resembled the Japanese 'naginata', with the spear spun rapidly between the fingers of one hand, like a rotor-blade, and the hand held above the head. This would be impractical in close-formation fighting but I have seen it done and it is intimidating as well as distracting. The stopped-forms held a victim back and prevented even the most determined from travelling up the shaft. They are found in other contexts and sources,[8] the ancestors of the winged and the toggled boar-spears of the later Medieval period. Evidence, such as it is, therefore suggests that in battle the Norman heavy cavalry favoured small-point spears enabling them to

113

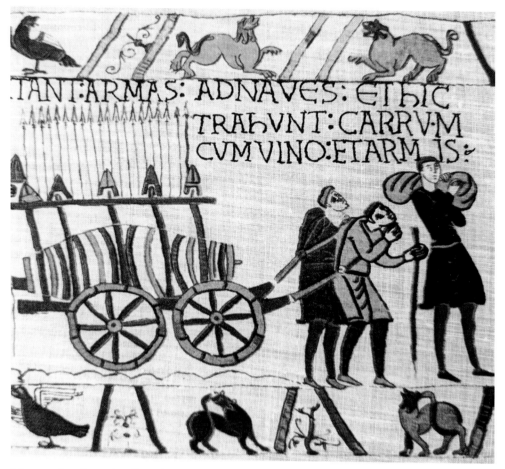

...ÍANT:ARMAS: ADNAVES: ET ÞIC TRAÞVNT:CARRV·M CVM VINO:ETARM IS:

Norman javelins, also 'Dutch courage'

maintain movement and retention by speeding withdrawal, yet stout enough not to bend when used against mail armour. This would be a good reason to avoid couching the spear as a lance and so making recovery less likely.

The standard Norman cavalry sword was a long-bladed slashing type, not far removed from the spatha of the Roman cavalryman or the Sudanese kaskara. As with a mounted policeman's baton, reach was important. Also the forward weight of the blade would improve a downwards delivery. There would, of course, be many qualities of blade, from work-hardened iron to forms of steel, which we discuss below. Unlike later *armes-blanche*, we should not imagine the Norman horse presenting point to an enemy. They expected to use their swords primarily against infantry and invariably for slashing. The same considerations do not necessarily apply to the infantryman's weapon though dismounted horsemen are unlikely to have carried anything but long swords. For close infantry combat shorter blades and thrusting movements can be equally effective. Sword-and-buckler was to become a very English form of the (recorded) art of

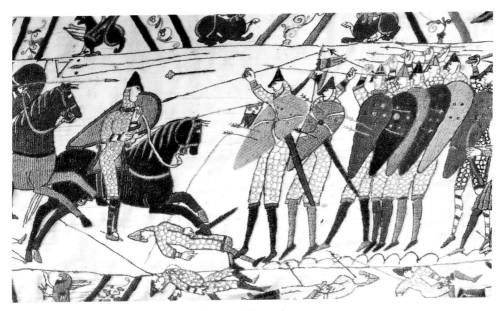

Spearheads and an example of couching with gonfanon

swordsmanship in the near future and as short blades are known from Anglo-Saxon graves it may be that some infantry used shorter swords and thrusting movements in 1066. Maybe shorter swords were employed by men who rolled under a spear 'hedge' to slash at opponent's legs, as the Spanish were famous for doing centuries later.

The long-handled, heavy bladed axes of the military men, especially the presumed huscarles (or housecarls) who we see on the Tapestry, are quite distinct from the slim felling-axes of the woodsmen shown in the shipbuilding scenes (which resemble the 'long-fellers' of later southern-English woodsmen), because the technique used would be quite different. The hatchets or clubs thrown through the air are also quite different from the 'T'-side-axes of the shipwrights. Again, we clearly see in such specialist knowledge of tools a male influence at work and as the needleworkers worked directly they knew the difference. The same is true of spear types. These were men who knew a hunting spear or a 'dart' from a horseman's spear. We can surely be in no doubt that they also knew their horses. They sound or look as though they are as far from being monks as they are from being women.

On both sides the defensive armour of the best troops was mail, later dubbed 'chain-mail' because the Victorians saw the simile. The quality no doubt varied both in metal quality and in ring-size, the finest being fine gauge, small-ringed, riveted mail formed from natural alloy-bonded iron. But as there was no such thing as tool-steel, with which to cut harder irons and semi-steel natural alloys, the majority would have been fashioned from soft, wrought-iron wire, easier to wind on to a mandril and then cut, in order to make the 'C'-form blanks required by the mail-maker. It was then necessary to flatten the open ends of each link and

115

punch through them, then to next loop four together, close the 'C' and rivet them all shut. A laborious and lengthy business that made even poor-quality hauberks, byrnies or shirts expensive items. As we see in the margins of the Tapestry it was one of the spoils of war to strip the dead and such mail was repaired and reused until the links wore thin with friction and corrosion. 'Butted' (unriveted) mail might have formed the cheapest of defences. We have no way of knowing.

The principal protection offered was against slashes. A heavy blow would still break bones even if it did not break the links, so a padded jacket or 'gambeson' was probably worn under mail. This, together with the drag of 30 to 40lb of mail was a warm outfit on cold days of battle and conducive to heat-stroke in warmer weather, and it certainly increased the effort involved in moving the limbs. Of course, soldiers become accustomed to the weight they carry, through constant familiarity, but the perspiration involved in the adrenalin-heat of battle would be tremendous, hence the need to effect combats of short duration. The balletics imagined by some reenactors are most unlikely to have been common. Nor would the mail shirt protect from a serious stab, especially a determined spear-thrust, certainly not a two-hand blow with an axe, so a shield was also essential. Other than the duke and Eustace, mail *chauses* (leggings) are rare and forearms are left un-armoured from necessity of movement.

The curious quadrilateral bindings on the chests of a number of mail-clad soldiers on the Tapestry themselves invite speculation. They most likely indicate some sort of fixing holding the mail towards the upper torso, so reducing drag and displacement. This would be effectively achieved if it also included some sort of leather reinforce over the shoulders, or even *cuir-boillu*, or else a breastplate beneath the mail, or on others as part of the gambeson. The rare armours shown on the Tapestry come from the eastern Mediterranean. One of Guy's men, with a Danish (or Viking) axe in his hand, appears earlier apparently wearing squamatid armour, a coat of scales. These offer better defence than mail because they do not have the same give, they resist more and are equally effective against slashes. Their weakness is that they are sewn or laced to a leather or fabric under-garment and an upwards thrust can therefore run up under the scales to pierce this undergarment. With such a combination of distinctive weapon and armour we are surely looking at a Varangian.

The other rare armour, apparently Odo's personal choice, is lamellar. In this defensive arrangement vertical slats a few inches long and more or less rectangular are laced together so that they overlap (like scales) but are connected at both top and bottom, allowing no upward thrust to be effective, unless the plates become detached, but still permitting great flexibility. Moreover, they do not have to be made of metal but can be of *cuir-boillu* or even horn pieces, making them lightweight, without drag, but as effective as mail. They are also more easily repaired in the field than mail armour. Such armours were a feature of Byzantine lands and of their enemies for centuries to come, being adopted subsequently by Turkish, Persian and Indian warriors.[9] In Japan, where they

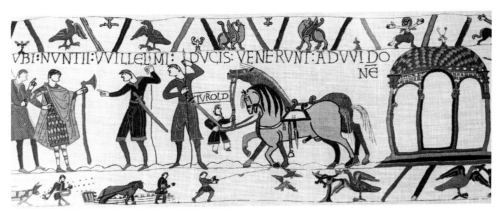

Squamatid armour

evolved independently, they even offered protection against some of the finest swords ever made. Their construction required time and skill and, of course, specialised knowledge. They are unlikely to have been European made.

Universally the armoured militus (knight or sergeant-at-arms), even infantrymen, wore a conical helmet, usually with integral nasal, usually (though not invariably) over a coif of mail. This helmet was also of several qualities, the best being of superior iron and raised in one piece with applied reinforcing bands, though some may only have had an iron cage over a leather (cuir-boillu) skull. Such helmets would ward off blows, though they were not invulnerable. The warrior's major concern would be to prevent scalp, and particularly forehead, cuts as these bleed profusely and fill the eyes, preventing vision. Blows to the nose are notoriously bloody and painful but also disorientating, hence the nasals. The serious weakness of all such helmets was the iron rim, and skull fractures would have been common. Still, a man without a helmet would certainly invite a downward blow, hence the conical shape designed to deflect vertical cuts delivered to the crown of the head to one side or the other, often (one suspects) at the expense of a clavicle. If you remember the Brittany campaign, one man there appears to wear a 'harness-cap' or padded lining. If so it is the only evidence we have of such precautions at that date.

The vast majority of armours and helmets and, of course, all weapons, relied on iron and the quality of such ferrous artefacts was all important. Iron was not a cheap material. Its production at that date was by the indirect process of extraction whereby the iron in the ore was extracted by melting-out at lower heat associated impurities. This was a lengthy process of bloom-smelting, chaffing and fining. The initial result of heating the ore was a spongy mass of impure iron, called a 'bloom', in the bottom of the furnace, a lentiform, which had then to be extracted, reheated and heavily hammered to drive-out remaining impurities while bringing the mass to (hammer) welding heat and bonding it together. There was of course no such thing as cast-iron.

117

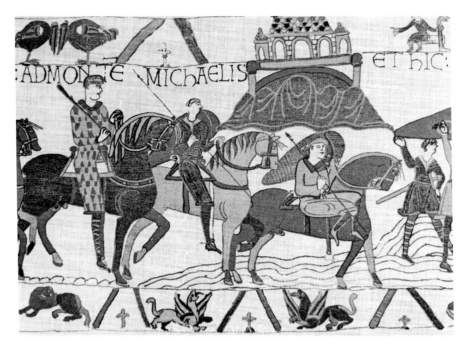

Lamellar armour

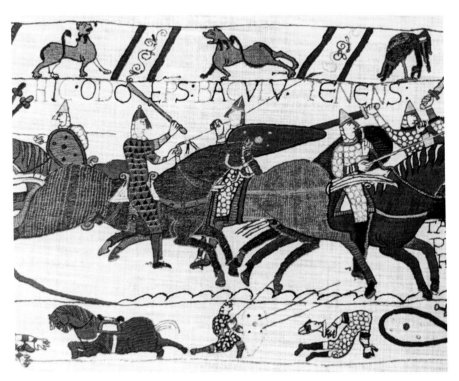

Lamellar armour

It will, perhaps, now be instructive to include some discussion of bows as they formed the second part of William's tactical success at Battle. He was aided by luck consequent upon finding water for the heavy cavalry and then recognising the advantages of a traverse. But undoubtedly the employment of archers in an offensive role to provide a distraction and covering fire was an example of his ability to adapt to changing and serendipitous circumstances with an immediate decision. It seems to me self-evident that, as he could have had no foreknowledge of Harold's defensive (defensible) position when preparing his invasion, so the archers were not originally included as part of a combined operation brigaded with the cavalry. The cavalry were always expected to carry the day against English infantry. What was remarkable about this conclusion to the battle at Battle was the use of the arbalest or crossbow against the famous English infantry of the Select Fyrd, a weapon that had not been used before in this country.

It seems to have been unknown in England and in other kingdoms as well for Princess Anna Comnena (1083-1148) commented on the First Crusade's use of them at the end of the eleventh century, as weapons previously unknown in Byzantium.[10] They were however mentioned at the Siege of Senlis (947) and at Verdun (985)[11] and, although it cannot be proved, I wonder if these 1066 arbalestiers were recruited from Basque whalers out of Bayonne, for Norwegian whalers continued to use primitive crossbows right up to 1900. Our earliest reference to Basque whalers is in 1059[12] and Norwegian crossbows were powerful enough to slow a Right Whale. The bows themselves could therefore have been very strong. We know of yew-bows fitted to arbalests much later when other materials, often presumed by modern authors to be more effective, were commonly in use. We do not know when the composite bow, built-up from wood, horn and sinew in 'sandwiches', was first employed in England, but the technique was used for ordinary reflex bows in Central Asia even before the Crusades.

The advantage of the crossbow, as said, is its ease of employment. Held with the tiller on or under the shoulder it can be easily aimed and a reasonably powerful bow would, according to Payne-Gallwey,[13] probably shoot point-blank at 50-60 yards and certainly carry for 200-300 yards, proving very dangerous at 100 yards. The kinetic striking energy of a bolt or quarrel at a range of 50-100 yards would be considerable, even using a self-bow. Such weapons required greater force than could be exerted by the arms alone to span them, being loaded by lying on the back to use the feet or by employing a belt-loop. The *Carmen*[14] tells us that shields did not stop the bolts. Reloading was relatively slow but the other advantages allowed rapid training of recruits and power was all important. The principal disadvantage at Hastings would have been that expended bolts were non-returnable, placing great demands on the supply of ammunition.

Judging by the archers on the Tapestry and by the usual practise in battle of volley-firing, ordinary bows would have been used for 45 degree angle parabolic fire, whereby their weighty projectiles would transfer kinetic to potential energy. This would allow them to fire over the heads of the crossbowmen and

at considerable speed. In this way a steady point-blank, flat trajectory fire from crossbows would ensure that English shields were presented to the enemy while parabolic fire rained-down from above. Unless the English had been trained in the Roman *testudo* formation the results would have been murderous. Harold has been our witness to this. The range of self-bows is difficult to estimate. Later longbows regularly practised at 10-12 score yards (200-240 yards) and 14 to 14½ with lighter shafts. Thus, a range between 150 and 200 yards parabolic is not unlikely in 1066 and although not capable of piercing a shield at 100 yards was still injurious.

Though not a weapon, mention should be made of the triangular stirrup-iron and the use of stirrups so clearly shown on the Tapestry. Especially when employing a heavy-horse, as opposed to a pony, the stirrup does provide a rider with additional stability and even the ability to rise slightly from the saddle in order to increase the downwards force of a descending sword-blow. This said the horsemen on the Tapestry do appear to ride 'deep saddle', which would be less tiring over a period of time than 'posting' and together with stirrups and the high cantle-pommel saddle such a posture would make couching of the lance effective. And stirrups, of all things, tell us that these warriors are not copied from some ancient Roman document, they tell us beyond a doubt that these scenes are from the life and contemporary for stirrups were, in 1066, a recent introduction. They had not existed in the Roman world.

# Chapter 10

# The Psychology of the Tapestry

Two major lacunae stand out from the vast body of research, speculation and discussion that surrounds the Bayeux Tapestry: a failure to apply logic and a failure to grasp psychology. Strange as these may sound I think them worthy of consideration. We can approach the psychology of the Tapestry from two directions. We can ask what did contemporaries require of it and how did they interpret their met expectations? This is the psychology of the original users. Secondly, we can ask what do we now expect of it and why do we interpret it in this way? This is the psychology of interpretation. There is a wide divide between these two approaches, just as there is between our two separate societies and cultures, though in each case we can say that people tend to favour evidence that may be used as an exemplar and, thus, so much may be in common. We will naturally think of our own expectations as far more sophisticated than theirs, but that misses the point that our objective is to understand the Tapestry's creators and users, not to rehabilitate them or to attempt to integrate them into our own age. As with words, we have to ask what did the pictures mean then? We must also ask what the grouping of individual picture elements might have meant? While the psychology can be described as subjective, the application of logic is the objective study and is therefore probably the easiest aspect to discuss. Let us commence with logic.

Logically it is fallacious to say that buildings or clothing shown on the Tapestry are inaccurate or notional, for if they are, then so are the tools depicted and so doubt must be cast on the storyline, and in fact the whole, now pointless, Tapestry artefact. What would be the point in creating it? Both logic and experience tell us that the physical objects of the historic past, whether artefacts or depictions, are not subject to the same political distortions as a story-line will be, whether one that was deliberately written or one freely deponed by witnesses.

This is why we create museums containing collections of artefacts, so that we might reassess the truth of our traditions periodically. Objects may indeed be rearranged to conform to a constructed story-line, to illustrate a political view. But they are of themselves. They are physical and honest and are primary evidence. They do not lie, Only interpretations of them lie. What we have to

do is accept their logic rather than any pattern that has been imposed upon them. A gun may be proved to be the murder weapon employed, but the story behind its employment may be subject to many different narrations, especially by opposing counsels. If the objects shown on the Tapestry are not everyday objects, recognisable by anyone at the time, but inventions or adaptations from some other culture, then the story told must certainly be fictitious for there will be no points of reference left at all. If the gun is not a gun, then one can neither prove nor disprove the murder. This Tapestry artefact is designed to tell a story, one that contemporaries would believe. That surely was its purpose, whether in lies or in truths, to instruct. The caveat is that we do not have to believe the story, only its constituent artefacts, the three dimensional items it displays. It may be political, yet its basic elements will be real and so they will be inherently truthful. The gun may or may not be the murder weapon, but it is certainly a gun of given type, calibre and make, that validates it as evidence.

The psychology of the Tapestry is equally complex. To take a simple example, speculations involving the movements of military forces in 1066 are inevitably underlain by an expectation of detailed local knowledge yet how, in the total absence of maps, signposts or even any concept of aerial overview, could strangers navigate unless they had accurate, possibly even willing, co-operation from local guides, or unless they had thoroughly scouted the countryside? We have generalised locations (north, south, east or west) planted firmly in our subconscious, but to a total stranger in a new landscape in 1066 the objective might simply be 'over there'. Certainly no concept of looking down in aerial over-view, no knowledge of the shape of our island. No one in 1066 could imagine or draw an outline of the British Isles. It had not been done though Tacitus had recorded its circumnavigation and so some knew it to be an island.

It is an error to approach the psychology of depictions by employing a set of values devised for another era or culture, in this case our modern world, let alone to compound this with further expectations of a separate cultural vocabulary, including expectations of post-Renaissance artistic conventions. The Tapestry has been condemned for not showing landscape depictions, yet its contemporary viewers never expected to see such things. They would have been baffled to understand scale, vista, topography or vanishing point – spatial perspective was incomprehensible. It was not until c.1400 that such things were attempted in western art, whether vernacular or esoteric. The real question is, why would a landscape be included at all? Why would they need a *mis-en-scene* for their drama in a world that had no theatrical traditions? Yet to a modern viewer such acceptance of alternative conventions is subliminal. We argue that they must have wanted one. Why? The occasional simple marker would be sufficient to provide what we might term locational punctuation.

Similarly, we are also afflicted with a revisionist culture seeking to transpose the everyday images of the Tapestry onto an earlier biblioscape. If this was the case we might view the inclusion of those everyday items not known at all in

the Latin past (such as 'T'-(side) axes, horse's collars, the detailing of ships, the use of stirrups) as additional and educational inclusions, providing a vernacular grounding for the otherwise religious, esoteric and academic training of senior clerics immersed in ancient graphics. That would be a thoughtful provision in any age but hardly welcomed. Of course, there is no reason why stylistic influences should not elide from age-to-age if exemplars were employed[1] for we are all subject to subliminal memories that emerge without conscious effort. But this form of instruction would then have surely derived from the scriptorium and one doubts that needlework was taught alongside illumination. Even if it was, we have no evidence of a cartoon for our Tapestry. Without one we have no evidence at all of instruction, only evidence of everyday familiarity with the objects depicted.

As no trace has been found of an underlying cartoon the canvas must have been worked directly. It therefore follows that the needleworkers of each section were experts in technical fields, suggesting that these needleworkers were men, at least when detailing male activities, for how would they otherwise have such precise knowledge of technical objects and exclusively male activities? Given the simplicity of the needlework it would be easier to teach a soldier or a sailor to sew pictures than to give precise instructions on ship profile, sails and rigging to someone who had never been to sea. Maybe, then as now, most sailors and soldiers were competent needleworkers.

The problem for revisionism is that the everyday objects of the Tapestry are, undeniably, just that and some of them (e.g. horses' draught-collars) unknown before in any earlier illustration, not even repeated for centuries to come. Even the standardised armours are realistic: the new kite-shape for shields, individual gonfanons, the form of swords, the exceptional appearance of a Dacian shield and also of squamatid and lamellar armour, while the stirrups shown are not found in any Roman depiction. Let us be realistic. Standardisation would be just that, devoid of individuality, yet individuality is revealed in every aspect of the Tapestry's pictures. The copied, the notional and the formulaic are, by definition, neither individual nor ahead of their time and may not even be practical. So logically they could only be repetitive, imperfect, antiquated and simplified. Many of the artefacts of the Tapestry are unique and, seemingly, ahead of their time.

To speak of the landscapes of the Tapestry is to invoke and implant an alien, modern world onto the past, one that wants and expects to see them, moreover one that can also classify them. This destroys the integrity of the historic experience. Quite apart from scale, vista, topography and spatial perspective, which we take for granted because we have been taught to perceive them in the interpretation of more recent depictions, together with a general conviction that every 'stage' should have its scenery, the very morphology of landscapes was unknown at this time for the simple reason that no relevant, let alone cogent, set of definitions existed, no lexicon. Men deponed in *Domesday Book* (which is our only verifiable

reference) in common nouns but also according to their different understandings of landscape elements and not according to fixed, universal definitions. There was no set vocabulary.

The people of the Tapestry, its contemporary viewers and its creators, had no need of a visual landscape background, because that was not the purpose of the embroidery. They were not interested in seeing landscapes, seascapes or townscapes, for them the action was all important. As with a child's game of soldiers (or farms) a landscape did not matter, only what happened in it, though from time-to-time, in order to clarify the action of the story, it would be necessary to indicate the crossing of water (otherwise why the toy boats or pontoons) or to add the punctuation of an odd tree-group. Trees, buildings, animals, birds, even activities, were merely props for the unfolding story. They were necessary to provide occasional clarification, to provide a basic framework that would support the 'actors' shown on this stage of life. But mostly they told the story, hence the duck and the heron at Pevensey. They told of fenland and, incidentally, of autumn as well as displaying human attributes. What is an interesting social detail is the accuracy of these props. For example, we can distinguish not only trees but that trees are on occasion pollarded oaks. How accurate can you be? These are hardly notional or even formulistic trees.

It would, of course, have been ridiculous to confuse the 'production' (Tapestry) by gratuitously inserting alien matter, so the people and the props had to be down-to-earth, everyday-depictions, not introductions from elsewhere. The structures depicted on the Tapestry can be demonstrated to have existed, not only by replication but from surviving and archaeological evidence. To deny them is nonsense.

Having stated all the above, the action on the battlefield shown by the Tapestry leaves much to be desired. We would love to know more, so we try to read more into it, though we should remember that it is a story. It is only as reliable in its set of actions as William of Poitier's account or Wace's, or any other (including monks in Peterborough listening to hearsay). The story will be spun by the tellers. The advantage of winning is to get to write the history. Even if vouched for by an eye-witness, how reliable will one soldier who was in one place on the battlefield be? His experience was limited and stories when repeated not only move outside a locality, they also change according to who is telling what to whom. Memories become more consolidated in time and sensory limitations as well as training will influence the attention paid to both features and to recall, as psychologists know. Are we not missing the point of the story told by the Tapestry? The actual study of politics and tactics did not matter at all to contemporaries. Justification and bravery did. Divine justice did. Battle scenes, here and on later tapestries, conveyed what was important to contemporaries and the tactics employed were of no interest (especially if they concerned the unimportant mass of common soldiery), because analyses of the mechanics of power and politics were not appreciated until exemplified by Machiavelli[2] and warfare was not systematically

analysed prior to Guibert[3] and Clauswitz[4]. Contemporaries of the Tapestry did not think of battles as won by genius but rather by bravery, leadership and divine intervention. Besides, who in their right mind would divulge and advertise the secret of their military success? Most viewers wanted to see a tale full of sound and glory, signifying nothing. Success created the righteous war long before Machiavelli, thanks to Eusebius of Caesarea and Augustine of Hippo.[5]

The organisation, identification and interpretation of sensory information, in order to understand the environment of the Tapestry, comprises our perception of it and intersubjectivity can only proceed from proper cognition. Dismissing any likely source of evidence can only result in distortion and ultimately in disaster, for psychologically the society that required this artefact had its own cultural and social values, ones we need to recover if we are to understand this society. We need to learn to judge the peoples of history from an ethnographic perception rather than attempting to justify our own present values (and prejudices) by implanting these onto the past and then claiming some sort of descent. History is not a justifying excuse for present failures, but a study of progress (in the abstract). In this respect the figures in the margins are as valuable a source of information as the schema itself and by attempting to understand them psychologically we have now unlocked the Tapestry, though we still have to admit that we may never know it all. Sadly, much of our early Medieval history is still in thrall.

The entire picture of the Conquest handed down to us by text and Tapestry is in reality presented (and perverted) by the victors and we have been psychologically enslaved by them. We have no wholly English account to set against this overwhelming propaganda. The only snippets any of the English have left us are contained in the *Anglo-Saxon Chronicles*[6] which, although written in Old English, were completed after the Conquest by writers under the strict supervision of their victors. It is a common misconception that they were compiled by some exiled community. They were not for, like all such chroniclers, they were directed by their Norman superiors. Such writers complained of local conditions, restrictions placed on their conventual houses (especially of taxation–related matters, which they had no means of understanding and deeply resented), all without any real knowledge of the outside world, without what we would consider a single reliable source. There was no BBC, there were no press or television reporters and so their knowledge and observations were restricted to purely local and minority sources, coloured by the credibility they attached to fortuitous arrivals at their doors. They recorded the concerns of their new masters and without verification had to accept hearsay. And, as we have seen, stories may change as well to conform to the expectations of the listeners, even when the intention is honest. Memories can be influenced by spiritual, theistic and fantastic imagery, a good example being *The Angels of Mons*, but listeners themselves can also rearrange received information. If a result is entirely unexpected, then the accuracy of memory itself is likely to be highly questionable and, in our context, interpretation is likely to be confused through the application of religion or superstition.

Psychologically these confined clerics were not 'of the world', only of their own, cloistered, environment. They were writing in order to please their superiors and subject to savage monastic discipline, hardly prone to self-expression or error. They described events as they understood them and as directed and were in no way impartial or dispassionate witnesses. They were not true witnesses. The Conquest was to them an 'Act of God' and even the English believed that their misfortunes and humiliations were punishments for sin.[7] Yet we have to acknowledge the Conquest as a complete game change, especially the replacement of former landholders by a very much smaller group of chief-tenants who then doled-out sub-enfeofments. Virtually the whole of the kingdom was confiscated, passing from diverse and ancient influence under a kingly hand, moderated by advice from a counsel (Witan), to a novel, exclusively regal and entirely personal possession. William, having no experience of regal responsibilities, brought with him the despotic outlook of a Viking, stamping on English kingship a personal fiefdom that even exceeded the indolence and ignorance of the late King Edward. No trace of any former social hierarchy appears to have survived the Conquest and this degree of change had never happened before, not even in the Migration period.[8] England's thirty-four shires were under a single unrestrained hand, a despotism, for the first time in their history. With such a thorough erasure of the established system and such comprehensive replacement there was never any hope of a return to former values, nor a review of earlier structures and history. So all that remained for the future were the victor's achievements and records.

We have already made an association between Bishop Odo and the subject of our Tapestry, together with the probability that he wrote the brief that gave himself so much emphasis and prominence. After all, who but Odo could have been privy to the secrets we find half-divulged in the Tapestry's first section? There was no tradition of creating an official history and there was no reason the Normans should feel obliged to set the record straight for posterity. They had won and where else do we see contemporaries creating a dispassionate record of achievement? The closest motivation for our Tapestry is a Viking propensity to boast, so that if we accept Odo as the author of the brief, which was worked-up into a bombastic announcement of victory, we can draw some interesting conclusions as to his character. His personal seal displayed a bishop on one side and a knight on the other and we can conclude that his church militant attitude owed more to Viking blood than to religious zeal.

The first section of our embroidery has always been taken to be a history and it certainly introduces, retrospectively of course, the concept of the ailing Edward in need of a successor. But have historians been misled by their own sentimentality for a supposedly saintly figure? King Edward's concept of kingship had more to do with ideas of personal pride and possession than with a Witan and the English. It seems as though commentators have imposed a full-blown feudal structure onto a pre-Conquest society in spite of the warning from David Douglas that

there was no such development in pre-Conquest France or Normandy, let alone England. Supposing the embroiderers were told to emphasise Edward's frailty simply as a retrospective justification for installing post-Conquest social stability: a strong man was needed in order to govern? Nowhere does the Tapestry tell us of a promise to anyone in particular, a strange omission if the succession did depend on direct nomination. Yet the sheer detail in the opening chapter of the story declares its importance to its author. It is no pre-amble but was seen as a definite necessity in the brief. I think it to be far more convincing as a demonstration of the out-witting of Harold, in which case this first thirty percent of our narrative is dedicated to boasting of how the biter was bitten by a clever bishop and his brother.

We have seen how Harold was regarded as a wily fox, acknowledged as such on the Tapestry but also in the *Vita Ædwardi Regis*, a clever and scheming politician whose reputation was well-known, whose accomplishments were acknowledged, a man well-fitted to govern a kingdom. From the first it appears that Odo was keen to present himself as Harold's superior in cunning, his pride in outwitting him created this self-congratulatory and openly admitted declaration of how it was done. In the process the embroiderers were given a few snippets of restricted information, just to bolster vainglory. In addition to this, Odo was also able to present himself as a military leader, a commander on a par with the acknowledged General Harold. Though our Tapestry is concerned with historical events they are nevertheless vehicles by which Odo can develop his own legend. He is seen as advisor and planner to this great and ultimately successful enterprise, but he is also presented emphatically as the spiritual inspiration, thus combining temporal and spiritual accomplishments. Finally, we see Odo the warrior once again and here he apparently saved the day when the cavalry, and possibly even William, wavered at a critical moment. Who knows, perhaps the winning tactical inspiration was his? Who observed the traverse? Who instructed the archers? We do not hear of Odo in at the kill and clearly someone directed the archers, and someone wanted them prominent on the Tapestry.

Here we have a fascinating self-appraisal and psychological profile of the Bishop of Bayeux, banned from the true glory and rewards of his genius by his religious vocation, confined by his cloth. And if he enquired about a bishop becoming a king, well that would not be surprising and until the final expression of feudalism was formulated by William (on Salisbury Plain in 1086) all things (in 1067) were possible. Odo certainly understood the psychology of leadership. Before the advent of massed armies, a commander had to lead from the front and be distinctive – and no one could miss Odo in his lamellar armour, unlike William in his mail hauberk. At this date there was no defined heraldic structure by which to distinguish one's leader and the shields and gonfanons we see displayed offer no help in identification, but the armour was unmistakeable. If Odo understood the psychology of command and was such a competent self-publicist then I think we can accept that he had as few scruples about challenging a sibling as most of his noble contemporaries exhibited.

We must not lose sight of the fact that in 1066 the hearth-troop was still the war-band and there was no structural deference (among the nobility) to birth or 'blood' – there was no feudal psychology. The 'I'm as good as you' mentality stands out in William's dealings with successive kings of France. At heart such men were still Viking leaders. There was no Norman army, rather a combination of hearth-troops under several banners and Odo had his own milites and no doubt both Odo and William were able to recruit by offering gifts of destriers from their own studs to free-lances. It was only after the Conquest of England that true feudalism was born for it was only in England that such a legal structure was enforceable.

Undoubtedly a major influence on this invasion, as on attempts just before and after it, was the unique existence of the geld. The post-Conquest need to regulate and verify such payments among the new super-rich then led to the major audit known to us as *Domesday Book* and this in-train created the English feudal system, that is the feudal systemisation of England under a despot. This was not merely a hierarchical system of holdings and sub-lettings as had already been practised in Normandy, but a system acknowledging the crown as its ultimate source, with all such feudal fealty sworn primarily to the crown, all tenures and property being hereafter devolved as of the crown, ratified by the oath-taking at Salisbury in 1086[9]. It was King William's bargain with his vassals, consequent upon the Domesday surveys and his personal acknowledgement of all free tenures. No longer could an Englishman or a Frenchman swear fealty to a lord alone and then use his oath and membership of a hearth-troop as an excuse for disobeying the crown. From 1086 onwards, primary fealty of the individual was to the crown, over-riding all previous proto-feudal obligations and commendations to an immediate overlord.

From then on succeeding generations of land-holders, whether holding 'in chief' or merely their humbler vavassours, traced their pedigrees to the Norman (legal) validation of the actual Conquest as secured by Conquest-period grants in *feudum* to themselves. Over the centuries, as the feudal structure crumbled and capitalism gained the ascendancy, the feudal mechanism was forgotten, while such holdings turned into freeholds, and so the direct lineage claims turned into pedigrees that (thanks especially to civil wars) could also convert vicariously by death, forfeiture and regranting, becoming property rights and not just lineal pedigrees. This made descent by one scale or the other, but still from some half-perceived Conquest validation, psychologically even more desirable both to the landed classes and to parvenus who had taken the vacant places and who now aspired to belong. By the nineteenth century it was socially essential for them all to establish a firm link (however hypothetical) with the Norman Conquest. The history books pandered to such needs, flattering such land-holders (often relatives) and especially the aristocracy, as a superior race, naturally advancing claims to fame originally derived from the victor's histories of long ago. After all, there were no others and the French Revolution had badly shaken the established social order. The Saxons/English were written out for lack of any defence or reference.

Late-nineteenth-century historians pictured them as incapable of government or self-defence, lazy, drunken and retarded. Even the objective Professor Maitland descended to the observation that 'their (barley) fields were wide because their thirst was limitless'[10]. Only a vernacular undercurrent of egalitarian legends (in particular Robin Hood) remained as a protest. Because possible remnants of the English landholders of 1066, now the English squirearchy, had never even been suggested as Saxon/English, it was accepted that they too must be anciently and wholly Norman for they were now socially and educationally superior to their tenant farmers and, of course, aspired to belong to the aristocracy.

New World democracy, nostalgia and new technology assisted by financial considerations, amplified the Robin Hood or Saxon/English rehabilitation in the twentieth century, it was good for business. But by then the established (and establishment) academic view was that England's history had only really begun in 1066, with the arrival of 'civilization' in the form of a dynamic master-race, the polymath Norman supermen from whom the old aristocracy were certainly descended. These were virile and active warriors, hierarchical and disciplined, who built castles and churches everywhere, restored religion (including the Latin tongue so essential to an English education), created books, laws, *Domesday Book* and the Bayeux Tapestry. They were the civilizers. It was impossible to challenge this accumulation of supposed evidence, all founded on the victors' own accounts, without appearing to be socialist. At least not until Holywood came along. This was the cement of the social order. Politically, socially and psychologically it was accepted that however questionable the technical pictures and details on the Bayeux Tapestry might be the actual details of the (non-physical, unprovable) story it told were beyond question. Psychologically, students should accept the story yet refuse to believe the evidence of their own eyes. The architects of the established social order, the establishment, knew best.

In our history books important history began in 1066. Yet the Saxon/English were far from militarily incompetent, as I hope my analysis of the battle at Battle has helped to reinforce. Even in this narrow window of perception the psychology of refusing the evidence of one's own eyes and intelligence reigns supreme. In spite of the solid evidence of the Tapestry the stereotypical picture of the Saxon warrior is of a man often without armour and always with a round (and flat) shield. The formidable Colonel Lemmon has even told us that the Saxon armour shown on the Tapestry is wrong.[11] This picture-in-the-mind is so pervasive that re-enactment groups still perpetuate it, specialist history magazines present it[12] and documentaries fail to challenge it.

It is indeed difficult to comprehend how such a relatively small group of invaders was able to seize power after 1066. That is the nub of the problem. The invading army has been estimated at between 8,000 and 10,000 men (though there is no real way of establishing a figure), of whom at least twenty percent, maybe more, must have either died at Battle or succumbed later from their wounds, maybe even more from sickness. In *Domesday Book*, of those Norman names we

know were at the battle, we find surprisingly few holding lands twenty years later. No doubt William's initial success drew in even more adventurers and mercenaries from the whole of western Europe but the wastage due to disease and campaign post-1066 must also have been enormous. Moreover, the supply of milites was not infinite yet Europe continued to find sufficient combatants for numerous wars of its own. If the English had seriously contemplated resistance I believe they had a national strength of between one and two million men and boys all told, not the ridiculous 200,000 so often quoted as recorded in *Domesday Book*,[13] and they also knew their countryside far better than these strangers. They could have put up serious resistance, but they did not. I wonder why. It is time the question was asked.

The events of the years immediately succeeding the Conquest do seem to have been reduced to a simplistic 'us' and 'them' argument for convenience, the 'us' being (to be politically and psychologically correct) the inheritors of the Norman achievement, but this is hardly accurate. Liquidising history in this way entirely ignores the desirability of the kingdom in 1066 and its diversity, including underlying pre-Conquest tensions between the far north and the shires to the south, as well as the more subtle differences between the old Danelaw and even older Saxon England. It also ignores the simple question of where did the dispossessed survivors of 1066 go, those landholders who had gone into hiding after the battle? The companion to this is where did the sudden increase in minor sub-infeudations, minor mesne lordships, come from in the twelfth century? Their Norman-French names do not guarantee the same pedigree. It seems to me that a root-and-branch re-appraisal of the process and mechanics of this Conquest period is urgently required. We need to understand how and why an accommodation was reached with these foreign invaders, one of such magnitude and so comprehensive. Economics would seem to be the key, though it may be easier to understand as wealth.

I think that one problem has been reluctance to discuss – the ethnic divide between England and the Danelaw, even the more Viking orientated north. The creation of a Danelaw had brought in new settlers with a new language and novel systems much earlier, yet the resulting composite of vanquished, beer-drinking race(s) of 1066 is still not credited with any superiority over wine-drinking foreigners, 'good Christian men who live upon wine [and] are deep in the water and frank and fine', as Belloc put it. Not taking the accommodation made by Alfred and its cultural consequences fully into account has been one of the major handicaps to the study of *Domesday Book*.[14] However, this remarkable and unique administrative achievement shows that the Saxon-English grasp of administration and of arithmetic was far superior to any of these invading peoples and it survived these culture-clashes, though nevertheless modified by fusion. The accomplishment of the audit (*Domesday Book*) represented the culmination of a long and ancient cultural process, one corrupted by incomers' logic but then developed and ultimately refined by a need to accommodate such changes.

After 1086 no comparable document to Domesday was ever again produced in western Europe, so the skills required for its production were inherited by the new administration of 1066 and not, as we have so often been assured, introduced by them. Fundamental to the collection of the geld was the ability to assess tax-liability and this was only possible through the application of a *Capitatio Terrena*.[15] Its accomplishment relied not only on records and scribal/clerical competence by royal servants but also, essentially, on the ability of very ordinary inhabitants to each measure their own *vill* and its appurtenances, it relied on education to a remarkable degree. If we have those amongst us who still wish to maintain that the Normans were far better fighters than the Saxons, we have to interpose that the Saxons at least could count, measure and calculate.

Apart from the victors' histories, panegyrics of self-praise and praise of the ruler, we really have only two objective sources of evidence for this Conquest period: *Domesday Book* and the Bayeux Tapestry. We have deduced that both of these are English creations, though both were designed post-Conquest in order to serve the victor's purposes. *Domesday Book* is purely impartial. It is a ledger-record not designed to present the Conquest as either 'good' or 'bad' but only concerned with the changes it produced in local economies and in a tax-system. The Tapestry, however, is not impartial insofar as it tells a story, for that story is as concerned with justification as are the panegyrists. Inherently it is neither honest nor accurate. The depictions, however, the people and objects shown on the Tapestry, cannot help but be accurate and impartial artefacts created by the vanquished, yet such is the psychological response to both *Domesday Book* and to the Bayeux Tapestry, a response promoted particularly in the last century, that we now accept the deliberate fiction it presents as 'fact' while simultaneously dismissing the real facts it presents as fiction. Surely this must be the ultimate example of successful victor's propaganda.

# Chapter 11

# Who Embroidered the Tapestry and How?

When the Tapestry was first recognised and throughout the nineteenth century the answer to this question was easy: *Le Tapisserie Broidé de la Reine Mathilde*. It was at Bayeux, so it was the Bayeux Tapestry. Now we know that it was made in England and it is doubtful it was made for Bayeux Cathedral, it seems the legal title to the artefact rests with the English crown, for a felon's goods (at that time) escheated, along with his estates, to the crown. So, if the bishop's English tapestry is argued as not belonging to the English crown we might ask whether the French are also entitled to possess the bishop's earldom of Kent and his estates elsewhere in England. I think not. Furthermore, if it was not embroidered by Queen Matilda, we need to ask who created it? And, of course, it is not a tapestry. Is it not surprising and more than a little embarrassing that even after 200 years of intensive study we know comparatively little about it or who made it and have given it such erroneous common and legal titles.

Currently academic opinion favours an embroidery workshop in Canterbury, because the iconography suggests (to some scholars) references to texts known to have been available in St Augustine's monastery and it also favours direction by some senior (Norman) academic who could instruct the (inferior) workforce in the fine details required. That there was a team is undeniable. The variations in style and depiction are self-evident and, as an embroidery, it is argued that this team must have been female. This leads many to the conclusion that a convent, in or near Canterbury, possibly one concerned with important pieces of embroidery such as *Opus Anglicanum*, was responsible but under the direction of some scholar capable of astute, esoteric connections only understood by men like himself and able to borrow very expensive books to use as exemplars. Why this team of women should have been directed by the equivalent of a university don with the experience of a modern encyclopaedia and also with Rabelaisian propensities is an interesting question.

It seems to me that this line of arguing has become quite attenuated, though it does allow us to dismiss many of the Tapestry's difficult details as inventions,

imaginary, or copies of older and male-produced, manuscripts. It also seems stereotypical: women do the 'women's work' while men provide the inspiration and academic input. Nor is this purely a gender-based argument for it was a male preserve to produce documents, to illuminate them and to study. However, other and certain male preserves were warfare, sailing, ship-building, hunting and the construction of buildings of all sorts, especially of military defences. It is not only instructive for us but it is also a severe handicap to the traditionalists' theory of female embroiderers that there is no evidence of an outline drawing or cartoon, though it is claimed there must have been one.[1] Why is that? If no trace has ever been found it is safest to assume that it did not exist. We should not twist the facts to suit our theories. It is true that we know of English gold-embroidery (*Opus Anglicanum*) that required a cartoon, but our Tapestry involved neither bullion work nor consistent repeat motifs. It involved no complicated stitches or heavy background filling. Given that we have no trace of an underlying cartoon and given that any senior clerical academic would certainly have spent a life completely divorced from any of the fields of specialisation enumerated above, how did the women supposedly involved come by such accurate information? The traditional explanation, that the Normans were a master-race of polymath supermen, just will not hold water. So, who was it directed these English artisans? For we certainly know it could not be a clerical superman, ignorant of the world. In fact, the number of accurately represented specialisations in all-male activities provides us with a mass of vignettes that also and by far outweigh the few possible (unproven) references to manuscript illustrations. The men who directed the search for manuscripts would not be familiar with the real world either, such was the divide between the cloister and the world, the religious and the secular at this time. In fact, it is doubtful if any individual possessed such comprehensive expert knowledge.

In the course of this study we have analysed a number of specialised fields. We have seen that shipping and sailing were very well understood by the artisans of the Tapestry. Similarly the tools of the shipbuilding trade were known in detail. Yet they did not know how to ship and unload valuable horses. Some of these embroiderers were humble enough in origin to know the tools of agriculture and its practise, including undoubtedly unique details. We have seen that building with earth and timber was accurately depicted with stave-construction, reverse-assembly and trapped joists evidenced in civil and in military architecture. Then in the wider military field these artisans not only knew different weapons, they also knew different spear-types and their functionality, they knew mail armour and that high trajectory fire from bows draws to the chest and not to the cheek or mouth and some among them knew about the very rare armours of the eastern Mediterranean. From our discoveries we can say that some were English but some possibly of Scandinavian origin. I think that there can be no doubt that these artisan-embroiderers were men, not women, and that they were not monks or clerics, in spite of their expertise in fables and also in religious imagery. The layman would

learn such things from clerical instruction, but no such instruction or experience of the working world would be available to the cloistered cleric.

What were these specialists with military experience doing as embroiderers? The flamboyant colours we see in the margins may themselves offer a clue, for while unusual colouration certainly adds variety to repetitious imagery, it might also be the result of colour blindness. Colour and form are located in the extrastriate cortex and cerebral achromatopsia is colour blindness arising from ischaemia or infarction of the ventral occipito-temporal cortex and is frequently more complex after brain trauma.[2] Therefore, insult to the head could cause colour-vision loss or confusion while a blow behind the left ear, say over the top of a shield, to this area would be very dangerous. Given the common form of helmet, 'boiled egg' fractures of either skull hemisphere must also have been common. Here would be one explanation for achromatic representations: some of the embroiderers may have experienced traumas consistent with injuries sustained during military conflict.

The needlework technique employed (laid and couched work with stem and outline stitches) is not particularly sophisticated. Neither is its execution here as competent as contemporary bullion-work survivals. Because the execution of these stitches is open and swift (helping it to be lively and engaging), I suggest that such products may not have been uncommon in the dwellings of the affluent. Later, true tapestries came from documented ateliers, employed cartoons and were woven with greater sophistication and labour. The amazing display of technical knowledge on the Bayeux Tapestry lifts it from the amateur field and being an embroidery, not a true tapestry, any cartoon would have been worked on the linen base, which would certainly have left traces noticed over the years. Had it (like true tapestries) been designed to be heritable and portable for a peripatetic lifestyle, it would have been in sections, not presented as a continuous panorama. We know that in the later medieval period in England and Italy royal patrons employed large teams of mixed male and female workers under the direction of male designers for whom creating a cartoon, or pouncing the more repetitive elements, was common practise.[3] At this date however, c.1070, we have no records to assist us. We see a markedly different workshop arrangement to that of any of the later true-tapestry products.

The intrusion of interlace or ringerike design is an obvious clue, but it is very much harder to say how many separate pairs of hands were involved over all. Indeed, this would make a study in itself. The scene of woodsmen felling trees for the shipwrights is accompanied by particularly realistic birds, which we can accept as woodpeckers. So did the same hands embroider the whole scene at this point, someone who knew 'man and bird and beast'? When William's forces make landfall at Pevensey we see a very convincing duck springing skywards. So what else can we relate in this section to one person with the 'fancy of a fowler'? The wyverns are, again, different where 'Duke William exhorts his knights', while the mounts are decidedly wooden and the winged horses above them quite amusing.

Yet where 'English and French fell together in battle', the liveliness and originality of the afflicted mounts is remarkable and clearly informs the viewer that some of the needleworkers were better at horses than others. They were, presumably, horse-men to have such empathy with these creatures. They feel for the poor beasts, they are more to them than expendable tactical units or financial debits.

There is a good deal more we would like to know about the practical production of this artefact. Was it worked in sections and these joined and camouflaged with an infill, or was it continuously worked? The latter seems the only feasible explanation as it would be essential to maintain tension while each section was worked. This suggests that a reasonably long piece was sewn together to be worked to completion, then rolled-on from one roller to another within a long frame, and this would also allow top and bottom tensions to be maintained, presumably by lacing to each frame as show in later illustrations[4] and as with the preparation of vellum and parchment. The variations in Tapestry width are explicable as changes in density of weaving of the original linen ground of 18 inches stretched by the lacing and perhaps also accompanied by dampening the workpiece in order to improve tension. Such a method of working by winding a long length is radically different from any later methodology for either embroidery or tapestry, but then we have no record of male-only embroidery teams at a later date, or of such virtuoso displays in technical detail, or of such a lengthy single work-piece, all of which are unique to our embroidery.

The choice of ¼ toise for the depth was probably dictated by the reach of the embroiderers (weavers could have gone a full toise), for whether working in underside couching or another stitch it would not be easy to raise (pinch) the surface of a tensioned workpiece held between end rollers and with tensioned side frames, so two hands would be required in order to pass the needle from recto to verso: width was dictated by reach. The individual stitches seem to vary a little from 1mm each to 2mm, granting the effect of mass even at close range. Nevertheless, this methodology is economical for it leaves large areas of the linen field as an exposed background (unlike *Opus Anglicanum*) and it uses only wool and no expensive silks or bullion. Those brief reversals of events, such as the death of King Edward, may have been included for emphasis, but they could also be the result of one team of workers jumping ahead prematurely instead of checking with their supervisor what the team behind them were doing. The economy of the method suggests the workmanship is good, but it has not been laboured, the product will not ultimately be fit for a king, certainly not for God. This is a practical, everyday commission, nothing out of the ordinary for this workshop but required by the patron as soon as possible.

Its cartoon-like quality is not the result of a lack of artistic technique among all contemporary English illustrators (as commentators sometimes imply), but of the vernacular nature of this workshop, which did not engage any great artists, while the open background is the only possible technique for such an enormous textile. The temptation has been to represent the style as less sophisticated than,

say, Continental illuminations, but this is a total misconception. Manuscript illustrations of pre-Conquest date are both sophisticated and distinctive, for example the *Benediction of St Aethelwold*,[5] datable to the 970s, has much more embellishment and is far more sophisticated than the Bayeux Tapestry, while the *Grimbold Gospels*[6] produced at Winchester in the early eleventh century has both sophisticated figure-work and composition. It is true that after the Conquest surviving illumination styles do begin to change from an insular style and to absorb influences probably derived from Ottonian and Carolingian manuscripts as, for example, the Trinity College Psalters' depiction of St Eadwine writing,[7] but that belongs to a later date when there had been time for new men and new influences to intrude into a requisitioned scriptorium.

That artistic sophistication could be transferred to textiles is evidenced by the silk embroidery (*Opus Anglicanum*) fragments taken from St Cuthbert's tomb at Durham, said to have been the gift of King Aethelstan or of his queen, made at Winchester in the early tenth century. But such rare fragments as these are from high-value, small textiles, things not designed as items of utility but truly as treasures. The English native tradition of drawing does, however, seem to have lingered on in the post-Conquest period and for some time afterwards, for elements of the fourteenth century *Luttrell Psalter*[8] still appear to echo the Bayeux Tapestry figures and others found in manuscript illuminations of pre-Conquest date. Another piece of evidence worth remembering is the *Bury Bible of St Edmunds*,[9] illuminated at Bury St Edmunds Abbey, not by one of the brothers but by Master Hugo, a secular artist and metalworker employed by the abbey in the 1130s. Historians have, perhaps, been too eager to divide both pre- and post-Conquest worlds into competent clerics and simple seculars. The acid test, in my opinion, is worldliness: the greater the knowledge of the outside and secular world exhibited in a work, the greater the realism as opposed to the display of piety, the less likely it is that a cloistered cleric was involved in its production.

Was there sympathy expressed on the Tapestry for the English cause, given that the embroiderers were English? This is very difficult to establish though some have tried to detect and argue as much. There are no obviously subversive messages and all the flattery is directed initially at Duke William, then at Bishop Odo, for clients do not pay for unflattering portraits. There may well intrude some apologist elements, attempts to suggest that Harold was a victim of circumstances, which could be English or they could just be noble sentiments, take your pick. In the first place we are told of his voyage to France in sympathetic terms, larded with warnings it is true, but not overly harsh. The coarse story he tells to listeners in Normandy is not really open to amelioration, but it would be a useful fact for any claimant to the English throne to know. His actions in the Brittany campaign are apparently laudable. His return to England seems to express sympathy for his humbled state and the offer of the crown to him, by unknown persons, has elements of tempters offering an irresistible award.

Of course, the invasion and battle scenes give major emphasis to the Norman-French, their cause and their actions, yet English troops are shown to fight bravely and well: to say otherwise would, of course, diminish the victors' own bravery and achievement. The absence of a Malfosse incident from the Tapestry is yet another indicator that none of the embroiderers was a survivor of the battle. Like the crossbows, they knew it not. Yet they had heard of the hidden traps in the marshy ground beneath the slopes of the English left flank for the wooden-looking horses of the massed Norman-French cavalry are suddenly transformed into very realistic dying destriers, somersaulting and kicking in their death-throes. At this point we can truly say that we move from the embroidery as an artefact to evidence of a work of art, this by virtue of the empathy it expresses with the subject depicted. And if there was no Malfosse shown on the Tapestry, presumably Odo did not experience it though well aware of the lillies he had encountered – if he was the patron who commissioned the embroidery. A good reason for giving him command of the archers at this point in the battle.

So, if Englishmen embroidered this artefact they were careful to present the wishes of their client, even though they were ignorant of some important details. All the indicators we have are that they perfectly understood the details they depicted. Here we have a curtailed and partial account focussed principally on noble participants. It is not a common soldier's-eye view but a privileged one. Whoever 'wrote the brief' was a cavalryman. This commission was a business, not an enterprise, so the embroiderers all drew upon their own experiences, which must have included participation in such brutal warfare. These were men who had gained their experience in England and *before* 1066. The events of a particular day were subsequently dictated to them by someone outside the team or workshop and who (the common experience of all soldiers in action) saw only the events that unfolded before him. They drew on their own experiences and their patron from his, coloured by his personal pride.

So, there was no prepared framework of events, no agreed official version of events to portray, this was not made as an official history for the benefit of posterity, only as a basic outline account with special emphases. Nor was there any story beyond presenting the success of the Norman cause. After all, that was what the person who commissioned the Tapestry wanted the embroiderers to say and perhaps the same person told them what (in his opinion) had happened at the battle. This client was important and therefore laid particular emphasis on the cavalry within which he had served. We might suspect that there was a brief written description or framework of events, a brief, of the scenes and events that were to be shown, probably dictated by the patron to a scribe or clerk and then passed to the production team where specialists would take relevant sections under the direction of a supervisor. An accurate record of the whole day, or campaign, was not required and did not exist in any form but the salient points of a brave victory needed to be followed, including the worthiness of the foe. Viewers would expect the technical details to be correct.

Something more needs to be said, to be considered. This survival is truly remarkable, virtually intact and moth-free, not reused, cut-up, put down a guarderobe, not eaten by rats or mice or rotted by rain penetrating the roof, saved from sunlight so that localised bleaching is not apparent, faded only in respect of vegetable dyes occasionally subjected to light at any level – how was this achieved? Well, in a cedar-wood box for some centuries, though probably not for all its time. Photo-chemical deterioration limited to once-a-year exposures, mechanical damage very limited for the same reason and then by display on a roller, physical damage limited to each end: very little at the truncated end of story, the missing conclusion, rather more evidence of restoration at the beginning of the Tapestry. So perhaps it was rolled to begin at the beginning and this exposed outer was therefore abused the most. What is not evident is real damage to the margins, in fact just a little to the foot of the Tapestry and very little to the heading, whether above the upper margin or within its content. This is all the more remarkable in that medieval arras/tapestries were hung from tenter-hooks and any such treatment, let alone repeated hangings or extended hanging, would seriously damage the heading, displacing the weave and embroidery, eventually tearing through the selvage. However skilled the restorers, the evidence of such damage would be irreversible and, anyway, we have no reason to believe that the hanging would be treated with any special care.

Of course, serious doubts have been raised about the nineteenth-century restorations and also about the earliest attempts at recording the images in the eighteenth century. In 1907, Charles Dawson raised doubts and quoted Mr Hudson Gurney in 1814,[10] who had said that the Tapestry was 'injured at the beginning and very ragged towards the end', a position that now seems to have been corrected by extensive restoration.

For display within Bayeux Cathedral in the eighteenth century a half-liner or heading band was sewn on to the head selvage, yet unless the nineteenth-century restorers effected work that was little short of miraculous, the present, apparent, state of preservation of the upper margin is astonishing. If we look at the earliest drawings, those of Nicholas-Joseph Foucault (d.1721) and later reproduced by M. Lancelot in 1729, the Antonine Benoit sketches of 1729 and Father Bernard de Montfaucon's engravings of 1730, as well as Stothard's engravings (1816-19) we see the same picture, damage at the foot but quite amazing integrity to the heading. If there had been stress, then the earliest photographs by E. Dossetter, reproduced by Frank Fowke (1873-75) could not show the linen at the headings intact and almost perfect in every respect.

This comprehensive strength at the heading, in both the weave of the linen ground and the integrity of the embroidery, can only mean one thing. It was never hung on tenter-hooks. On the face of it this means that our Tapestry was never hung. It was produced and then stored, but why? Only by resorting to pure speculation can we construct an explanation. Just supposing it was produced to celebrate the victory of Eustace of Boulogne's invasion and Bishop Odo's installation as king

or regent, or even as archbishop, then the failure of this invasion and William's return would place Odo in great danger. He might then have hidden, or sent to safe-keeping, such serious evidence of pride and of outright treachery. Maybe it was never delivered to him. Someone, perhaps, later removed the damning conclusion to show William its content, causing William to arrest Odo, triggering the subsequent Domesday Surveys of Kent and Sussex (after 1082), which then confirmed all King William's fears. As a result, or partial consequence, we now have *Domesday Book*, the comprehensive audit of 1086.

I think we can now confidently claim that unless some hitherto unknown and highly specific (genuine) document is produced providing evidence to the contrary, the Bayeux Tapestry was made in England, not in France, by men, not by women, and by seculars rather than by clerics ignorant of worldly matters. The inescapable corollary seems to be that these secular male embroiderers were not men with personal experience of the battle at Battle, nor even of recent Norman-French developments in armaments. The probability is that they were Englishmen under English direction, possibly with a written brief, an atelier contracted to a Norman-French client and very possibly, at least in part, themselves ex-soldiers. They also had excellent local knowledge of landscapes and architecture and had been well-schooled (though not formally educated) in aspects of religious information involving the fables of Aesop and as much as contemporary bestiaries were able to inform the world. Some among them also appear to have been well-travelled, able to add to the stock of available literary knowledge from their own experience. Finally, we are left with the very strong evidence that this unique artefact actually survives because it was never used for the purpose for which it was constructed. It remained a superfluous and largely irrelevant document until rediscovered in more recent times.

# Appendices

# Appendix I

# A Note on the Invasion Fleet

We probably know more about the shipping involved in Duke William's invasion fleet than we do about any other seaborne attack at this time. For a start we have their depictions on the Tapestry and we also know the name of the duke's own ship, the *Mora*. We also have a list of ships supposedly contributed by William's joint venturers, the *Brevis Relatio* in the Bodleian Library,[1] which totals 776 vessels from fourteen barons (two of them religious houses) and yet excludes the *Mora* and which also claims that the final total was 1,000 vessels. That said there is still a great deal we do not know and are left to surmise.

The ships on the Tapestry are always described as longships but the study of Scandinavian evidence[2] has revealed that various types of longships existed. Duke William's vessels, like English vessels, were of the type we have for so long associated with Vikings. In northern waters all were open ships with low freeboards and shallow draughts, often manoeuvred by oars or sweeps but usually with one (dismountable) mast and a large sail and capable of travelling if the need arose in either direction. The smaller vessels were lightly built, so that they could not only beach with ease but also be carried ashore. Experiment has shown that fairly large vessels could be dragged for short distances, provided their ballast and cargo were portaged, for example across the Mavis Grind at the end of Sullom Voe,[3] in this case to avoid the treacherous currents that separate the North Sea from the North Atlantic around the Shetland islands, verified by experiment with the *Borgundnarran* in 1999, a 9-tons tare vessel replicating a Skuldelev ship.

So this broad longship type was extremely versatile. The warships, especially those crossing the North Sea, were sometimes called Drekars or Drakars, dragon-ships, though the name Skeld or Skelð might more accurately describe ships like the *Skuldelev II* (reconstructed as the *Sea Stallion*) found at Roskilde, which is 98 feet long and with thirty or forty benches (equating to a sixty-man crew). The more decorative, like the Oseberg ship, were the Drakars, though this vessel probably only had a thirty-man crew and was only 70 by 16½ feet. Karve seem to have been like the Gokstad ship or even the Tune ship with crews of fourteen to thirty-four men and about 70 to 75 feet long, while those called Snekke were

the standard longships of forty-one men and measured 56 by 8 feet, so they were long and thin, general workhorses, suitable as transports or for war. Finally Knarr were the real trading and transport vessels, 50 to 60 feet by 15 feet, mainly designed to sail and judging by the Roskilde ship, capable of carrying up to about 20 to 24 tons. The carrying capacity of other vessels is something we can only estimate in terms of their crews when fully armed. For an eighty-man ship probably at least 17½ tons but for the smaller Karve or Snekke, with half that number, perhaps in the region of four tons.

The larger longships were designed for longer voyages and especially for naval (hand-to-hand) battles but inshore, and for amphibious operations, their impressive size would be a disadvantage. They were designed to carry fighting men, not cargoes. Vessels like the Karves and Snekkes were easier to construct in quantity, versatile as warships or as carriers and ideal for inshore and amphibious operations, so these are the ships most likely to have been employed by Duke William and the type we seem to see as ubiquitous on the Tapestry. We need to remember that he would be calling on all available shipping, so these are the most likely vessels to appear. The big warships would belong to Scandinavian lordlings and so already be engaged for Hardrada's attack on the north of England, across the open waters of the North Sea. William was transporting valuable cargo and wished to avoid a dangerous sea battle. He needed swarms of lighter vessels that could cross the relatively short space of the Channel ready to off-load and then undertake amphibious duties. The only other type he may have needed, especially for his destriers, was the Knarr, but we have no idea how common this was outside its Scandinavian homelands.

So how can we make any assessments? It seems to me that we need to make some calculations of the overall load to be transported for the invasion and then match that against the ship-list. Of course, we do not know the size or proportional composition of the invasion force, so we must proceed with the elections already made. We have accepted the suggestion of perhaps 1,200 cavalry, 4,000 or so infantry, 800 archers and another 3,000 or more sundries but many scholars have proposed more and I think it likely that such a force would certainly travel with as many servants and hangers-on as would be in a late-medieval army: the priests, servants, scullions, sutlers, ostlers, grooms, cooks, cads and also essential craftsmen such as shipwrights, smiths and farriers, amongst whom we should also look for sailors and longshoremen. So, I am going to propose 1,200 horses, 6,000 armoured men and 6,000 unarmoured men as a test of the ship numbers given. I am also going to assume an average body-weight of 12 stones for men, accepting that the actual men and boys involved could have been more or less. The horses I have averaged at 15 hands and so 9½ hundredweight (plus slings and cordage) with a hundredweight of tack and saddlery each. Armoured men I have awarded a further 40 pounds each for mail and spears, though without swords and shields, which last I have restricted to a total of 8,000 men, armoured or unarmoured, as a separate account.

- Thus, 6,000 armoured men (210lb or 15 st each on average) = 562.5 tons
- 6,000 men and boys (170lb or 12 st each) = 455.36 tons
- 1,200 mounts + tack (10.5cwts each) = 12,600cwts (1,411,200lb) = 630 tons
- 8,000 shields, probably @ 3lb per sq ft and 5 sq ft overall = 15lb each = 120,000lb = 53.57 tons
- 8,000 swords, probably @ 1lb per foot length + scabbard and belt, say 5lb each = 40,000lb = 17.85 tons
- Water for the mounts (if less than a day), say 8 gals each = 83lb each = 99,840lb in total = 44.57 tons (9,600 gals) – CAVEAT = this might be doubled for safety if loading was protracted.
- Drink for the men (12,000 men) @ 3 pints each = 35,000 pints = 46,688lb = 20.84 tons (though, again, more if at sea waiting on during embarkation)
- Food for the men (crossing and on landing) @ 3lb each = 36,000 lb = 16.08 tons
- Food for the mounts (if less than a day) say 20lb each = 24,000lb = 10.7 tons (minimum, could be more)
- Containers for liquids = 9,600 gals for mounts + 4,500 gals for men = 14,100 gals = 56-57 tuns (@ 250-252 gals per tun) each weighing perhaps 3cwts (tare) = 336lb x 57 = 13,152lb = 8.55 tons (minimum, possibly double if more drink carried)
- Sundries, such as tools, iron, anvils, whetstones, leather, small side-arms, sheerlegs, tents for VIPs., cordage, tackles, canvas, pots, pans, etc. possibly 80 tons
- Ammunition (arrows and bolts) @ 8 tons for ready use (153,600 projectiles)[4] + 8 tons for heads (6 tons iron + 2 tons slack cooperage) = 16 tons
- FINAL TOTAL = 1,916.02 to about 2,000 TONS

If we have around 20 tons capacity, with each Knarr capable of carrying ten mounts (in safety for all) with immediate food and water, then we will require 120 Knarrs. That leaves (if we ignore the manpower element) 1,286 tons (all told minimum) remaining and if we now assume that all other vessels are 4-ton capacity Karves or Snekkes then we will require 335 more ships in the fleet, a final ship total of only 455 vessels, well within the ship-list total. It therefore appears that Knarrs were not used and that instead they could even have used Karves and Snekkes for horses, though these would have great difficulty in carrying two or three horses each with safety, even with the gunwales raised. At three each they would require 400 ships, plus 335, a final total of 735 ships ex-776 contributed. At two each they would require 315 ships, plus 335, a total of 935 ships. Redistributing the loads to be carried so that some ships could function as attack vessels replete with soldiers while others were the carriers, sailed rather than being rowed, could expand the numbers actually involved, we could also add to the water, food and wine carried in order to provide rations during the journey and once ashore, and increase the armaments carried. Wace[5] said his father had told him that there were 696 ships all told, including the skiffs. This sounds like a man familiar with ships

and shipping, as one would expect of a man from Jersey, maybe even a man who was involved in loading the invasion fleet. I am inclined to trust his total.

We are left with the conclusion that even had Duke William's force been larger the ships he used were far from impressive, some probably quite small. The ubiquitous vessels of the Tapestry might well be a fair representation of the workhorses of eleventh-century shipping, vessels well suited to inshore work and to the passage of shallow rivers, but hardly the type to overawe an enemy at sea. They do, however, explain how the duke could amass so many ships at short order, even though the Norwegian fleet had made primary demands. The claim made of 1,000 ships, therefore, sounds like a sea full of ships rather than a precise count. Yet here, once again, I think we have evidence of Duke William's ability to analyse and to take expert advice, for the use of smaller vessels (of the Snekke and the Karve type) was not only convenient but displays considerable knowledge of ship-building, if modern replications are to be believed as practical archaeology. The sixty-oar *Sea Stallion*, which today operates out of Roskilde (and in 2007 made a 1,000 miles journey to Dublin), though an impressive warship, is actually slower than the smaller thirty-oar *Helga Ask* modelled on *Skuldelev V*.[6] William's small ships, therefore, were fast and efficient attack craft even if their carrying capacity was limited and they were ideal for inland waterways.

There remains the question of ship-building. Smaller vessels were relatively easy to build, though each required resources in both material and in skilled manpower. Some writers have suggested that they could be entirely constructed from green timber, but this seems hardly practical. Keels, stems and stern-posts at least would need to be carefully selected and seasoned to some degree in order to avoid drying shakes and twisting, though they would be shaped ready and while green for ease of working. Shipwrights did not possess tools of tool-steel and the Tapestry clearly shows the types of tools used for riven and green woodworking. The large dimensions of these primary members would dictate some seasoning, especially the mast-step part of the keelson, and the same could apply to futtocks. Oak was the preferred timber and winter felling the usual practise, though the original (*Skuldelev II*) of the *Sea Stallion* was felled in the summer of 1042 at Dublin, presumably for winter drying. For the strakes it would be easier to split, shave and contour sappy greenwood of the following year, bending to shape and clench-nailing onto the part-seasoned frame. Planks for this purpose, feathered and of an inch and less in thickness, would soon start to dry when clinker-constructed, making caulking requirements more obvious. As vessels appear to have been tarred as well as caulked, the surface would need to be relatively dry, for adhesion, when this was applied and then leaving the tarring to set over a winter period would be sensible.

We have no reason to suppose that all these vessels used in the invasion fleet were built at one time let alone in less than a year from start-to-finish. I suggest there was not the skilled manpower even along the whole Atlantic coast. Many must have been ordinary trading and fishing craft, perhaps even

Basque whale-boats, either chartered or purchased by, or even in the everyday commission of, the lords who provided them in 1066. I also suspect that many were much smaller than the standard-sized Snekke, hence the numbers involved. The relatively small size, then, of the overwhelming number of vessels as well as the need to sacrifice offensive capability to carriage, would dictate that William required fair weather for the crossing to be in any way successful. Even then it was touch-and-go. Once across, however, the duke and his captains would have a small fleet of fast, versatile and shallow-draught vessels at their disposal, ships and boats admirably suited to penetration along inland waterways and fens and to tip-and-run tactics along a coast. These vessels, with their 1 foot or so draught and capable of portage, would certainly give him command of the Pevensey lagoon and its feeders, so reducing overland travel for requisitioning and then, for his infantry at least, in the event delivering them fresh to the rendezvous for their important battle.

# Appendix II

# Notes on the Map of Pevensey in 1066

The precise definition of the Pevensey Lagoon and its fens in 1066 must, for want of a soil-science survey, remain a matter for intelligent speculation. Nevertheless, the statistical picture provided by *Domesday Book*, though no more an ordnance survey than it is a census, does provide us with unequivocal commercial information and a broad form of landscape overview akin to a *terrier*, one of those descriptions of bounds so familiar in Anglo-Saxon charters. This was how such things were done to create surveys, for contemporaries had no concept of aerial survey. Using these statistics and equating the (now) Pevensey Levels with a comparable ecology, the Cambridgeshire Fens, I have suggested extents for the accumulating marshes, reed-beds and even reclamations behind the longshore drift (and its spit), also the roddons deposited by local watersheds, all of which, acting in concert, continued to fill the basin of the lagoon over the succeeding centuries, the basis of the Levels we see today.

The castle, or fortress (burgh) of Pevensey/Anderida still retained its access to the sea in 1066 and though there possibly was minor commercial activity at Bulverhythe/Hastings (salt and/or iron) the overwhelming commercial activity in this part of the Sussex coast was focussed on Pevensey. This tells us it was a major port and so fulfilled the need for extensive wharves on which to unload the precious destriers, which would in itself and even without the specific evidence of the Tapestry confirm that this was the key point of disembarkation. No doubt swift assault craft went in first, as Wace relates, and infantry could debouch on any shore from longships. Then we have also to consider the unloading of the commissariat and munitions, difficult without wharves, and the bonus of possible proximity to a source of both remounts and harvested fodder. The precious cavalry could also have their horse-lines within the safe enceinte of the fortress with an internal strongpoint for further security and oversite of these lines.

Not only did the port of Pevensey have access to salt water, siting on its promontory and defensible at the isthmus as well as at the fort, it was also a harbour with a large expanse of sheltered salt-water anchorage protected from south-westerly gales by Beachy Head and from easterlies by the

Eastbourne spit. The diminishing lagoon seems to have remained tidal up to the eighteenth century, subject to inundation in the nineteenth, and is still very waterlogged today in season, and in 1066 the records of *Salinae,* or salt-houses, around the lagoon help us to delimit the tidal reach for local fuel – reeds and rushes – were burned to evaporate seawater trapped at high tide. I have guessed that the western lagoon wetland was increasingly clogged with saltings and fens, which would provide rich grazings, as in the Cambridgeshire-Norfolk Fens and as on the marshy Essex coast, while roddons crept down from the watersheds of the north-east depositing soil into the lagoon. Reclamation seems to have, therefore, been both natural and artificial for *Domesday Book* tells us of encroachments upon this landscape by ploughs both before and after 1066. Indeed, it would not be surprising to find that reclamation on the Bexhill side followed the sites of much earlier salt-pans, an accumulating part-bricquetage landscape very like the Red Hills of the Essex coast's saltings – centuries of terracotta by-product dumped as a base for salt pans that steadily crept outwards from the shoreline.

So, I have lumped all the washes, reclamations, fens, fresh-marshes and saltings visually together and shown them as a flat land water/scape, which may, very often, in reality have been penetrated by skiffs or even larger vessels when fishing or fowling or moving goods. To the north, the river seems to have been tidal and navigable almost to Ashburnham, thanks to run-off from the northern landscape where there was intensive agriculture. Local knowledge, or co-operation, would, therefore, have enabled the invaders, with their suitable, shallow-draught craft, to cross the lagoon and penetrate deep inland without any need to establish new camp-lines or a castle elsewhere. The indications, in *Domesday Book,* are that the invader's hand fell a little less heavily on the Pevensey side of the lagoon than on the Hastings side, some places and not others. I think we can assume that local guides were forthcoming from among the local freemen and maybe some of the burghers were even pro-Norman. We should not be blinded by (recent) nationalist sympathies. In 1066, men defended their territorial interests not the ideals of others.

The absence of recent or modern 'Hastings' from these folios was explained by J.H. Round[1] as an empty space in the survey which, inexplicably, was never filled. S.H. King[2] attempted to enlarge upon this by making the burghers of Bullington/Bollington those of an early Hastings situated at Bulverhythe. Nevertheless, the larger number of burghers at Pevensey, their post-Conquest expansion and the evidence of a longstanding mint (noted as at Pevensey, not Hastings, after 1066) when combined with the Cinque Ports combination of Hastings-with-Pevensey, seems to me conclusive proof that our 1066 Hastings was in fact Pevensey with the subsequent Rape of Hastings in its purlieu. The locality had always been the territory of the Hastingae, hence the confusion. Neither the invaders nor the embroiderers had either maps or signposts to inform them so, if the locals said it was all Hastings because it was the country

of the Hastingae, who would/could correct them? What the locals said was a fact. After all, they ought to know.

I have attempted to respect both run-off and tidal effect, presuming that when Anderida was first constructed as a fort of the Saxon shore silting and vegetational 'creep' will have been very limited, though thereafter incremental and probably the result of first Roman and then Saxon exploitation of Wealden iron deposits, through wash-out from workings and from soil run-off as a consequence of intensive arable farming supporting the industrial centres. My base map is the first edition Ordnance Survey (sheet 88) of 1813, modified up to 1863, with railways deleted and the Levels opened out to their lowest contour, when the number of 'eyes' (islands) tells its own place-name evidence. The place-name modern equivalents are taken from the excellent maps in the Phillimore *Domesday Book: Sussex*, number 2 (map 3 and the place-name index), the inspiration of the late, and great, John Morris in 1976. I also consulted the OS 'Lewes and Eastbourne', 1940 and 1946 (revised) sheet 51, 1 inch to the mile, for the historic pattern of innings and watercourses within the recent Levels. There is no reason to assume that the inland landscape of 1066 would be materially different (even if so today, in places) from that of the early nineteenth century, only over the Levels. The mixture of woodland, grassland and potential arable would probably be much the same, and the roads, though unmetalled, would probably be very similar. It is an ignorant superstition (propaganda) that all was wildwood and waste, no more accurate than the supposition that fenland was, and is, unprofitable, as may be seen today in what remains of the Camargue of southern France.

# A Glossary of Creatures Found on the Tapestry

In 1066 there was no established zoology, let alone any agreed text or taxonomy. There was not even a heraldic connection for the science and art of heraldry was in gestation rather than infancy. So the wild and wonderful world of fabulous creatures we see in Fairbairn's nineteenth-century lists[1] did not exist. In fact it was the demise of the white suit, or full armour, that paradoxically saw the full flowering of heraldry from the sixteenth century onwards as elaboration of achievements (and demand) grew. The origins of our 1066 birds and beasts are to be found, instead, among the writings of scholars, classical texts repeated by authors and copyists who had never seen many of the creatures they listed and who were nevertheless keen to rehabilitate them in a Christian context.

These fabled, fabulous beasts were the most fascinating and readily endowed with human or divine characteristics, especially those confirmed by ancient writers such as Aesop. Yet in 1066, even the compilation of bestiaries was in its infancy and not all of Aesop's stories were known. Commercial concerns, other than the church, had not yet corrupted the ancient exemplars and illustrations were less common than descriptions, so it is quite dangerous to attempt to confirm eleventh-century depictions by using fourteenth- or fifteenth-century bestiaries. The secular market had not yet been created. Maps were not as we now conceive them, even in the fourteenth century. Instead they were compilations of vignettes intended as *aides-memoire* for expositions, indices for fabulists like Sir John de Mandeville[2] to enlarge upon and so, with this commercial expansion, came the stimulus for even weirder zoology than the church had employed. We have to be very careful not to judge our Tapestry by the very different repertoire of later centuries and certainly not by information from our modern world.

This said, the people of 1066 could see what was around them and they also believed in what religious scholars told them. Such beliefs do not make them fools. As I have been at pains to stress, they were educated to a world we no longer comprehend. Anyone who has read Massingham[3] or, more recently and botanically, Rackham[4] will know that our ancestors' agronomics and their systems of learning were very different from our own, but though different they were surprisingly efficient. The final demise of self-sufficiency and peasant

151

agronomics in the early twentieth century was due to the increasing subtlety of taxation rather than to imperfect husbandry, social or land-management. Our present agricultural and social worlds are quite alien to the many centuries that preceded them, to the worlds of Cobbett[5] and Massingham and the medieval husbandman.

So it was that zoologically they knew what they could see and what they had experienced and what they had never seen they took on absolute trust from the 'clever people' around and above them, just as we accept quantum physics. After all, scholars must know for they have been educated to explain Schroedinger's cat. What is surprising is that so many people, quite obviously, could then look at a fabulous creature and recognise its significance. The aforementioned cat is rarely so fortunate.

| | |
|---|---|
| **BADGER** | A nocturnal, and so less well understood, animal with an almost impenetrable hide, fierce and very dangerous when cornered and its bite said at this time to be fatal. |
| **BEAR** | Perhaps the most powerful and ferocious wild animal likely to be encountered 'in life', a creature not to be opposed but rather to flee from. So to muzzle a bear, other than one trained as a cub to captivity, was an impossible feat. You would be lucky even to be able to kill one and walk away. |
| **BEAVER** | A creature whose testicles were esteemed as a medicine. When cornered by hunters they were said to castrate themselves by biting off their 'potency' and so escaping. Later recipe books say the tail is a delicacy. |
| **BOAR** | Another fast and ferocious opponent in the wild, capable of inflicting horrific injuries with its tusks and also said to be fatal. Of course, even the domestic boar and sow were far from predictable. |
| **CALADRIUS** | Usually shown as a pure white bird, except that on our Tapestry there is no white and outlined blank linen represents the ghostly and speculative. Here they have to have colour, so why not that of the noblest of raptors, the golden eagle? It is positioning that convinces me that these large eagle-birds are such special indicators, yet even as eagles they would have kingly attributes. Everyone knew that only the noblest born in the land could be associated with either gyr-falcons or eagles. Eagles, like absolute monarchs, make the decisions. They do not 'wait on' for instructions, but they either rest or pursue their quarry. The caladrius, however, is more of a physician, guarding and consorting with kings yet, when they turn away, it is indicative of sickness and death. |

| | |
|---|---|
| **CAMEL** | A beast capable of carrying exceptional burdens and with great stamina, dependable in difficult situations and for unusual loads. Few in England would ever have seen one. |
| **CENTAUR** | Neither man nor beast, an ungoverned creature in need of superior power to guide it and authority to make it acknowledge the True Faith. I suspect that what lies behind this is an allusion to bestiality, linking abhorrence to pagan worship. The Sagittarian link with archery does not seem to be apparent here on the Tapestry. |
| **CROW** | This omnibus classification stands for all carrion birds, especially corvids, for whom I also employ the modern collective vultures. Carrion birds were the harbingers of war and gruesome death, feasters off the battlefield. The intelligent carrion-crow and the raven in particular were hated for pecking out the eyes of the defenceless. Birds of war, rejoicing at death, so readily anthropomorphised on our Tapestry. |
| **DRAGON** | A fire-breathing quadruped (in England) with a powerful tail, though whether reptilian at this date is doubtful. A most formidable foe. The Old English drake would seem to be our creature, hence fire-drake. England seems to have divorced the dragon from the wyvern at an early date. The hagiographies of the eleventh century only made Saint George a martyr and the dragon legend appears to have returned to us at a later date with the crusaders. It was not until the fourteenth century that George became the patron saint of England and, by then, English artists had certainly elaborated the reptilian dragon-quadruped. Ours seem quite tame by comparison with the later models. |
| **EAGLE** | A raptor of the highest nobility and so, like the lion, terrible to behold. Proud, fierce, strong and with a remarkable overview and very keen eyesight, but also associated with Saint John the Evangelist and scholarship so, by extension, with the wisdom of law-giving and knowledge of right and wrong. |
| **FLAMINGO** | Not recorded in any known contemporary source but shown on our Tapestry, the drawing is unmistakeable, so someone had seen them in the Mediterranean. On the Tapestry they are shown as a deep red colour as though confused with the phoenix (see PHOENIX). |
| **FOX** | We can thank Aesop for our identification of the wily-fox, a sly and clever creature perfect for politics, never short of promises, schemes and ideas for self-improvement. |
| **GOOSE** | Another *locus classicus*, the legendary watch-dog of ancient Rome, noisy rather than dangerous. |

| | |
|---|---|
| **GOAT** | According to Isodorus the goat will 'pursue difficult matters', which probably agrees with other authorities that he makes a good watchman. In Aesopian fable he is wise enough to know when and where he is safe from his enemies and he stays there. Curiously foresters believed that geese and goats tainted the pastures frequented by deer, causing slinking (abortion), so a goat might also be a nuisance in context. |
| **GRYPHON** | A cross between raptor and predator, eagle and big cat. They signify strength and vengeance, as one might expect, are said to tear men to pieces and are often segreant or rampant. Mandeville later elaborated their prowess as equivalent to eight lions and 100 eagles and they certainly became popular in later heraldry. |
| **HARE** | Proverbially fast yet timorous, a dweller among fields and arable and so easily associated with peasantry. 'As wise as a hare' said Skelton, probably because a hare will flee when pursued, run to cover and then start again in a circle. The rabbit has the sense to run as fast as he can in a straight line and so he escapes his hunters. |
| **HAWKS** | Difficult to separate from the eagles on our Tapestry, except by context. Fierce, merciless birds of prey delighting in feeding off the weak, rewarded by their masters for licensed savagery. Nevertheless, as hawks are trained to come to the astringer's hand, so they can be disciplined for all their love of slaughter. The Old English name of 'havoc' is therefore compellingly expressive. |
| **HERON** | Perhaps from his habits and habitats a representative of the quiet, solitary life, yet in falconry often employed as the symbol of autumn. Autumn was the season for hawking due to the large flocks of passage birds landing on the south-east and southern English wetlands. |
| **KITE** | Especially the now rare red kite, once the 'dustman of London', voraciously consuming all sorts of carrion and offal. I think there can be little doubt that the red coloured carrion birds shown here are intended as kites rather than crows. |
| **LION** | The noblest of the big cats, probably thanks to Aesop's treatment as the 'king of the beasts', so a very superior form of pard. Terrible to behold, they are also said to show pity to men and so the lion is accorded ferocity tempered with wisdom and also with pride. Of course, the eleventh century did not restrict kingship to existing royal families, so anyone with kingly qualities or relatives might be a lion. Certainly it denoted and denotes high nobility. |

| | |
|---|---|
| **MASTIFF** | The householder's guard-dog, his warning and defender against intruders. The scholars said that dogs were more sagacious than other animals and gifted with both courage and speed, though our mastiff is quite distinct from the faster hounds (brachets and liams) used for hunting. His Old English name of ryðða, or ridder, seems appropriate. |
| **OSTRICH** | Though known to Pliny as a large bird that cannot fly, and which thrusts its head into a bush in order to hide, neither he nor Isodorus had a proper description. It had obviously been known to the *venatores* of the Roman circus but was probably only rarely provided and seen even then, except on mosaics in North Africa, so its form and appearance would be quite unknown in Western Europe in 1066. |
| **OX** | The universal beast of manual work, patient and stolid, which when in harness (unlike the horse) works until it drops. Nevertheless the bull was also seen as a blindly dangerous, heavyweight opponent. |
| **PARANDRUS** | A beast that can change its appearance but of which at this date we have no certain exemplar, a shape-changer, and so akin to the later were-wolf, you never knew for sure who or what they were. Pliny said that the parandrus changed colour, Isodorus said 'the shapes of the wicked change for their many villainies and they turn bodily into beasts'. I suspect that in England there may at times have been identification with the Old English 'ferende gæst' (moving spirit) which, if a swan, as most linguists believe, would change shape when hiding its head or even in its metamorphosis from a cygnus (the sooty-coloured cygnet) to a (white) swan. Para + Andrus means 'contrary to man', but Pliny's 'Blemyah' was also acephalous and so that came to mean 'headless people'. Later, bestiaries made the parandrus into a hairy quadruped. Everything created had its 'whit' (identity) and so we can have a *double-entendre*, swan or parandrus, for the English were later very fond of bestiaries and I see no reason why, even this early, they could not blend riddles with gnomic traditions. Grendel in *Beowulf* is termed ellen-gæst or a sinister and powerful ghost, though it is often translated as a mistake for 'ellogast' (see Sedgefield's *Beowulf* (1913) line 86). There is also the mythical 'duphon' of the Hautes-Alpes (probably an eagle owl) to consider. |
| **PARD** | A big cat, with all the attributes of such powerful, wild creatures and not to be trifled with. As Isodorus said it |

'likes blood'. As zoological knowledge developed so the later heraldic bestiary eventually distinguished between cat species and elaborated their depictions, but at this date such nuances were unknown. In Old English 'pandher' was a spotted big-cat and also the heraldic leopard. No one had a record of a striped big-cat, yet someone embroidering this Tapestry had seen a striped (Bengal tiger) big cat.

**PEACOCK**    Not, one suspects, commonly encountered in the eleventh century but nevertheless well recorded. Classically Argos 'panoptes' (many eyed) was 'all-seeing', so what was more natural than an association of the peacock with the omniscient god (Father or Son), just as the phoenix was omnicompetent? Also symbolic of the never sleeping, spiritual watchman.

**PHOENIX**    Anciently fabled as a bird that lives for 500 years, builds a nest, sets fire to it and then rises from the ashes renewed and empowered. This was an obvious symbol of the Resurrection and so it became the emblem of Christ as the exceptional man. Omnicompetent, one capable of all things physical and spiritual, even rebirth. It is always shown as dark red.

**RAM**    A beast of metal, stubbornness and fecundity, they will fight in order to be primus inter pares, but they are also destined for sacrifice, so only the victor survives. Old English weðer, though not necessarily meaning gelded.

**STAG**    The noble yet solitary monarch of the glen and moorland who shelters his household from hunters when woodland is available. A proud fighter, sagacious in his leadership, magnificent in appearance, circumspect enough to know when to flee and, according to Isodorus, 'deer are the foes of snakes'.

**TIGER**    The heraldic 'tyger' was the only one found in English heraldry until very recent times as the real or Bengal tiger was unknown in the eleventh century. Bestiary tigers were spotted according to Isodorus, in other words indistinguishable from pards. However, someone embroidered a *striped* pard. Where did this come from? The later heraldic tyger had no stripes either and was given a tusk or tooth protruding from its nose.

**VULTURE**    A term I have used for all carrion/corvid birds as modern parlance – see CROW. Vultures, of course, are only rarely seen in England, though not unknown.

**WINGED LION**    Signify destiny, especially amongst noble warriors and men. Fortune favours the bold. It is also the symbol of St Mark, author of the Second Gospel, and so a bringer of truth and enlightenment.

**WOLF**     A less likeable predator and, in Aesop, not as clever as the fox. Obviously, a Medieval pest, dangerous, bloodthirsty, opportunistic, preying on the weak and vulnerable, often in packs, much like the common mercenary.

**WYVERN**   A bipedal semi-reptilian and though the apparent origin of the Wessex dragon – and even perhaps the Welsh – not a fire-breather, hence in England it was adopted in heraldry later on as quite distinct from the fire-drake or quadrupedal dragon. The fork-tongue gives away its poisonous nature of lies and bile. Why its tail was nowed, or curled, I have no idea, but it would imply a more sedentary role than the dragon. I think this creature was the Old English 'wrm' and thus distinct even then from the drake (draco). In French heraldry the dragon (fire-drake) is usually bipedal and synonymous with the wyvern but we can see that on our Tapestry 'wrms' are quite distinctive in appearance and in role. As the English dragon subsequently became more reptilian, so wyverns seem to have become confused in general heraldry and in the bestiaries with 'vipera' and 'hypnalis' (a sort of asp), but English heraldry maintained their traditional appearance and they remain popular heraldic supporters. The clear distinction on our Tapestry between the fire-drakes and the many wyverns is another clear indicator of English workmanship and thinking.

# Notes & Sources

## Chapter 2: Methodology, Bestiary and Division

1. Francis Wormald, 'Style and Design' in Stenton, *The Bayeux Tapestry: A Comprehensive Survey* (1965).

2. C. R. Dodwell, 'The Bayeux Tapestry and the French Secular Epic', *Burlington Magazine* 108 (1966). In spite of this in 2016 the BBC made a photo-montage of the nave of Bayeux Cathedral with the Tapestry hung on the walls.

3. Arthur Wright, *'Fools or Charlatans' the Reading of Domesday Book* (2014) pp.159-162; also, *Domesday Book Beyond the Censors* (2017) pp.73-86

4. ibidem (2014).

5. Cyril Hart, 'The Canterbury Contribution to the Bayeux Tapestry' in *Art and Symbolism in Medieval Europe: Papers of the Medieval Europe Brugge Conference 1997*, vol. V, ed. G. de Boe and F. Verhaeghe (Zellick, 1977) pp.7-15. Also, Richard Gameson. 'The Origin, Art and Message of the Bayeux Tapestry' in *The Study of the Bayeux Tapestry* (Woodbridge, 1997).

6. David Bernstein, *The Mystery of the Bayeux Tapestry* (London, 1986).

7. For this re-identification of the site of the battle at Battle as the adjacent Caldbec Hill, rather than Battle Hill, see the comprehensive case made by John Grehan and Martin Mace in *The Battle of Hastings, 1066, The Uncomfortable Truth* (2012).

8. Q.v. Wright (2014) pp. 156-161 in particular, also Wright (2017) pp.73-86.

9. Wright (2017) pp.84-86. There is no evidence, repeat no evidence, for a Weald full of rooting pigs, quite the opposite: this dogma is a factoid devoid of foundation.

10. Wright (2014 and 2017).

11. Only Book XII contains a bestiary, some real and some (now known to be) fabulous beasts; he died in 636 and his *Etymologiae*, well-known in religious circles, then spread widely into secular realms. The work was an encyclopaedia or summa of universal knowledge (sometimes called the *Origines*). See Priscilla Throop, *Isodore of Seville's Etymologies: Complete English Translation* (Vermont, 2015).

12. Another encyclopaedic work which included zoology among many other fields. See William Thayer, *Pliny the Elder: the Natural History* (University of Chicago, 2009); also Loeb Classics, 10 volumes (Harvard University Press). Books VIII-X deal with land animals, marine creatures and birds.

13. Maurus, abbot of Fulda and Archbishop of Mainz, died in 856. His encyclopaedic *De Universo* or *De Rerum Naturis* drew largely on Isodorus for Book VIII on animals.

14. This seems to have been translated from Greek into Latin c.700 A.D. and is said to be the predecessor of bestiaries; in *Codex Exoniensis* may be fragments of an Anglo-Saxon copy, q.v. Throop, pp.335-367.

15. George Bernard Shaw, *Back to Methuselah* (1921), in the Preface he writes, 'Alopathy has produced the poisonous illusion that it enlightens instead of darkening'.

16. Psalter (Ps.8), B.L. MS Harley 603, f.4V (English, early eleventh century) q.v. Brunsdon Yapp, *Birds in Medieval Manuscripts* (British Library, 1981) p.24

## Chapter 3: The Opening Chapter Begins

1. Trevor Rowley, *An Archaeological Study of the Bayeux Tapestry, the Landscapes, Building and Places* (2016) p.32

2. Frank Barlow, *Edward the Confessor* (1970 and 1979) pp.226-227, quoting the *Vita Edwardi Regis*; 'We are told that Harold, like Tostig, could cleverly disguise his intentions… ambitious and persevering, he was cautious and thoughtful in his approach, moving circumspectly towards his goal and enjoying life on the way. He studied… the princes of Gaul (France), their characters, policies, resources… noted down most carefully what he could get from them if he ever needed their services' and he could dissemble. We will do well to remember this thumbnail character sketch.

3. Q.v. Wright (2014) p.79 and quoting the Domesday Book entry for Saltfleet in Lincolnshire and Chester, also William of Poitiers. See also Richard Hodges, *Dark Age Economics* (1982 and 1989)

4. Bertrand and Lemagnen *The Bayeux Tapestry* (Editions Ouest-France 1996), sections 5-6. Marc Morris, *The Norman Conquest* (2013) p.113 says, 'only narrowly escape shipwreck', perhaps relying on William of Poitier's account, *Gesta Guillelmi* for the Tapestry gives no evidence of danger.

5. Wright (2014) pp.136-140, quoting both the *Dialogues of the Exchequer* and the *De Domesday* of the Venerable Bede.

6. The *Golf Hours*, BL Ms 24098 'September'. Rowley (2016), p.17, says the slinger is copied from Cotton Ms. Claudius B.IV, f.26b, but this is incorrect as not only are both the figure and the aspect of the birds incorrect, the slinging technique is patently different.

7. Trevor Rowley, *The Man Behind the Bayeux Tapestry, Odo, William the Conqueror's Half Brother* (2013) pp.106, 151-154 and the evidence of his personal seal (sigillum) with one side a bishop and the other a mounted knight.

8. Rowley (2016) pp.58-61; also B.Gauthiez, *The Urban Development of Rouen, 989-1345* (2013). The Tower itself was destroyed in 1204 and no description of it exists. Nevertheless, Rowley attempts to make Rouen the model for the White Tower (of London) and for Colchester Castle! A. Taylor in

*Anglo-Norman Studies 14* (1992) suggested instead that this was Guy of Pointheau's castle at Beaurain, though that appears to have been no more than a masonry-revetted motte, like the final and early twelfth century phase of Rayleigh Castle in Essex, q.v. L. Helliwell & D.G. Macleod *Rayleigh Castle* (Southend-on-Sea, Rayleigh Mount Local Committee, 1981): I would suggest a similar date. Rouen seems most likely, something of a 'wonder of the Age' being built of stone.

9. Neither Isodorus nor the 'Physiologus' provide physical descriptions, calling it simply a shape-changer. At this date the Tapestry provides our earliest illustration of whatever the creature is.

10. *The Book of Kells: forty-eight pages and details in colour from the manuscript in Trinity College, Dublin*, selected and introduced by Peter Brown (1980) ills. 14. This and the eagle of St John (39) also both include flamboyant colouration.

11. Another example of copying. The side-axe is the ancient tool of green-woodworking used for smoothing and thinning work: this tool, with its broad 'T'-blade, is often described as 'the Saxon axe' surviving into the fourteenth century as the typical carpenter's side-axe (in France larger forms seem to have developed into the 'doloire'), q.v. W. H. Goodman, *The History of Woodworking Tools* (1964), pp.28-29. It is quite unlike an adze.

12. William of Poitiers (*Gesta Guillelimi*) claimed that Harold undertook to marry one of Duke William's daughters, very young at the time, and David Hill in 'The Bayeux Tapestry and its Commentators', *Medieval Life* 11 (1999), used this to deny any sexual allusions in this imagery. He argued that the name Aelfgyfu would have been adopted on her marriage to Harold (because it was a fashionable name?). Eadmer, however, in his *Historia Novorum in Anglia* (trans. Bosanquet, 1964) said she was a sister of Harold's, destined to be married to a Norman lord, again ignoring the blatant sexual innuendo. Eadmer, of course, was writing under direction and after the event when King Edward was already being represented as a saint and Edith much the same, so it would by then have been essential to suppress any memory of those pre-Conquest events which might cast doubt upon these Norman (Church) claims of sanctity.

13. She is so named in the well-known illustration in the *New Minster Liber Vitae* (British Library, Stowe 944, f.6) where she and Cnut are shown presenting a cross in 1031 at Winchester.

14. Q.v. 13 (supra) *Historia Novorum in Anglia*: Eadmer (or his director, Anselm) was anxious to support the Norman claim to an entail from Edward to William.

15. Chris Brookes, *The Anglo-Norman Kings* (1962); also Frank Barlow, *Edward the Confessor* (1970 and 1979): 'while Edward weakened himself in England by imprudent actions' (p.103) and he concludes that good luck rather than political wisdom followed him and 'diplomatic promises were cheap' (p.109), also 'such hysterical expressions… are bizarre trappings for an efficient

government' (p.159), 'neither a wise statesman nor a convincing soldier' (p.72) and Brookes concluded, 'bred to hunting and idleness'.

16. Q.v. Wright (2017) p.176 and Barlow (1970 and 1979) pp.159 and 176, Charter of 1044 (Old Minster, Winchester) and a draft charter of 1063 (grant to the priest Scepio).

17. Barlow (op. cit.) pp.299-300: a wife 'like a beloved daughter' (viz. heiress); 'Edith was the gem in the middle of the Kingdom' thanks also to the *Vita Ædwardi Regis*.

18. See Barlow (1970 and 1979) on the *Vita AEdwardi Regis* in Appendix A, especially pp.292-293.

19. Q.v. note 2 (supra), Barlow (op. cit.) pp.226-227.

## Chapter 4: The Opening Chapter Concludes

1. See the 'Glossary of Creatures' for parandrus and shape-changers.

2. Arthur Wright, 'The Mottes of Old England' in *Wiðowinde* 180 (2016) pp.35-40.

3. Q.v. Rowley (2016) pp.69-70 (quoting M. J. Lewis); Abbot Scolland of St Augustine's Monastery, Canterbury (1070-1089), formerly a monk and scribe at Mont-St-Michael, suggested as the designer of the Tapestry (assuming it was made at Canterbury).

4. *Les Trés Riches Heures du Charles, Duc de Berry*, c.1400.

5. Wright, art.cit. *Wiðowinde* 180 (2016): the conclusion is inescapable for the needleworkers could not make such accurate depictions from a description (of each) alone and there are no known illuminations for them to have copied, nor were they given an expenses-paid trip to Normandy and Brittany, anyway, what about the necessary security clearance for such installations?

6. Rowley (2016) p.83. For Grimbosq he cites J. Decaens in *Archaeologie Medievale* II, 1981 reporting an excavation of the 1970s.

7. F. Woodman (2015) *Edward the Confessor's Church at Westminster: An Alternative View*, p.63, in W. Rodwell and T. Tatton-Brown (eds) *Westminster I. The Art, Architecture and Archaeology of the Royal Abbey*, British Archaeological Association Conference Transactions XXXIX, Part I (2015).

8. Cecil Alec Hewett, author of *The Development of Carpentry in Essex 1200-1700* (1969), and *English Historic Carpentry* (1980 and 1997); *English Cathedral and Monastic Carpentry* (1985), *Church Carpentry* (1974)

9. Arthur Wright, "The Mottes of Old England", *Wiðowinde* 180 (2016) pps.35-40, and 181 (2017) pp.38-40

10. In the timber-tower revetted by a motte the entrance will generally be on an upper floor and it makes sense to construct an adjunctive fore-building to guard it and act as a sentry-post. Entrance to an upper floor, with a fire safely on the ground in the basement, means a mezzanine level around the central void, itself a useful vantage point. Both these features seem to have been retained (or 'fossilized') in subsequent stone towers (keeps or donjons).

11. Q.v. Jean Chapelot and Robert Fossier, *The Village and House in the Middle Ages* (University of California, 1985).
12. For example, Aldingham, Castle Acre, Castle Camps, Castle Rising, Castle Hedingham (and maybe also Elmdon and Berdon) all began as ringworks. At Aldingham, Rumney and Goltho the succeeding phase was to infill the ring-work in order to create a platform or motte. This may well have been the process elsewhere, if only we had accurate archaeological records.
13. For this opinion see Frank Barlow, *Edward the Confessor*, (1970 and 1979) pp.225-226.

## Chapter 5: Chapter Two

1. Q.v. Wright (2014) pp.148-159, 164-168, 332-333; and (2017) pp.120-125: the concept of linking tax to land is only possible if there have been land surveys and specie taxation requires the tax-payer to be in a money economy. It also requires the specie to be of guaranteed standard, not debased.
2. The Skuldelev III Ship (knarr) is perhaps our best example of such vessels with higher-freeboard and even distinct, welled, holdspace at times. They could transport livestock, bloodstock are, however, far more of a problem to carry for any distance by water.
3. Identified by Bridgeford, op.cit., pp.276-284: Wadard seems to have been a 'brave lion' though otherwise unknown.
4. Q.v. ibidem, pp.132-133.
5. Rowley, op. cit. (2016) pp.154-160.
6. David Hill, *Ethelred the Unready*, B.A.R. 59 (Oxon. 1978), *Trends in the Development of Towns during the Reign of Ethelred II.*
7. Rowley op. cit., (2016) p.155 (source uncertain) says that in 1061 Robert Guiscard took horses from southern Italy to attack Sicily in special transports. What we do not know is whether these were bloodstock) or the Mediterranean vessels used, but William of Normandy does not appear to have had knarrs and so could only have carried a few mounts at a time even with gunwales raised.
8. Marc Morris, *The Norman Conquest* (2012), p.171.
9. Peter Poyntz Wright, *The Battle of Hastings* (1996) pp.56-57.
10. Rupert Furneaux, *Conquest 1066* (London, 1973). My own estimation is not so far different from that of Colonel Lemmon though I think Furneaux's ship-sokes very convincing. It all depends on the numbers of ships engaged and their capacities.
11. Wright (2014) pp.250-251.
12. ibidem, p.252 (1266 Assize of Bread: 800gms = 1.75lb).
13. Bridgeford op.cit., 'a helmet with tassels at the rear', p.134; Bertrand and Lemagen (1996) 'streamers or flying ribbons', so that 'the horsemen (could) recognise their leader'. They are possibly also shown on William where he gives Harold arms?

14. William (or Robert) Wace's, *Roman de Rou* repeated by Bridgeford, p.134 but nowhere else is he on a black horse, though Odo is.
15. Q.v. Bridgeford (op.cit., 2004), in particular pp.285-291 for his possible connection with St Augustines, Canterbury, as well as with Bishop Odo.
16. Not everyone agrees that this was where the heavy cavalry (including the Duke), put on their harness but Grehan and Mace observe that the *Chronicle of Battle Abbey* identifies the place as 'Hechelande' (heathland) or Blackhorse Hill, the summit of Telham Hill (op. cit. 2012, p.44).
17. 'In the Middle Ages the road system of England was rather denser than it is now', Oliver Rackham, *The Illustrated History of the Countryside* (1994 and 2000) p.122. See also Chris Taylor on the history of roads and Paul Hindle, *Medieval Roads and Tracks*, Shire Archaeology (2013).

## Chapter 6: Chapter Three

1. Charles H. Lemmon, *The Field of Hastings* (1957).
2. Lemmon, p.22. It was Wace in his *Roman de Rou* who spoke of improvised barricades and passageways across a ditch and E.A. Freeman then elaborated this to 'entrenched' defences and a 'three-fold palisade' in his *History of the Norman Conquest of England*. Harold chose a naturally strong position with only a saddle joining the Battle and Caldbec Hills, on his left he planted a part submerged cheval-de-fris, 'lilly-traps', which are later shown on the Tapestry. It has been suggested that these are 'reeds' but as this is their sole appearance on the Tapestry it is a highly improbable introduction in the middle of a battle!
3. Apparently, Jim Bradbury first suggested the Caldbec Hill site at the Battle Conference of 1983 and then in *The Battle of Hastings* (1998). Some authors refer to Battle Hill as 'Santlach' but I have avoided this, though if a sandy subsoil could be proven it would simply add to the wisdom of the Caldbec site.
4. John Grehan and Martin Mace, *The Battle of Hastings 1066, The Uncomfortable Truth* (2012) ably and thoroughly take up this analysis and discuss its relevance to the available sources.
5. ibidem, Diagram C, p.127: I think this shows the English line a little too far back, but it is really a matter of personal judgement. I would leave myself room to retire (if Harold) upslope once the narrow available plain to the front had become obstructed and the boggy ground rendered less accessible to infantry. This would give an enemy two obstacles to cross, both equally bad for their morale and hampering to their movements.
6. Q.v. Arthur Wright, 'Men and Supermen: the Norman Myth', *Wiðowinde*, 179 p.19. The need for water is the key to the battle. The Cald-bec might also help account for the subsequent dysentery among William's troops, being all that was available?
7. ibidem. Indeed, this is the answer to the question 'did the English have bows?' If they did not, then the Norman-French forces would have needed more than the eight tons minimum I have suggested, probably more like 30-40 tons, an

impossible weight to transport! This was a long day, they would soon have run out of ammunition yet they had plentiful supplies at the end of the day.

8. The *Carmen de Hastingae Proelio* of Bishop Guy of Amiens, who died c.1074, was possibly written within two years of the battle and tells us of crossbowmen among the archers. The importance of these is that the projectiles were non-returnable and so their expenditure required careful regulation, unlike that of the archers proper.

9. Though some have claimed that parabolic fire is not evidenced in the tapestry or elsewhere (e.g. English Heritage Guide, *The Battle of Hastings and the Story of Battle Abbey* (1999), p.23.) the fact that they are drawing to the chest is conclusive proof of high-angle fire.

10. The grisly details are given in the *Carmen* with Eustace, William, Hugh (of Ponthieu) and Robert Gilford or Gifford as participants. Bridgeford (2004) discusses this at length.

11. William of Poitiers appears to refer to this obstacle, William of Jumèges identifies an *Antiquum Aggerem* and Orderic Vitalis a steep bank with ditches. The *Chronicle of Battle Abbey* made this into a wide chasm or cleft, heavily overgrown and Colonel Lemmon identified it as the Oakwood Gill, beyond Caldbec Hill, convincingly adducing thereto various documentary sources.

12. Peter Poyntz Wright, *Hastings* (1996), p.80, seems to have examined the same source (?) and come to the same conclusion regarding the arrow to the helmet. The evidence is there to see, it was not originally in the eye.

13. Bridgeford (2004) p.149, in spite of the fact that this rider is 'gernon-less'. Also see ibidem, pp.197-198.

14. As Eadmer put it in his Historia 'the victory gained is rightly and doubtlessly to be ascribed to the miraculous intervention of God who by punishing the evil crime of Harold's perjury thus showed that he is not the God who countenances inequity' The 'Divine Will' justification.

15. William of Poitiers tells the tale (apparently confusing the 'lilly-traps' incident with the Malfosse) of Count Eustace attempting to escape with fifty horsemen and being called back by William. The Tapestry appears to tell an opposite tale! There has been much debate about feigned retreats by the Norman-French cavalry but a rallying of wavering elements is far more likely. Poitiers says that for good (Divine) measure Eustace was punished by receiving a near fatal blow to the back: he seems to have recovered surprisingly quickly!

16. Brian Bates, *The Real Middle Earth, Magic and Mystery in the Dark Ages* (2002).

## Chapter 7: The Conclusion to the Tapestry

1. The earliest reference is an inventory of Bayeux Cathedral's furnishings in 1476 (q.v. Trevor Rowley, *The Man Behind the Bayeux Tapestry: Odo, William the Conqueror's Half Brother* (2013) p.85) but our earliest record is from the papers of Nicolas-Joseph Foucault (d.1721) in a drawing published in 1724 by Antoine Lancelot: the origin of this drawing was finally located in 1728 by

Brother Bernard de Montfaucon. In 1732 Antoine Benoît produced a sketch of the rest of the Tapestry (q.v. Bridgeford (2004) pps.29-31). The tail section 'peters out in Benoîts' drawing much as it does now', he says.

2. Andrew Bridgeford (2004), though Trevor Rowley prefers Odo.

3. Q.v. Bridgeford (2004) pps.263-269; also Anne Savage, *The Anglo-Saxon Chronicles* (Phoebe Phillips, 1982) pps.167-168.

4. Q.v. Bridgeford (2004) pps.187-188; Savage (1982) pps.177-178.

5. ibidem, pps.200-205.

6. ibidem, p.204

7. Q.v. Rowley (2013) pps.43-46 and pps.116-119

8. Bridgeford (2004) pps.272-294.

9. ibidem pps.225-245.

10. The identification of the toise as a fathom of six feet I derive from exhaustive entries in M. Devèze, *La Vie de la Forêt Française au XVIe Siècle*, two vols. (1961).

11. Longer than this becomes exceptional, the problem being to find boxed-in-the-heart oak timbers of sufficient dimension to carry a king (crown)-post truss construction.

12. William (als. Robert) Wace in his *Roman de Rou* which although a late arrival among the records of invasion seems to have been based on information from his father who, in turn, appears to have participated in the invasion. Bridgeford, op.cit. (2004) pps.300-301 observes that Wace is not always reliable when compared to other sources but himself notes the reference (pps.214-215) and I find it entirely credible having uncovered so many fiscal defalcations by Odo and his coterie/vavassours in my own researches (Wright (2014) especially pps.156-161) all of which can only have been intended as a play for ultimate power: thus the reason for Odo's downfall – as well as for Domesday Book.

13. Q.v. Arthur Wright, 'The Myth of Magna Carta', *Wiðowinde* 173 (2015) pps.36-38.

## Chapter 8: The Landscape of Invasion

1. Marc Morris, *The Norman Conquest* (2012 and 2013), p.171.

2. There is confusion here as 'Pellinges' may not be the same location as later Peelings, a place on Pevensey spit, so I have opted for Harebeating, a little to the north and on the west side of the lagoon.

3. There are other explicable reasons, we have only to consider the affluence of much later Cambridgeshire 'fen-tigers' to understand that there were alternative and profitable enterprises to hand. These fen-tigers of the Cambridgeshire-Norfolk Fens made a very handsome living from eels, fishing and especially fowling before the draining and reclamation of their area. Their scale of trapping and sniggling defies comprehension and even without firearms I see no reason to doubt that similar catches were possible. See Audrey James, *Memoirs of a Fen Tiger* (1984) as told by Ernie James (1906).

4. Q.v. Anne Reeves, 'Earthworks Survey, Romney Marsh' pps.61-92 especially fig 2 (p.63) in *Archaeologia Cantiana* vol. CXVI 1996)

5. Q.v. Wright (2014) pps.365-368 and 374-380 and (2017) 110-111

6. Q.v. Wright (2017) pps. 81-85. Also consider the evidence of Nick Austin (infra) for evidence of Roman-period smelting to the north of Bulverhythe and Wilting.

7. Nick Austin, *Secrets of the Norman Invasion* (1994)

8. Phillimore's *Domesday Book*, 2, Sussex, ed. John Morris (1976), maps 3 and 4 (with locations). To prepare my reconstruction I also used the O.S. first edition, Sheet 88 (Hastings) and O.S. 1940-1946, Sheet 51 (Lewes and Eastbourne).

9. Q.v. R.F. Tylecote, *Metallurgy in Archaeology* (London, 1962) p.248 for references to Folkestone and Richborough; H. Cleere and D. Crossley, *Iron Industry of the Weald* (Cardiff, 1995) discuss the Roman industry and also the occurrence of tile fragments stamped for the *Classis Britannica*, pps.79-84

## Chapter 9: The Accuracy of Weapons and Armour

1. Wright (2017) pps.81-86

2. William of Poitiers and the *Carmen* both emphasise the French use of archers, making no mention of English archers and the Tapestry only shows one of the latter. Baudri de Bourgeuil, (c.1050-1130) who as Abbot of Bourgeuil (post 1079) wrote both a praise poem for Adela of Normandy and one on the Conquest of England, insisted that the English did not know of archery at all! Henry of Huntingdon, to whom we seem to owe the arrow in the eye story, (c.1088-1157) has Duke William pouring scorn on the English lack of militarism, ignorance of bows and submission to defeat! Such accounts are the distortions of history handed down to us by those ignorant alike of events and artefacts and they have coloured appraisals ever since. H.D.H. Soar in his *The Crooked Stick: A History of the Longbow* (2004) p.58 dismisses the English as only familiar with 'low-powered hunting bows': one must marvel at his ability to stalk game! Sir Ralph Payne-Gallwey in The Crossbow (1903 and 1981), p.31, repeats that 'the bow was little used by the Saxons at the time of the Conquest'. In fact, we hear of English archers effecting steady execution at both Maldon and Stamford Bridge.

3. Q.v. Payne-Gallwey (1903-1981) pps.26-30, quoting evidence gathered by W. Frankland in 1795 and Sir Robert Ainslie in 1797. Also, the same author's *Treatise on the Turkish Bow*, pps.19-23.

4. The author of the *Carmen* mentions that shields did not stop crossbow bolts and Domesday Book makes regular mention of arbalestiers, though whether these were users or makers of arbalests is unclear. Of course, the Tapestry shows only conventional bows.

5. The Second Lateran Council (1139) forbad the use of crossbows on Christians. The earliest English royal maker appears to be Peter the Saracen, maker to King

John in 1205 (Close Rolls of John; Bentley, *Excerpta Historica*, p.395 quoted by Baron de Cosson in *Archaeologia LIII*) and Richard I's passion for sniping with one is well known, also his condign death by one at Chalus. The Genoese were apparently arming with crossbows by 1181 (*Monumenti – Historia Patriae*, vol II, 21 quoted by Delauney in *Etude sur les Anciennes Compagnier d'archers, d'arbaletiers et d'arquebusiers*, 1879) probably quoting Bernardo Justiani (1408-89). Vandenpeereboom, *Gildes, Corps et Metiers, Sermontes, Etc*, Patria Belgica, 1874, claimed that the crossbow was known in Belgium by the end of the eleventh century. The use of composites or 'horn bows' seems to have been fairly common in the latter half of the twelfth century according to Joseph Alm *European Crossbows* (trans. Bartlett Wells) Royal Armouries monograph 3 (1994) and he and F. Rohde (über *die Zusammensetzung der Spätmiltelalterlichen Armbrust, Zeitschrift für Historischeur Waffen-und Kostümkunde*, Berlin, 1940) thought that these had evolved from the ancient Asiatic composite bow. Composites used tendon, sinew, yew, whalebone or ramshorn all bound together and two different adhesives.

6. Peter Poyntz Wright, *Hastings* (1996)

7. Major A. Logan Thompson, *Classic Arms* vol.6, no 4 (1999), p.24

8. Many writers have chosen to represent such features as copies from earlier sources when they are, in fact, specialised by function (subject to fashion and evolution). So we see double lugged (or stopped) spears in the Caedmen Ms. and single ones in the *Homilies of St Gall* (Basle, UniversitatsbibliotheK, Ms. B.IV.26.f.68v and the Utrecht Psalter at Canterbury (B.M. Ms. Harl.603f.IV); there are many archaeological specimens of bladed spears in the London Museum, (especially from Anglo Saxon grave assemblages). Later specimens of lugged, barred, stopped or toggled hunting spears may be seen in most of the European armouries, such as the Tower of London.

9. A particularly fine specimen can be seen on the early eleventh century Byzantine ivory plaque of St. Demetrius (Metropolitan Museum of Art, New York). There is also speculation that the standing figure on the Norwegian tapestry fragment from Baldishol Church is wearing lamellar; though a textile of later date both figures appear to be eleventh century (Oslo, Kunstindustrimuseet). There is also the gilt-bronze, Byzantine, plaque of St Theodore in the British Museum (MLA 90, 7-1,3) showing an eleventh century lamellar cuirasse.

10. The *Alexiad* of Anna Comnena, probably written between 1118 and 1148. In view of the earlier use of crossbows in the west and the subsequent evidence of Saracenic craftsmen, let alone the origins of the Asiatic composite-bow, it is surprising the Princess should be ignorant of them. It only goes to show that one should not rely on single sources, even when contemporary, for news and knowledge were not universal.

11. See Alm, op.cit. (1947) Royal Armouries Monograph 3 (1994) pps.6-7.

12. Richard Ellis, *Men and Whales* (1991 and 1992) p.45

13. Payne-Gallway, op.cit (1903 and 1981), pps.20-27.
14. *Carmen de Hastingae Proelio.*

## Chapter 10: The Psychology of the Tapestry
1. 'Many of the images in the Tapestry are derived from classical sources, mostly from copies of illuminated manuscripts in circulation in the eleventh century': Trevor Rowley, *An Archaeological Study of the Bayeux Tapestry, The Landscapes, Buildings and Places* (2016) p.10. He cites no authority for such a sweeping statement and it certainly demands firm evidence and a distribution network. We will explore how the flimsiest of connections between images (e.g. the slinger on the Tapestry) have been promoted to 'duplications' simply because they have the same vague subject. It is not good enough to say that because we have a photograph of a steam train that it must be the *Flying Scotsman* in 1936, or the *City of Truro*, or *Mallard*!
2. Niccolo Machiavelli *The Prince* (1514?)
3. Comte de Guibert (J.A. Hippolyte), *Essai Général de Tactique* (1770)
4. Carl von Clauswitz, *Vom Kriegë* (1831)
5. *The Prince*, XXVI: 'iustum enim est bellum quibus necessarium, et pia arma ubi nulla nisi in armis spes est'. Supposedly quoting Livy, but a doctrine/sophistry ascribed by the Church to Eusebius of Caesarea and Augustine of Hippo.
6. An excellent translation, collation and review of them is that by Anne Savage *The Anglo-Saxon Chronicles* (1982)
7. This excuse for a failure to effectively combat the Vikings (until 1066, of course) was combined with Millenarianism for the 'Second Coming' was widely forecast for the year 1,000 and Wulfstan (among others) wrote that 'after a thousand years will Satan be unbound'. This and the belief in Divine (predestined) Will, which made all events inevitable, must have had a dreadful effect on many people.
8. We have to remember that England had always been a collection of Kingdoms and remained split into two power-blocs as late as Alfred, in spite of apparent unification under Offa. Both rivalry and conflict tended to ensure dynastic fluidity whilst the quasi-egalitarian aspects of kingly control and lack of an overarching (or feudal) central authority kept successions relatively fluid.
9. Q.v. Wright (2017) pps.156-159: the creation of a (the) feudal system with the Oath at Salisbury (as a consequence of the Domesday Surveys). As David Douglas put it in *William the Conqueror, the Norman Impact upon England* (1964), pps.96-97, 'There seems little warranty for believing that anything resembling tenure by knight's service, in the later sense of the term, was uniformly established, or carefully defined, in pre-Conquest Normandy ... it would be wrong to deduce ... that before the Norman Conquest the structure of Norman society had as yet been made to conform to an ordered feudal plan'.
10. F.W. Maitland, *Domesday Book and Beyond* (1897).
11. Colonel C.H. Lemmon, *The Field of Hastings* (1957 and 1977) pps. 5-6

12. E.g. Major A. Logan Thompson, 'Anglo-Saxon Spears and Shields' in *Classic Arms*, vol.6.4. (1999) pps.20-24
13. Q.v. Wright (2014) pps.250 and 254-255 and 259-261.
14. ibidem pps. 36–41 and 113–131.
15. Wright (2017) pps. 120–121.

## Chapter 11: Who Embroidered the Tapestry and How?

1. Trevor Rowley, *An Archaeological Study of the Bayeux Tapestry* (2016) p.7. The execution of embroidery on the *Tapestry* is different from *Opus Anglicanum* work which did (especially with bullion) require a pounced pattern (see below).
2. Information from Dr B.A. Newman-Wright.
3. We know of professional embroiderers named Aelfgyd (at Oakley Buckinghamshire) and Leofgyd (at Knook in Wiltshire) from Domesday Book; when Queen Matilda died in 1083 she bequeathed a chasuble being woven at Winchester by Alderet's wife and a cloak wrought in gold. Such work in silk and gold thread, possibly some of it from Byzantine workshops, would seem to have been personally distinctive: the *Liber Eliensis* records that Brithnoð's nuncupative will to Ely was witnessed by the deposit of two crosses of gold and two lappets from his gown, the latter of valuable gold and jewelled work, as well as a skilful pair of gloves. This proof of investiture seems to have survived into the chronicler's own day. (For the relevant text of CAPITULUM 62 see *Liber Eliensis*, ed E.O. Blake, Royal Historical Society, Camden 3rd series, vol. XCII (1962) pps.133-136.) For the use of underside couching in bullion work see Kay Staniland, 'Embroiderers' in the *Medieval Craftsmen* series (British Museum, 1991) p.45 and for the use of cartoons pps.23-25 and p.29; for repetitive motifs pps.30-32.
4. Staniland, figs.24 and 29.
5. Q.v. D.M. Wilson, *Anglo-Saxon Art from the Seventh Century to the Norman Conquest* (1984).
6. C.R. Dodwell, *The Pictorial Art of the West*, 800-1200 (Yale, 1993).
7. Trinity College Cambridge, Ms. R.17.1 (f.283v).
8. British Museum Add. Ms. 42130.
9. Corpus Christi, Cambridge, Ms.2
10. Charles Dawson, *The 'Restorations' of the Bayeux Tapestry* (London, 1907).

## The Invasion Fleet

1. Reproduced as Appendix B to C. Warren Hollister's 'The Greater Domesday Tenants-in-Chief' in *Domesday Studies* (1987).
2. A.W. Brogger and H. Shetelig, *The Viking ships, their Ancestry and Evolution* (Oslo, 1951); Ole Crumlin-Pederson, *Viking Ships and Shipbuilding in Hedeby* (Roskilde Museum, 1997); Keith Durham, 'Viking Longship', *New Vanguard*

*47* (Osprey, 2002); Jan Bill, 'Viking Ships and the Sea' in *The Viking World*, ed. S. Brink and N. Price (2008).

3. 'Borgundnarran', BBC *Secrets of the Ancients* (1999) documentary.
4. Q.v. Arthur Wright, 'Men and Supermen: the Norman Myth' in *Wiðowinde* 179 (2016) pps.19-20.
5. William or Robert Wace (c.1110 – post 1174), who wrote the *Roman de Rou*, had a father from Jersey who may have been part of this fleet and who claimed that there were only 696 all-told.
6. Personal communication from a crew-member of the *Helga Ask*.

### The Map Of Pevensey In 1066

1. *Feudal England* (1895 and 1909), p.568.
2. S. H. King in H. C. Darby and Ella M. J. V. Campbell, *The Domesday Geography of South East England* (CUP 1962 and 2008), p.471.

### A Glossary Of Creatures Found On The Tapestry

1. James Fairbairn, Fairbairn's Crests, revised by Laurence Butters (1986)
2. Supposed author of The Travels of Sir John de Mandeville, circa 1360 (possibly Jean de Long or Jehan a la Barbe)
3. H. J. Massingham. The Wisdom of the Fields, (1945) and many other works
4. Oliver Rackham, The History of the Countryside, (1986 and 1995) and The Illustrated History of the Countryside (1994 and 2000)
5. William Cobbett, Rural Rides, Etc, (1822)

# Index